SHARAKU'S JAPANESE THEATER PRINTS

AN ILLUSTRATED GUIDE TO HIS COMPLETE WORK

by

HAROLD G. HENDERSON
and LOUIS V. LEDOUX

DOVER PUBLICATIONS, INC.
NEW YORK

DEDICATED TO THE MEMORY OF

S. C. Bosch Reitz

Published in Canada by General Publishing Company, Ltd., 30 Lesmill Road, Don Mills, Toronto, Ontario.

Published in the United Kingdom by Constable and Company, Ltd., 10 Orange Street, London WC2H 7EG.

This Dover edition, first published in 1984, is an unabridged republication of the work originally titled *The Surviving Works of Sharaku*, published by E. Weyhe, New York, in behalf of the Society for Japanese Studies, 1939. For reasons of space the arrangement of the frontmatter is here slightly condensed, the present pagination beginning with page 3. The corrigenda noted on a separate sheet in the original edition have been corrected directly in the text of this Dover edition.

Manufactured in the United States of America
Dover Publications, Inc., 31 East 2nd Street, Mineola, N.Y. 11501

Library of Congress Cataloging in Publication Data

Henderson, Harold Gould.
 Sharaku's Japanese theater prints.

 Reprint. Originally published: The surviving works of Sharaku. New York : Published by E. Weyhe in behalf of the Society for Japanese Studies, 1939.
 Bibliography: p.
 1. Tōshūsai Sharaku, fl. 1794. 2. Actors in art. 3. Theater in art.
4. Ukiyoe. 5. Theater—Japan. I. Ledoux, Louis V. (Louis Vernon), 1880–1948.
II. Title.
NE1325.T65H4 1984 769.92'4 84-4156
ISBN 0-486-24704-X

NOTE

This book which describes and illustrates all of the works of Sharaku that are known to survive, was designed to accompany exhibitions at the Boston Museum of Fine Arts, The Art Institute of Chicago and the Museum of Modern Art in New York. The choice of impressions to be exhibited and the preparation of the text were undertaken by the undersigned committee of members of the *Society for Japanese Studies* each of whom individually desires to express appreciation of the characteristic generosity of Mrs. William H. Moore without whose aid adequate publication would have been impossible. Acknowledgement should also be made of the encouragement to undertake the work received from The American Council of Learned Societies through their award of five hundred dollars toward the preparatory cost of research, selection and photography.

It gives us pleasure to express our thanks to the museums and private collectors of America who have allowed the works of Sharaku in their possession to be examined and compared, and who have in every instance agreed to loan all that were chosen. A list of the provenance of the prints and drawings exhibited will be found on another page; and here need only be added a word of gratitude to Mr. Kihachiro Matsuki who for very little reward except that which is brought by a good conscience, has expended a great deal of his time in furthering the researches made for us in the theatrical archives in Tokyo. Our appreciation of the aid given by three other experts, Dr. Rumpf, Dr. Ihara and Mr. Kimura, is expressed in the prefatory essay.

The work of the two members of the Committee whose names appear on the title page has been invaluably assisted in its search of original Japanese sources by the representative of the Museum of Fine Arts and has been gone over with equal care in other ways by the Curator of the Buckingham Collection in Chicago.

HELEN C. GUNSAULUS KOJIRO TOMITA
HAROLD G. HENDERSON LANGDON WARNER
LOUIS V. LEDOUX MONROE WHEELER

CONTENTS

A LIST OF THE COLLECTIONS FROM WHICH THE 113 PRINTS AND DRAWINGS BY SHARAKU EXHIBITED AND HERE REPRODUCED HAVE BEEN TAKEN*

THE ART INSTITUTE OF CHICAGO (Buckingham Collection). Numbers 3, 5, 7, 8, 9, 10, 12, 13, 19, 25, 27, 30, 32, 43, 45, 46, 47, 50, 53, 56, 61, 63, 73, 75, 79, 80, 81, 85, 88, 90, 92, 95, 96, 99, 106, 114, 115, 118, 126, 128, 142, 145.

Collection of Frederick S. Colburn, Esq., Evanston, Illinois. Numbers 49, 105.

Fogg Art Museum, Cambridge, Massachusetts (Duel Collection). Numbers 62, 83, 93.

Collection of Gilbert E. Fuller, Esq., Boston, Massachusetts. Numbers 24, 39, 76, 77, 86.

Collection of Edward Grabhorn, Esq., San Francisco, California. Number 131.

Collection of Louis V. Ledoux, Esq., New York City. Numbers 1, 16, 22, 28, 29, 40, 41, 44, 51, 87, 100, 101, 116, 125, 129.

Metropolitan Museum of Art, New York City (Church Collection). Numbers 42, 91.

Metropolitan Museum of Art, New York City (Mansfield Collection). Numbers 26, 59, 82, 98, 119.

Museum of Fine Arts, Boston, Massachusets (Bigelow Collection). Numbers 48, 52, 68, 70, 84, 108, 111, 122.

*Note: The provenance of exhibited and reproduced photographs of 28 other prints, five drawings, and one fan which make the record of Sharaku's work complete, in so far as is known, will be indicated where each is catalogued.

Museum of Fine Arts, Boston, Massachusetts (William S. and John T. Spaulding Collection). Numbers 1a, 2, 4, 6, 11, 14, 15, 18, 20, 21, 23, 37, 60, 66, 67, 69, 89, 94, 97, 103, 107, 109, 110, 113, 117, 123, 137, 140.

Portland Art Museum, Portland, Oregon (Mary Andrews Ladd Collection). Number 74.

Collection of Carl Schaubstadter, Esq., New York City. Number 104.

No one could write about the artist whose work is the subject of this monograph without making his opening sentence an appreciation of the zealous and meticulous scholarship of Dr. Fritz Rumpf, the learned director of the Japaninstitut of Berlin. His *Sharaku* published in 1932, ranks as by far the most important book on the subject in any language, and as present conditions make a third edition impossible now, Herr Rumpf very graciously has given the compilers of this catalogue a complete list of the revisions he would desire to make. The Committee has also had the benefit of special researches into the history of the Japanese theatre during the final decade of the eighteenth century which have been made for us by Dr. Toshiro Ihara, the foremost authority in Japan, and his able assistant Mr. Sutezo Kimura. In Tokyo as in Berlin there is a considerable amount of original source material, some of which is unique and much of which is not duplicated in America. We are fortunate here, however, because the Museum of Fine Arts in Boston has in its own archives a considerable collection of similar documents some of which are not known to exist elsewhere; and these have been of invaluable assistance, sometimes in deciding doubtful points on which there was disagreement, and occasionally in providing entirely new facts or sidelights with which no one was acquainted. It is the bringing together of the results of researches in Berlin, Tokyo and Boston that has enabled us to resolve doubts regarding the stage scenes depicted in many of Sharaku's prints, and for the same reason the subjects of others that hitherto have been wholly undetermined can now be identified with assurance.

In these ways the present catalogue should mark an advance in the scholarship of the subject; but the central mystery enfolding Sharaku himself has become more impenetrable, more incredible than it has seemed before, because the new facts brought to light have more than confirmed the statements of his contemporaries regarding the duration of that amazingly short period in which he was said by them to have designed all his prints. Occidentals have argued that he must have worked from three to six years; the original Japanese sources gave him a working time of "a year or so" and "about half a year," and as a result of our present researches, we have apparently conclusive evidence for believing that the period of his productivity comprised only the last ten months of

the calendar year 1794. That year, we should add, had an extra intercalary month so that it contained thirteen months in all. The mystery of Sharaku remains,—in fact has become deeper; we have no new light to throw on what little was known of the blank years that preceded his sudden and violent burst of creative activity; and all we might add to the unproved theories of others regarding the blank years that followed would be equally unsubstantiated suppositions of our own. Details will be gone into later; but as this book is designed to accompany exhibitions of the surviving prints and drawings of the artist—originals where that is possible and photographs where it is not—many of those into whose hands it will come will not be familiar with previous writings on the subject and will wish a resumé of what is known about Sharaku himself, before they turn to more technical discussions and consider the new facts about his work that have been discovered in our recent researches.

Until only a very few years ago Japanese prints were regarded in the aristocratic and intellectual circles of Japan as entirely unworthy of notice. This was partly because they were produced in quantity by semimechanical means and partly because they were supposed to have no spiritual content but to express merely the vulgar tastes and vulgar interests of an upstart bourgeoisie. Another point urged against them was that the brush-work of the artist no longer could be judged or appreciated when his original design had been cut on a block and then printed. Prints were considered by the connoisseurs of painting to be as unoriginal and unrepresentative as we would consider the translation of a poem from one language into another and from that into a third. The popular theatre —Kabuki—fell under a similar ban of vulgarity; and although plays and prints were the passion of a very vital middle class, those who wrote subtle treatises on the recognized forms of art maintained comparative silence in regard to the masters—even in painting—of the light-hearted Ukiyoye or Genre School to which the print designers belonged, and disregarded the actors and dramatists who were the idols of the bourgeoisie. Even the class for whom they were made considered prints ephemeral things,—merely records for the moment of transitory styles and pleasures; and such lists as were compiled of the artists who made them give very little information about any of the masters and almost none at all about Sharaku, perhaps because the period of his work was of such exceedingly brief duration.

What little could be gleaned from contemporary or nearly contem-

porary sources about the life of Sharaku has been set forth with full detail as to the sources themselves, etc., in the biographical section of Herr Fritz Rumpf's book on the artist; and the compilers of this catalogue are unaware of any corrections or additions that can be made. It is unnecessary to repeat Rumpf's documentation which anyone may read who wishes to do so, and we give in more concise form the facts which are as follows: In the closing years of the eighteenth century, and therefore at about the time when Sharaku's burst of volcanic activity had burned itself out or for some other reason had ceased as suddenly as it seems to have begun, a certain Sasaya Hōkyō, who was interested in prints, began to compile notes regarding the artists who had designed them in the past as well as those who then were working. His entry about the master with whom we are concerned reads: "Sharaku lived in Hatchōbori, Edo. His name in private life was [sic]; his brush name was Tōshūsai. He drew portraits of actors but exaggerated the truth and his pictures lacked form. Therefore he was not well received and after a year or so he ceased to work." By 1802 and therefore about seven years after Sharaku had designed his last known print, the manuscript quoted above had passed through the hands of three other compilers, Katō Eibian, Shikitei Samba and Santō Kyōden, and had received the following additions or corrections in regard to Sharaku: "His name in private life was Saitō Jūrobei. He was a Nō dancer in the service of the Daimyo of Awa. The power of his brush strokes and of his taste are worthy of note. He was active for only about half a year and produced bust-portraits of the actors. . . ." Seven names of actors then are given and this list concludes the entry. Very shortly after 1802 the poet Shokusanjin who may have helped Sasaya Hōkyō in the original compilation, was working on the manuscript and the book finally was printed in 1833 under the name *Zoku Ukiyoye Ruikō*. Before then, however, a copy had been made, and in a duplicate that was not used as a basis for the published edition, there is a note dated 1813 which adds that later on Sharaku produced skillful oil paintings under the name of Yūrin and that he died in 1801. Neither of these statements has been confirmed and neither was repeated in the published form of the book. Such other approximately contemporary mentions of Sharaku as there are confine themselves to brief references to his work, and most of these are unenthusiastic.

Mention, however, should be made of a book published in 1802 (*Haishi Okusetsu Nendaiki*) and discussed in the *Ukiyoye no Kenkyū,*

Vol. VI, number 2, October 1928, which reproduces from it a map entitled "Yamatoye-shi no nazukushi"—"A collection of the names of those skillful in Japanese painting." This map includes some thirty-eight artists of the Ukiyoye school ranging in time from Moronobu to Hokusai. It shows a central "island continent" composed of seven artists (Moronobu, Toyonobu, Shigenaga, Harunobu, etc.) surrounded by "mainlands" marked with the names of the Torii school, the Katsukawa school, etc. Sharaku is shown as an independent island lying between the central group and the mainland reserved for the Utagawa school. It may be added that another separate island lying immediately to the "north" of Sharaku is marked "Kitagawa Utamaro." This in itself is proof that his importance was recognized in his own time—at least by some of his contemporaries.

It is known that the Lords of Awa—the Hachisuka family—kept Nō dancers in Edo and that the city residence of the Hachisuka retainers was at the place where the contemporary manuscript, quoted above, says that Sharaku lived. At the request of the compilers of this catalogue the present Marquis Hachisuka has had the archives of his family freshly searched, but no new references to Sharaku under any of his supposed names have been found. Those who wish to read the unconfirmed and frequently discredited theories and conjectures about him which have been set forth in the past may do so either in Rumpf or in the various Japanese books and articles on Sharaku which have appeared during the last few years.

It is known that someone who signed himself Sharaku, or Tōshūsai Sharaku, designed 136 prints impressions of which survive, and at least a few others which, although they do not exist now, may be assumed confidently to have existed because they were necessary to complete triptychs or pentaptychs parts of which remain. It is known also and through absolutely contemporary evidence, that this man's name in private life was Saitō Jūrōbei or possibly Jirōbei, that he was a Nō dancer in the service of the Hachisuka family and that he lived with their other retainers at a given address in Edo. Beyond this there are one or two statements that cannot be confirmed and various conjectures no one of which has enough to support it to warrant repetition here. What little is actually known we have stated. The rest is silence; but the work that the man did grows in fame and reputation year after year, and we will devote the next paragraphs of this introduction to a brief historical account of the appre-

ciation of Sharaku, and some discussion of the legend that has grown up about him in the popular imagination of the Occident until his unknown personality, the unknown facts of his life have come to be consistently spoken of in Europe and America as tragic.

In Japan the name of Sharaku remained practically unknown and completely disregarded until it was called forcibly to the attention of his countrymen by the growth of his fame in Europe. The earlier Occidental books on Japanese prints gave comparatively little space to him, but the French who were leaders in such matters had been eagerly collecting his works for a number of years when in 1910 a German enthusiast, Dr. Julius Kurth, published the first book on Sharaku in any language and succeeded in listing therein about 70 subjects, 57 of which he was able to reproduce. Herr Kurth unfortunately had drawn his information and his examples mainly from German collections, and he does not seem to have put himself to the trouble and expense of going to Paris; but in January of the following year the French collectors exhibited at the Musée des Arts Décoratifs 105 Sharaku subjects some few of which were also shown in second states, and all of which were illustrated in fully adequate size but without very much text, in the superbly printed catalogue of the exhibition, which is known from the names of its compilers, as the Vignier-Inada Catalogue. At that time the greatest collections of Japanese prints in the world were in France; and in so far as Sharaku was concerned the honors remained with the French until 1932 when Fritz Rumpf published a work of painstaking and scholarly research in which he described 134 prints which he accepted as by Sharaku, and reproduced 130 of them in wholly inadequate size, largely through re-photographing other reproductions. By that time, however, a number of books and articles about Sharaku had begun to appear in Japan; and because of the death of some of the great Parisian collectors as well as the tragedy of the World War and the enormous increase of interest in other countries, the majority of the really important collections of Japanese prints were to be found no longer in France but in Japan itself and in America—especially in America.

The Sharaku legend, to which reference has been made, was an invention of the Occident and was based on a theory that the shortness of the artist's working period was the result of what most western critics have considered the savagely satiric quality in his portraits of the popular theatrical idols of his time. It has been thought that both the actors them-

selves with their vanity, and the public who adored them, were so offended by Sharaku's delineations that the satirist was forced, after not more than about three years of activity, to cease making prints and to spend the remainder of his life in obscurity—perhaps on the country estates rather than in the city entourage of his feudal lord. Some years ago one of the compilers of the present catalogue attempted to explain the psychology of Sharaku and to describe his art with the legend in mind, and wrote as follows:

"The popular theatre was scorned—as prints were scorned—by all save the middle class townsmen; the aristocrats, in the seclusion of their palaces, had the Nō dramas of exceedingly abstruse meaning and lofty moral tone that were danced and chanted before hushed audiences of scholars. Sharaku was a professional Nō dancer in the service of one of the great nobles, and he appears in his maturity to have come suddenly and for the first time into contact with the theatre of the people. It is as though some cloistered Fellow of Oxford, who had given his life to playing Aeschylus and Sophocles there, should have witnessed a series of amateur nights in vaudeville. He saw the commonness of common men, their bestiality, their small conceit, their stupidity; he saw the animal characteristics in them so clearly that he would have been an excellent illustrator of Aesop or of *Gulliver's Travels*—the comparison with Swift is rather apt; and, in spite of rays of somewhat ironic humor that gleam occasionally from his portraits, he drew them in the main with savage scorn, with that blind bitterness which is the child of disillusion. He reveals the plebeian actors as Goya revealed the Spanish Bourbons—but there is this vast difference: Sharaku was able to let himself go, Goya was not. One can imagine what the actors themselves thought of these pictures; but in any case portraits of popular idols drawn in this vein are not likely to prove popular, and after two years of the uninterrupted production of masterpieces Sharaku ceased to make prints."

The legend had something to commend it—at least from the point of view of the West, but it did not take into account the definite possibility that Lord Hachisuka may very well have told Sharaku that association with the outcast actors and depiction of them were entirely unsuitable occupations for a man in his position; and in eighteenth century Japan one did not disobey his feudal lord. Other things that the legend failed to consider were the facts that during his brief activity Sharaku made portraits of actors appearing in all three of the most important theatres of the Tokugawa capital, and that the very existence of second states of some of his most satiric prints seems sufficient to attest a demand for them.

The legend is correct in its statement that the more "savagely satiric"

ōban prints on mica grounds were followed by the more innocuous and less interesting aiban set with yellow grounds, but the persecution theories based on this fact are partially invalidated by a knowledge that the government prohibited the use of mica grounds at about the time when Sharaku ceased to use them, and that some of the prints in hosoye form which came between the ōban and the aiban certainly are satiric enough to make an Occidental feel that the actors portrayed in them would have been justified in resentment.

The matter is dwelt on at some length here because it is inevitable to seek explanations of the sudden cessation of work by an artist who seemed at the full maturity of his power. There are, however, plenty of possible causes; and unless someone finally succeeds in proving that Sharaku really died in 1801—six years after he stopped making prints, or really was dancing Nō for the Hachisuka family as late as 1825, the possibility of death or physical disability cannot be wholly set aside. The only fact that we can state which might be construed as evidence of unpopularity is that second editions of most, though not all, of the prints of Sharaku do not seem to have been demanded; but neither was there a demand for new printings of the actor portraits of Shunshō, Shunyei, or Toyokuni.

It seems unnecessary to attempt here any fresh appraisal of Sharaku as an artist. His place is secure; and those who do not wish to form their own conclusions are at liberty to read, if they are familiar only with European languages, the brilliant discussions of his quality by such critics as Laurence Binyon, Arthur Ficke and Louis Aubert; whereas if they read Japanese they can turn to the considerable literature on the subject that has sprung up in Japan since prints began to be well regarded there and since the master with whom we are concerned came to be known again in the country of his birth.

Among contemporary collections of Sharaku prints the largest is that of Mr. Kojiro Matsukata of Kobe which numbers seventy-four examples, four of which are duplicates, and the next in number is the Buckingham Collection now owned by the Art Institute of Chicago, which contains sixty-three. The third great Sharaku collection of the present time is that formed by John T. and the late William S. Spaulding which has fifty-one prints, and when these are brought, as they will be, to join the thirty-six already in the Museum of Fine Arts, and the eighteen resulting duplicates have been eliminated, the Boston collection will have sixty-nine.

Our exhibition has been drawn only from the private and public col-

lections in America, but the comparatively few recorded prints by Sharaku not found here are represented by photographs taken from reproductions in books and catalogues. Borrowing from the Matsukata collection which has thirteen out of the twenty-eight subjects we lack, has been made impossible by the rules governing National Treasures and the decisions of experts in regard to lending; and neither the locating nor the bringing together of certain other unique or nearly unique examples that are known to have been in various European collections before the World War could have been undertaken without a far greater expenditure of time and money than we had at our command. America, however, may be proud of the fact that from collections here we have been able to assemble a larger showing of prints by Sharaku than ever has been brought together before, even at that monumental exhibition held in the Musée des Arts Décoratifs in 1911; and it may be added that whenever more than one impression of the same subject was located we have endeavored always to choose the finest.

Herr Rumpf lists 134 prints which he believes to be by Sharaku and reproduces 130 of them. The four that he had heard of but could neither identify nor reproduce we will discuss first, following his numbering for them of 131 to 134.

The first of these is known only through a brief reference in an unillustrated article, the writer of which is unable to identify the print, and we think that this may safely be eliminated. The second, Rumpf number 132, turns out to be the same as his number 64—our number 55. Rumpf's number 133 was known to him only through a description in a Sotheby auction catalogue, but a priced copy of that catalogue which we have shows that when the print came to be sold the auctioneer stated that it was by Shunyei and not by Sharaku, which means that it was one of those fairly numerous prints from which the signature of Shunyei, or sometimes that of Toyokuni, has been taken out and that of Sharaku put in. It cannot be counted as among the works of the artist with whom we are now concerned. Number 134 we have in the identical impression described.

Let us now turn to the 130 subjects reproduced by Rumpf. He himself doubted the authenticity of his numbers 43 and 130, and we have eliminated the first of the two from our list but have accepted the other as genuine. These four eliminations reduce Rumpf's list of known prints by Sharaku to 130, and of these we can show 102 originals with photographs

of 28 others, some few of which depict wrestlers rather than actors, or for other reasons stand apart from the rest of his work and are comparatively uninteresting. We are also able to show 6 prints not listed by Rumpf and hitherto unreproduced, but of undoubted authenticity. The addition of these brings the total number of designs by Sharaku now known to exist in prints to 136, of which 108 are represented by originals in the exhibition of which this is the catalogue, and are reproduced in the pages that follow. The photographs of the others are added so as to make the showing of his surviving work in prints complete.

Out of eight existing drawings of actors confidently, and we believe with justification, attributed to him, we can show three, with photographs of the others. We also reproduce two fans bearing his name, which may have been done by him.

It remains to state what other additions or corrections the present catalogue brings to the previous scholarship of the subject.

Theoretically the dating of actor prints should be a fairly simple undertaking. On each figure appears the private *mon* or crest of the actor, so that we have his name to start with, and all that should remain to be done would be to run through the list of parts that he is known to have taken, when that happens to exist, and decide which one is represented by the print being studied at the moment. But it is just here that the difficulty comes in. Sometimes the costume, hair arrangement and makeup are such that the print might equally well represent two or even three parts; sometimes the distinctive differences are so slight that they can be detected only by an expert well acquainted with the action of the plays and with the customs of the eighteenth century theatre. And then again the records of the stage, while fortunately fairly full, are widely scattered and by no means wholly complete. In fact those that cover the very period of Sharaku's activity—the year 1794—are even more incomplete than most of the others. The documents on the subject possessed by Dr. Ihara, together with those in the Theatrical Museum of Waseda University, Tokyo, to which he has access, form a very notable collection, perhaps the greatest in the world; but the documents assembled in Berlin and Boston likewise are of importance, and each of the three centers apparently has a number of items not possessed by the others. Illustrated play-bills are among the most reliable sources of information in these collections, but those covering certain of the performances with which we are concerned seem no longer to exist and while the text of one of the plays

is preserved in its entirety there are others for which only the barest outlines of the plot have been found. Our work in this catalogue therefore cannot be regarded as absolutely definitive. Fortunately, however, the researches made in the three great collections of source material have enabled us to state definitely the subjects of the great majority of Sharaku's prints, in some cases confirming previous attributions and in others giving entirely new ones. We have tried, throughout the catalogue, to draw attention to identifications which seem open to doubt, and to give our reasons for making certain decisions in controversial cases. We believe that the rather startling conclusions to which we have been forced by the evidence obtained cannot be controverted, except perhaps in minor details, by future investigators or through any new source material that may come to light.

Sharaku's actor prints naturally fall into three categories according to size. The largest of these is the ōban, approximately 15 x 10 inches; the second is the aiban, about 13 x 9 inches, and the smallest is the narrow hosoye which measures about 13 x 6 inches. These dimensions refer to full-size, untrimmed examples; individual prints which in some cases have been trimmed, of course are slightly smaller.

Of the ōban prints the majority are large heads or bust-portraits on a dark ground covered with mica. When Rumpf's and Ihara's conclusions about these were compared it was found that all the prints on which they agreed were attributed to three performances, all of which were put on at Edo in the fifth month of 1794. Furthermore it was found that for all but two of the few prints on which their reports disagreed, either Rumpf or Ihara had made an attribution to one of these same three performances. The question immediately arose of whether the two prints that were dated tentatively and inconclusively apart from the rest had not in reality been issued with all the others of the same size and type. That question was settled, however, and to our satisfaction when the Boston collection yielded documentary proof that both the actors represented in these two prints had played parts in the fifth month performances to which the costumes and hair arrangements shown would be appropriate.

Our first addition to the evidence about Sharaku therefore is a statement of the strong probability that all the ōban prints with dark mica grounds were issued in connection with the fifth month performances of 1794. There are 28 of these that survive, twenty-three showing single figures and five giving double bust-portraits. It does not seem possible to

decide whether or not all of these were issued at once, and as the performances lasted about two months each, it is quite possible that the prints representing them came out in two or even three instalments.

Besides the ōban bust-portraits there are known seven other ōban actor prints. All of these show two full-length figures and all but one—a night scene—have white mica backgrounds. As there are two actors in each it is far easier to identify the scenes depicted than it is when one actor is shown alone. There is not now any disagreement among experts as to the rôles represented in them, but it has remained for the present catalogue to point out that the plays they record were the ones immediately following the fifth month productions at the three theatres for which the ōban bust-portraits had been issued. Two of these productions began in the seventh month of 1794 and the other in the eighth month.

It is convenient to turn next to the hosoye, and of these there are 83 extant which are accepted as authentic. As this number is three times that of the ōban bust-portraits there have been more chances for differences of opinion regarding their attribution, but fortunately many of them, especially those with decorated backgrounds, fall obviously into sets which can be identified with a high degree of assurance, and it is equally fortunate that a quite large number of single sheet subjects, through the costumes and actions they depict, can be attributed beyond reasonable doubt. In regard to the last mentioned class we would express special thanks to Dr. Ihara for his quotations from the *Yakusha Ninsō Kagami,* a compilation of theatrical comment contemporary with the plays, no copy of which exists in America, for these have been of the utmost assistance in settling a number of points which otherwise would have remained open to question.

Details which will be found in the text need not be given here, but we may say that the first result of arranging chronologically those hosoye of which the dating seemed sure was to obtain abundant confirmation of the idea now generally accepted by Japanese writers on Sharaku, that all his earlier prints were signed "Tōshūsai Sharaku *gwa*," and all his later ones merely "Sharaku *gwa*." Another conclusion is that all of the hosoye are connected with plays produced between the seventh month of 1794 and the first month of 1795. We must note that this idea is not wholly supported either by Herr Rumpf or Dr. Ihara, and that we cannot produce absolutely positive evidence to sustain it. We can and do show, however, that all except 3 out of the 83 hosoye that survive may be put with

assurance within these dates, and while our attributions of the three doubtful ones are tentative there are reasons for believing them to be correct.

Of the aiban size of actor prints only 10 are known, and all of these are single bust-portraits on yellow grounds. They seem to be associated with plays produced from the eleventh month of 1794 to the first month of 1795. The dating of the portrait of Miyako Dennai and of the four prints representing wrestlers is treated fully in the body of the catalogue.

With one or two exceptions the ōban bust-portraits are not as rare as most of Sharaku's other prints. Several of the hosoye exist only in single impressions and in a number of cases only two are known to survive. We have given in the text of the catalogue all of the information that we have about the present location of the excessively rare subjects, and in connection with those that are less scarce we have indicated the number of impressions found in the collections in America. The comparison of different impressions is of extreme interest to students and in order to help in that regard we have given in each catalogue sheet references to previous reproductions of the subject under discussion, endeavoring to point out, wherever that was possible, the mere rephotographing for one book of a plate that had been used in another. In many instances this throws interesting light on the scarcity of prints by Sharaku and in many other cases it enables comparison of impressions to be made.

It seems best to discuss not here but in the body of the catalogue the considerable number of prints that have hand-written inscriptions with a date equivalent to the ninth month of 1794, and we describe in connection with its most conspicuous example another lot of prints bearing inscriptions that are believed to be in the calligraphy of one of the compilers of the original notebook from which we have quoted the earliest known references to Sharaku. The man who wrote those inscriptions seems to have formed a collection of prints by the artist we are studying and his seal has been found on the back of the one referred to just above. For discussion of these two sets of inscriptions see numbers 2 and 100.

The production of mica ground prints stops abruptly at the eighth month of 1794. This stoppage now is known to have coincided with a government edict against further issuance of prints of that type, and we have circumstantial evidence to show that between the promulgation of the law and its enforcement there must have been a considerable demand for at least some of those by Sharaku. In any case the period now under

discussion when the edict was about to be enforced marks a very definite turning-point, as is shown in the prints made for the play MATSU WA MISAO ONNA KUSUNOKI, produced at the Kawarazaki-za in the beginning of the eleventh month of 1794. To this play are assigned the first of the yellow-ground bust-portraits; for this play also were made the first of the hosoye on untinted grounds and the first with background accessories. And to make the break even more sharply apparent, of the twelve prints illustrating that production five are signed "Tōshūsai Sharaku" and seven are signed merely "Sharaku." Up to this period every print had the full signature; on the remainder the Tōshūsai does not appear.

The Kabuki theatre had a number of stock stories, and each time that one of these tales was put on there might be even greater variations from the normal in the version given than those which marked a recent American production of "Macbeth" in which the scene had been transferred to Haiti. There is a French version of the same Shakespearean story in which the protagonist, instead of being killed by Macduff, retires to a monastery to end his days in peaceful repentance; but the Japanese of the eighteenth century would have been perfectly capable of producing a variation in which Duncan murdered Macbeth and Lady Macbeth turned out to be in love with Banquo.

There must have been nearly 300 stage versions of the Soga story; and when it has been impossible to find the actual and complete text of a play whose characters are represented in prints by Sharaku, we have been obliged to draw our "Outline of the Plot" from contemporary references to the production or from general knowledge of the usual course of the action in the development of that theme. We believe that the outlines we have given are, in the main, correct for the versions represented; but it is only fair to those who will depend on this book to state the difficulties encountered in their preparation by citing the most complicated example of them.

GODAIRIKI KOI NO FŪJIME has to do with the well known stage story of the love affair of a *samurai* named Gengobei with a girl called Oman of the Pearl House whom he kills by mistake. Throughout the action of the piece his friend Sangobei, and Sangobei's wife, Koman, remain loyal to him. This is the so-called "Satsuma-Uta" version of the tale and it is supposed to have been developed from a seventeenth century folk song. The play was written by Chikamatsu in 1704 and revised by Namiki Gohei just before 1795. The revised version, which is the one put on in the first

23

month of that year under the title of GODAIRIKI KOI NO FŪJIME, gives the same names to the principal characters, but Koman was represented in it not as Sangobei's wife but as a geisha, and her relations with Gengobei were so altered that in the course of the action he killed her intentionally instead of killing Oman by mistake. Segawa Kikunōjo III made a conspicuous success playing Koman, the geisha, in that production; but in case the pitfalls lying in wait for cataloguers have not yet become sufficiently evident, we will end this digression by saying that although an Occidental who found a picture of Mrs. Siddons dressed as a bar-maid would not dream of considering her rôle that of Lady Macbeth, anyone who tries to identify the prints of Sharaku through study of the costumes, or to write outlines of the plays in which the actors represented appeared, must delve long and curiously among the dusty records of theatrical history before he commits himself to any conclusion. If he knew only the earlier version of the Gengobei story he would not expect to see Koman dressed as a geisha.

What errors will be found in our work we do not know; nor do we know what new facts, what additional prints may throw fresh light on our conclusions and perhaps reverse some of them. The edifice of scholarship never is finished, there always are new buttresses to be built, old stones to be replaced here and there; but if the text furnished to go with the extraordinary assemblage of master-works of a great print designer which we have gathered for exhibition and reproduction shall prove to have given the students of the future a foundation of more enduring value on which to build, we will consider ourselves rewarded by more than the pleasure we have found in the gathering of these superb prints whose quality will be evident in the exhibition and even will be visible to those who see merely the reproductions that follow with the text of our catalogue.

In the descriptions of each print, whenever a similar one was reproduced by Kurth or by Rumpf or in the lavishly illustrated Vignier-Inada Catalogue, we have given the reference and we have added for the convenience of our Japanese readers, references to reproductions in the books on Sharaku by Noguchi and Nakata; but except in a few special cases in which the reasons for doing so will be apparent, no attempt has been made to list other places where reproductions of the subject under discussion have appeared. Almost all books on Japanese prints and innumerable exhibition and sale catalogues of them that have been issued

within the past forty years in Japan itself, in Europe and in America, illustrate at least one Sharaku; but if we gave references to all of these much space would be used to little purpose. In a few instances, however, we have given for special reasons considerably longer lists. All our references to Kurth are to the edition of 1922.

It was in 1790 that the Tokugawa government decreed that no print could be published until its design had been approved by an official censor, and all the prints of Sharaku bear a censor's seal. He had only one publisher—Tsutaya—whose trade-mark appears on all authentic prints that bear the artist's signature.

The size of the print, the type of background used in it and the coloring of the costume depicted will be noted in the separate description of each subject.

In the following catalogue the surviving works of Sharaku are arranged in the six categories listed below, and the prints representing actors have been placed in accordance with the approximately chronological order of the productions in which they are shown as appearing.

The Manager	Nos. 1 and 1a
The Plays and the Actors	Nos. 2 to 127
Unidentified Actor Prints	Nos. 128 and 129
Miscellaneous Prints	Nos. 130 to 136
Drawings of Actors	Nos. 137 to 144
Fans	Nos. 145 and 146

The exhibition is arranged to be seen by a person moving from left to right.

THE PLAYS, THE ACTORS, AND THE RÔLES REPRESENTED

HANAAYAME BUNROKU SOGA

NO.	ACTOR	RÔLE
2	Ichikawa Yaozō III	Tanabe Bunzō, a cripple
3	Segawa Kikunojō III	O-Shizu, wife of Tanabe Bunzō
4	Segawa Tomisaburō II	Yadorigi, wife of Ōgishi Kurando
5	Sawamura Sōjūrō III	Ōgishi Kurando
6	Bandō Mitsugorō II	Ishii Genzō, chief aid to the avengers
7	Sakata Hangorō III	Fujikawa Mizuyemon, the villain
8	Arashi Ryūzō	Ishibe no Kinkichi, a money lender
9	Segawa Tomisaburō II	Yadorigi
	Nakamura Manyo	Wakakusa, her maid servant
10	Ōtani Tokuji	Sodesuke, a *yakko*
11	Sanogawa Ichimatsu III	O-Nayo, a courtezan
12	Sanogawa Ichimatsu III	O-Nayo
	Ichikawa Tomiyemon	Kanisaka Tōda

KOINYŌBŌ SOMEWAKE TAZUNA

INCLUDING THE FINAL SCENE

YOSHITSUNE SENBON-ZAKURA

KAWARAZAKI-ZA, FIFTH MONTH OF 1794

NUMBERS 13 TO 22A

NO.	ACTOR	RÔLE
13	Ichikawa Monnosuke II	Date no Yosaku, husband of Shigenoi
14	Iwai Hanshirō IV	Shigenoi, wet nurse of her lord's child
15	Tanimura Torazō	Washizuka Hachiheiji, brother of Washizuka Kwandayū
16	Ichikawa Ebizō IV	Probably Washizuka Kwandayū, the villain of the piece
17	Iwai Kiyotarō	Fujinami, wife of Sagisaka Sanai
	Bandō Zenji	Ozasa, wife of Washizuka Kwandayū
18	Bandō Hikosaburō III	Sagisaka Sanai
19	Ōtani Oniji III	Edohei, a *yakko*
20	Ichikawa Omezō	Ippei, a *yakko*
21	Osagawa Tsuneyo II	Ayame, the mother of Shigenoi

YOSHITSUNE SENBON-ZAKURA

NO.	ACTOR	RÔLE
22	Bandō Zenji	Onisadobō, a priest
	Sawamura Yodogorō II	Kawatsura Hōgen
22a	Modern reproduction of a recorded state of number 22.	

KATAKIUCHI NORIAI-BANASHI

INCLUDING THE *jōruri* EPISODE

HANAAYAME OMOI NO KANZASHI

KIRI-ZA, FIFTH MONTH OF 1794

NUMBERS 23 TO 29

NO.	ACTOR	RÔLE
23	Matsumoto Yonesaburō	Kewaizaka no Shōshō, a courtezan
24	Nakayama Tomisaburō	Miyagino, daughter of Matsushita Mikinojō
25	Onoye Matsusuke I	Matsushita Mikinojō, killed by Shiga Daishichi
26	Ichikawa Komazō II	Shiga Daishichi, the villain of the play
27	Matsumoto Kōshirō IV	Sanya no Sakanaya Gorōbei, a fishmonger who helps Miyagino avenge her father.

HANAAYAME OMOI NO KAZASHI

NO.	ACTOR	RÔLE
28	Morita Kanya VIII	Uguisu no Jirōsaku, a palanquin bearer
29	Nakamura Konozō	Kanagawaya no Gon, a boatman
	Nakajima Wadayemon	Bōdara no Chōzayemon

NIHONMATSU MICHINOKU SODACHI

INCLUDING THE *jōruri* EPISODE

KATSURAGAWA TSUKI NO OMOIDE

KAWARAZAKI-ZA, SEVENTH MONTH OF 1794

NUMBERS 30 TO 39

NO.	ACTOR	RÔLE
30	Ichikawa Omezō	Tomita Hyōtarō, son of Sukedayū
31	Ōtani Oniji III	Kawashima Jibugorō, the villain of the piece
32	Ichikawa Omezō	Tomita Hyōtarō
	Ōtani Oniji III	Ukiyo Tohei
33	Tanimura Torazō	Tomita Sukedayū, killed by Jibugorō
34	Ichikawa Ebizō IV	Ranmyaku no Kichi
35	Iwai Kiyotarō	O-Toki, wife of Saburobei

KATSURAGAWA TSUKI NO OMOIDE

NO.	ACTOR	RÔLE
36	Iwai Hanshirō IV	Shinanoya O-Han, a girl loved by Chōyemon
37	Bandō Hikosaburō III	Chōyemon, a middle-aged merchant
38	Osagawa Tsuneyo II	O-Kinu, wife of Chōyemon
39	Bandō Hikosaburō III	Chōyemon
	Iwai Hanshirō IV	Shinanoya O-Han

KEISEI SANBON KARAKASA

NO.	ACTOR	RÔLE
40	Ichikawa Danjūrō VI	Fuwa Bansaku, son of Fuwa Banzayemon
41	Segawa Tomisaburō II	Tōyama, a courtezan
42	Yamashina Shirōjūrō	Nagoya Sanzayemon, who is killed by Fuwa Banzayemon
43	Segawa Kikunojō III	Katsuragi, a courtezan, the heroine of the play
	Sawamura Sōjūrō III	Nagoya Sanza, son of Nagoya Sanzayemon
44	Sawamura Sōjūrō III	Nagoya Sanza
45	Segawa Kikunojō III	Katsuragi
46	Ichikawa Yaozō III	Fuwa Banzayemon, the villain of the play
47	Ichikawa Yaozō III	Fuwa Banzayemon
	Sakata Hangorō III	Kosodate-no-Kwannon-bō, a priest of Kwannon Protector of Children
48	Ōtani Tokuji	Monogusa Tarō
49	Ichikawa Tomiyemon	Inokuma Monbei
50	Sakata Hangorō III	Kosodate-no-Kwannon-bō
51	Bandō Mitsugorō II	Asakusa no Jirosaku, a farmer
52	Ōtani Hiroji III	Tosa no Matahei, a *yakko* in the service of Sanza
53	Arashi Ryūzō	Ukiyo Matahei, a *yakko* in the service of Banzayemon
54	Ōtani Hiroji III	Tosa no Matahei
	Arashi Ryūzō	Ukiyo Matahei
55	Sanogawa Ichimatsu III	Sekinoto, wife of Fuwa Banzayemon

SHINREI YAGUCHI NO WATASHI

INCLUDING THE INDEPENDENT AFTER-PIECE

YOMO NO NISHIKI KOKYŌ NO TABIJI

KIRI-ZA, 20TH OF THE EIGHTH MONTH OF 1794

NUMBERS 56 TO 66

NO.	ACTOR	RÔLE
56	Morita Kanya VIII	Yura Hyōgonosuke, a faithful retainer
57	Ichikawa Komazō II	Minase no Rokurō Munezumi, a faithful retainer
58	Ichikawa Komazō II	Minase no Rokurō Munezumi
59	Nakamura Kumetarō II	Minato, wife of Yura Hyōgonosuke
60	Nakajima Kanzō	Neboke no Chōzō, a packhorse man
61	Nakayama Tomisaburō	Tsukuba Gozen, consort of Nitta Yoshioki

YOMO NO NISHIKI KOKYŌ NO TABIJI

NO.	ACTOR	RÔLE
62	Matsumoto Kōshirō IV	Magoyemon, father of Kameya Chūbei
	Nakayama Tomisaburō	Umegawa, a girl loved by Chūbei
63	Matsumoto Kōshirō IV	Magoyemon
64	Nakajima Wadayemon	Tambaya Hachiyemon, a client from whom Chūbei stole
65	Matsumoto Yonesaburō	O-Tsuyu, a waitress in a tea-house
66	Ichikawa Komazō II	Kameya Chūbei, the protagonist of the drama
	Nakayama Tomisaburō	Umegawa

MATSU WA MISAO ONNA KUSUNOKI

INCLUDING VARIOUS EPISODES
AND A *shibaraku* SUBJECT

KAWARAZAKI-ZA, ELEVENTH MONTH OF 1794

NUMBERS 67 TO 80

NO.	ACTOR	RÔLE
67	Ichikawa Komazō II	Shinozuka Gorō Sadatsuna, discoverer of a plot against the Emperor
68	Onoye Matsusuke I	Magoroku Nyūdo, a priest
69	Iwai Hanshirō IV	A pilgrim
70	Iwai Hanshirō IV	Chihaya, sister of Kaneyoshi
71	Ichikawa Komazō II	Nitta Yoshisada, a great lord and the loyalist commander
72	Osagawa Tsuneyo II	Kojima, wife of Bingo Saburō
73	Nakajima Wadayemon	Daizō, a house-holder in league with the plotters
74	Matsumoto Kōshirō IV	Hata Rokurōzayemon, a loyal retainer
75	Iwai Hanshirō IV	Sakurai, the sister of Kusunoki Masashige, disguised as O-Toma
76	Ichikawa Komazō II	Ōyamada Tarō, a leader in the conspiracy
77	Osagawa Tsuneyo II	O-Roku, a hair-dresser acting as a "go between"
78	Iwai Hanshirō IV	Sakurai
79	Iwai Hanshirō IV	Sakurai, or possibly Chihaya, disguised as a peasant girl
80	Ichikawa Komazō II	Ōyamada Tarō

OTOKOYAMA O EDO NO ISHIZUE

INCLUDING THE *tokiwazu jōruri* EPISODE

SHINOBU KOI SUZUME IRO TOKI

THE SHOSA, TSUKAIJISHI

AND A *shibaraku* SCENE

KIRI-ZA, ELEVENTH MONTH OF 1794

NUMBERS 81 TO 101

NO.	ACTOR	RÔLE
81	Ichikawa Yaozō III	Hachimantarō Yoshiiye, commander of the loyalist forces
82	Ichikawa Yaozō III	Gengō Narishige, who dies to save Yoshiiye
83	Ichikawa Ebizō IV	Abe no Sadatō, leader of the opposing army
84	Ichikawa Ebizō IV	Abe no Sadatō disguised as Ryōzan
85	Nakayama Tomisaburō	O-Hide, sister of Abe no Sadatō and wife of Narishige
86	Nakayama Tomisaburō	O-Hide
87	Morita Kanya VIII	Kawachi Kanja, a spy
88	Sakata Hangorō III	Abe no Munetō, brother of Abe no Sadatō
89	Yamashita Kinsaku II	Iwate, the wife of Abe no Sadatō
90	Yamashita Kinsaku II	Iwate
91	Yamashita Kinsaku II	Iwate
92	Ichikawa Yaozō III	Saegi Kurandō

* * * * *

| 93 | Ichikawa Ebizō IV | Kamakura Gongorō Kagemasa |

SHINOBU KOI SUZUME IRO TOKI

94	Nakayama Tomisaburō	O-Fude, a cowherd
95	Sakata Hangorō III	Yahazu no Yatahei, a *yakko*
96	Ichikawa Yaozō III	A birdseller, really the ghost of Chūjo Sanekata
97	Ichikawa Danjūrō VI	Mimana Yukinori
98	Sakakiyama Sangorō II	Odai Hime, daughter of Michinaga

* * * * *

| 99 | Ichikawa Danjūrō VI | Arakawa Tarō |

TSUKAIJISHI

| 100 | Nakayama Tomisaburō | A lion dancer |
| 101 | Ichikawa Yaozō III | A lion dancer |

URŪ TOSSHI MEIKA NO HOMARE

AND THE SPECIAL
KAOMISE SHOSAGOTO
MANZAI AND SAIZŌ
MIYAKO-ZA, ELEVENTH MONTH OF 1794
NUMBERS 102 TO 115

NO.	ACTOR	RÔLE
102	Nakamura Noshio II	Ono no Komachi, court lady and poetess
103	Sawamura Sōjūrō III	Ōtomo no Kuronushi, rival poet at the court
104	Segawa Kikunojō III	Hanazono Gozen, wife of Ōtomo no Kuronushi
105	Sawamura Sōjūrō III	Ōtomo no Kuronushi disguised as a messenger
106	Segawa Kikunojō III	Hanazono Gozen
107	Nakamura Noshio II	Ono no Komachi
108	Nakamura Nakazō II	Prince Koretaka disguised
109	Nakamura Nakazō II	Prince Koretaka disguised
110	Sanogawa Ichimatsu III	Shizuhata, sister of Hata Daizen Taketora
111	Arashi Ryūzō	Ōtomo no Yamanushi, who poses as Prince Koretaka
112	Ōtani Hiroji III	Hata Daizen Taketora, a courtier
113	Segawa Tomisaburō II	Prince Koretaka disguised as a lady in waiting
114	Bandō Hikosaburō III	Goinosuke Munesada, a courtier
115	Nakamura Nakazō II	Aramaki Mimishirō in the guise of the New Year dancer Saizō

NIDO NO KAKE KATSUIRO SOGA

KIRI-ZA, NEW YEARS 1795
NUMBERS 116 TO 118

NO.	ACTOR	RÔLE
116	Ichikawa Yaozō III	Soga no Jūrō Sukenari, elder brother of Soga no Gorō
117	Ichikawa Danjūrō VI	Soga no Gorō Tokimune
118	Ichikawa Ebizō IV	Kudō Suketsune, who had killed their father

EDO SUNAGO KICHIREI SOGA

WITH THE *nibanme*
GODAIRIKI KOI NO FŪJIME
MIYAKO-ZA, FIRST MONTH OF 1795
NUMBERS 119 TO 127

NO.	ACTOR	RÔLE
119	Sawamura Sōjūrō III	Soga no Jūrō Sukenari, elder brother of Soga no Gorō
120	Bandō Mitsugorō II	Soga no Gorō Tokimune
121	Bandō Hikosaburō III	Kudō Suketsune, who had killed their father

GODAIRIKI KOI NO FŪJIME

122	Iwai Kumesaburō	Kumekichi, a geisha
123	Sawamura Sōjūrō III	Satsuma no Gengobei, the hero of the piece
124	Segawa Yūjirō II	O-Towa, a servant
125	Segawa Tomisaburō II	A geisha
126	Sawamura Sōjūrō III	Satsuma no Gengobei
127	Bandō Mitsugorō II	Hachiyemon, servant of Gengobei

UNIDENTIFIED
NUMBERS 128 AND 129

128	Segawa Kikunojō III	Possibly as Koman, the geisha-heroine of GODAIRIKI KOI NO FŪJIME
129	Segawa Kikunojō III	Probably as the *shirabyōshi* Hisakata in the guise of the New Year dancer Yamato Manzai

THE SURVIVING WORKS OF
Tōshūsai Sharaku

The Manager

NUMBERS I AND Ia

I

The theatre director Miyako Dennai III, fat, shrewd and complacent, seated in ceremonial costume and reading from a scroll that he holds open before him. The print is a masterpiece of characterization in every line of the face and hands, and to some it has suggested comparison with certain portraits by Holbein.

Brick red is the ground color of the main part of the costume and on this is a "Long-life" design in white. The remaining portions are in a somewhat faded blue.

Miyako Dennai at the time this print was made—some time in 1794, the exact date will be discussed later—had recently become owner-manager of the Miyako-za or "Capital Theatre." During the preceding year the Nakamura-za, of which the Miyako-za had been a subsidiary, had closed its doors; and when the owner-manager portrayed in the print raised the last-mentioned house to first rank by an important production there in the eleventh month of 1793, the event was momentous to him personally for the additional reason that in 1633 the first Miyako Dennai had founded the Miyako-za, and now after over 160 years of varied fortunes, it was once again under an entrepreneur of the same name and recognized as one of the three leading theatres of Edo.

Naturally the first part of 1794 was a time of celebration at the theatre. Immediately before HANAAYAME BUNROKU SOGA, the first play treated in this catalogue, there was produced as part of the ceremonies of rejoicing, a special *jōruri* entitled KOTOBUKI MIYAKO NO NISHIKI, which may be translated as "Long Life to the Splendors of the Capital." The print obviously is inspired by a similar congratulatory idea, for it shows Miyako Dennai in a dress covered with the Chinese character for *Kotobuki,* "Long-life." It may even have intended a punning reference to the play, for the picture itself is certainly a *Kotobuki Miyako no nishiki-ye* —a brocade-print of Miyako covered with best wishes for long life.

In the four other previously recorded impressions of this rare subject, inscriptions on the scroll which are the same in three out of the four but

not in the fourth, are visible in reverse through the paper. For a discussion of that state and of the inscriptions see the following number.

The portrait of Miyako Dennai is one of the scarcer full-size prints by Sharaku and only the two impressions shown here to illustrate different states were found in America.

The print has been reproduced once before, and at that time it was number 186 in the Ficke Catalogue of 1925.

Ōban. White mica ground. Signed: Tōshūsai Sharaku.

Ledoux Collection.

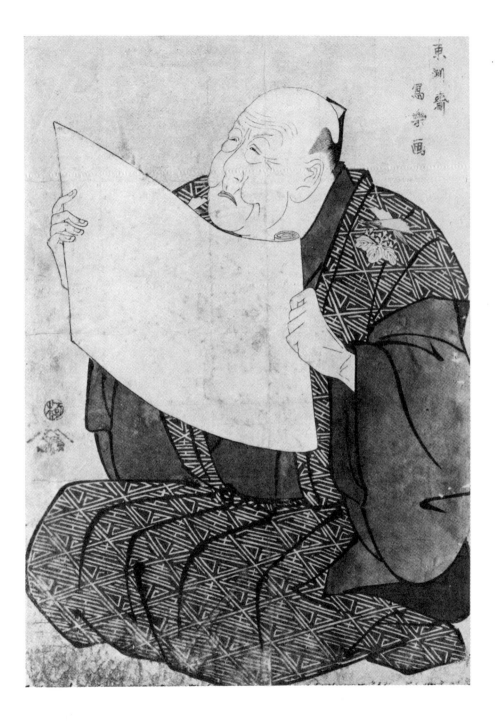

I a

Portrait of Miyako Dennai III reading an announcement.

The same print as the preceding number but in a state that shows an inscription on the scroll from which Miyako Dennai is reading. The impression has been considerably trimmed so that part of the figure and all of the signature are missing.

It has not been noted hitherto that in the four impressions with lettering which have been reproduced previously, the inscription in one differs from that in the three others. The print formerly in the Jacquin Collection which is reproduced in the Matsukata Catalogue as well as in the Vignier-Inada Catalogue, number 290, from which it was rephotographed for the illustrations in Noguchi, Nakata and *Ukiyo-ye Taisei,* agrees in the arrangement and wording of the inscription with the British Museum impression, splendidly reproduced in color by von Seidlitz, with the one formerly in the Gonse Collection which is reproduced in Migeon's *Chefs d'oeuvre d'Art Japonais* and with the one here shown. In the impression reproduced as Rumpf number 38, however, the inscription obviously is different not only in the text itself but also in the number and length of the lines in which it is arranged. Unfortunately Rumpf's reproduction is so dim and in such small scale that the Japanese characters cannot be read with any assurance; but according to him the announcement Miyako Dennai is reading states that "new portraits of the actors appearing in the second act which will follow immediately" have been published.

The inscription on our print and on all the others to which we have referred reads: *Kōjō. Kore yori nibanme shinpan nigao goran ni ire tatematsuri soro,* which means approximately: "Announcement. From now on we present for your inspection newly printed portraits for the *nibanme.*" The difficulty in determining the exact meaning comes from the word *nibanme.* If this is translated "second part," as is done by some authorities, the meaning of the announcement would be equivalent to that given by Rumpf. If, on the other hand, *nibanme* means rather "second

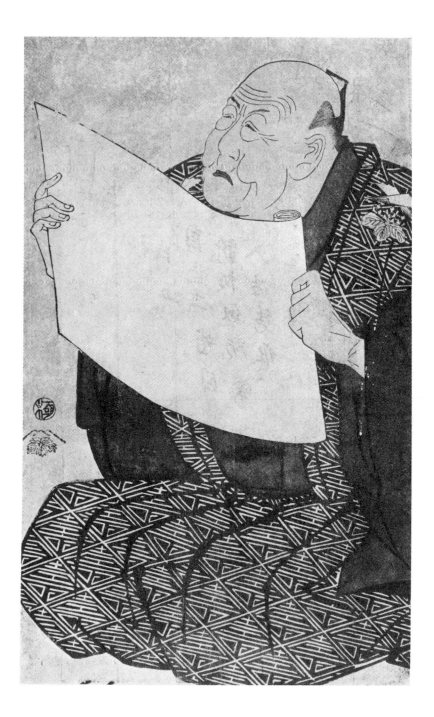

time," as is believed by other authorities both Japanese and Occidental, the meaning is changed and a previous series of portraits is predicated.

It is not necessary to go into the details of the argument, for the upholders of both translations agree that the picture was published as an advertisement for some of Sharaku's prints. In general, those who read *nibanme* as "second part" believe that it introduced the series of bust-portraits on dark mica ground designed for the play HANAAYAME BUNROKU SOGA, which opened at the Miyako-za on the fifth day of the fifth month of 1794—a dating which would make it one of the first Sharaku prints to be issued. On the other hand those authorities who read *nibanme* as "for the second time" predicate a previous series of prints and as to these, three suggestions have been made: First, that the early dating may be accepted, and that the first series was by some other artist than Sharaku; second, that the bust-portraits were not all issued at the beginning of the fifth month and that this print introduced a second series of them; third, that the series introduced was that of the large full-length figures which began in the seventh month. Those who advocate this last view call attention to the light mica backgrounds which are used only in the print we are discussing and in those in which two figures are shown at full length.

The present compilers cannot pretend to settle this vexed question, but we are unwilling to accept the idea that the reference may be to a "first series" not by Sharaku; and since we have found that all the bust-portraits on dark mica seem to be connected with fifth-month plays the likelihood of their having been issued in two sets seems to us considerably increased.

It may also be well to point out that in 1794 the word *nibanme,* used technically for the "second part" of a production, could hardly have had quite its later implication of "most important part," for during that year the "second parts" did not even have separate titles.

The probabilities as we now see them, therefore, are that *nibanme* does mean "for the second time," and that there was a "first series" consisting of either a part or the whole of the bust-portraits. On this theory exact dating is impossible, for the print may have been issued as late as the seventh month of 1794, and almost certainly was not issued as early as the beginning of the fifth month.

The British Museum impression has a pinkish ground and Rumpf records the same fact about the one reproduced by him. He also mentions impressions in which gold dust has been mixed with the mica, but this peculiarity does not seem to occur in any of the total of six impressions of the subject in any state which have been seen by the writers, or descriptions of which have been read by them. In the impression exhibited, the face and hands have been tinted pale pink; the coloring of the costume is the same as that in the preceding number.

Ōban. White mica ground. Signature cut off.

Museum of Fine Arts (Spaulding Collection).

The Plays and the Actors

NUMBERS 2 TO 129

Hanaayame Bunroku Soga

OR

THE IRIS SOGA OF THE BUNROKU ERA [*]

MIYAKO-ZA, FIFTH MONTH OF 1794

NUMBERS 2 TO 12

OUTLINE OF THE PLOT

It is said that whenever the manager of a Japanese theatre needs to be sure of having full houses and consequently large receipts, he invariably puts on one or the other of the two great and ever popular vendetta stories, either CHŪSHINGURA—the tale of the forty-seven loyal retainers who avenged their lord, or the story of the Soga brothers, twelfth-century youngsters whose father had been killed, and who in accordance with the knightly code of the time gave their young lives to accomplishing the required vengeance and through their deaths lived again as perennial heroes of the stage.

From about 1710 until after the period of Sharaku the presentation of the Soga story, in one form or another, as the opening play of the New Year, was a custom of the Edo theatre and as at the beginning of 1794 the Miyako-za had put on with conspicuous success a piece called HATSU AKE-BONO KAOMISE SOGA, the production of the fifth month may have been decided on by the astute manager because of the proved popularity of the Soga theme. HANAAYAME BUNROKU SOGA resembled its famous prototype in recounting a story of revenge accomplished by two brothers, but its action and its characters were in many ways different. Unfortunately no text of the present play has been found; we can see, however, that its main outline was taken from the well known *jōruri* DOCHŌ KAMEYAMA BANASHI and that it contained additional material drawn from CHŪSHIN-GURA. The basis of its action is as follows:

In 1701, during the Genroku era, the brothers Ishii Hanzō and Ishii

[*] Iris is the flower appropriate to the fifth month but the word is used here as an adjective of encomium.

Genzō avenged their father by killing Akabori Gengoyemon who was otherwise known as Fujikawa Mizuyemon, an action so similar to that of the Soga brothers that the two Ishii came to be known as the "Genroku Soga." The Tokugawa Shogunate did not look with favor on representations in the theatre of acts of violence that had occurred during their regime, and therefore the story of revenge with which we are here concerned was set backwards in time to the Bunroku era of the late sixteenth century; and in order to be sure to avoid conflict with the authorities the names of the characters also were changed, so that the Ishii brothers were called Gennojō and Hanjirō, while their brother-in-law and chief aid became Ishii Genzō and, incidentally, the real hero of the play.

We introduce first two married couples who had subsidiary parts in the action.

2

Ichikawa Yaozō III as the cripple Tanabe Bunzō.

The color of the costume is brick red and black, with touches of green in the cuffs.

This print bears a hand-written inscription giving the name of the actor and a date equivalent to the ninth month of 1794.

A considerable number of other prints in Sharaku's series of bust-portraits on a dark mica ground exist in single, early impressions which are inscribed with the same date and apparently in the same calligraphy. There is a difference of four months between the time when these prints were issued and the date inscribed on them, but this date coincides with that of the time when the government edict against the further issuance of mica ground prints which we have discussed in our introductory essay, was about to be enforced and its prospective enforcement seems to have stimulated in the autumn of 1794 the purchase of those by Sharaku which had been published during the spring and summer. Some collector of the long ago apparently bought a number of them at the same time and inscribed them when he got them. For further discussion of these inscribed prints see number 15.

It is possible that there is a second state of this subject, but we believe that the differences discernible between different impressions are due to a large—too large—number having been taken from the original blocks. The most striking of these differences is in the disappearance of the line marking where the right hand folds over the left, and the absence of this is especially noticeable in the impression reproduced in the Vignier-Inada Catalogue number 277 which appears again as Rumpf number 7. The impressions reproduced by Kurth, Nakata and Noguchi are better, but at least two of these are from the same original and neither has the clarity or the early delicacy of the one shown here which was picked from three in American collections.

Ōban. Dark mica ground. Signed: Tōshūsai Sharaku.

Museum of Fine Arts (Spaulding Collection).

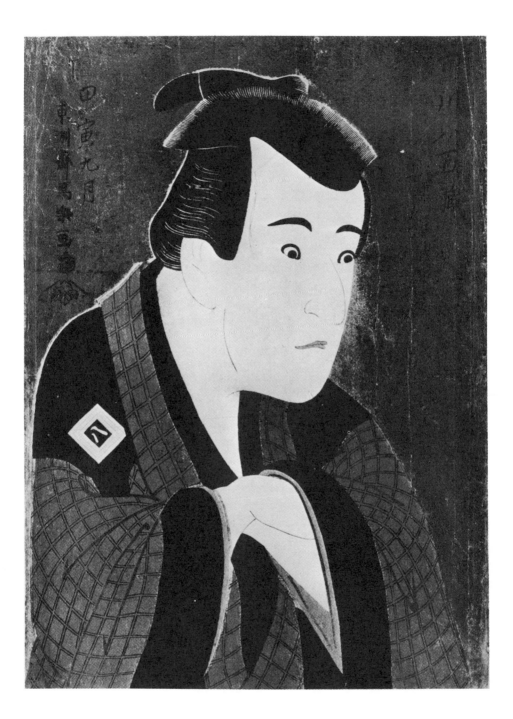

3

Segawa Kikunojō III as O-Shizu, the wife of Tanabe Bunzō, the character represented in the preceding print.

He is dressed in a white kimono patterned in faded violet, and under garments of green and rose. The head cloth is violet and the comb the usual yellow. The black obi shows traces of lacquer, and some mica is discernible in the white collar.

The impression reproduced in the Vignier-Inada Catalogue, number 275, is rephotographed as Rumpf number 8 and by Noguchi; the one formerly in the collection of Count Camondo is reproduced in the catalogue of Japanese prints in the Louvre, and an inscribed impression at one time in a Tokyo collection is shown by Kurth and Nakata. There are four in American collections.

Ōban. Dark mica ground. Signed: Tōshūsai Sharaku.

The Art Institute of Chicago (Buckingham Collection).

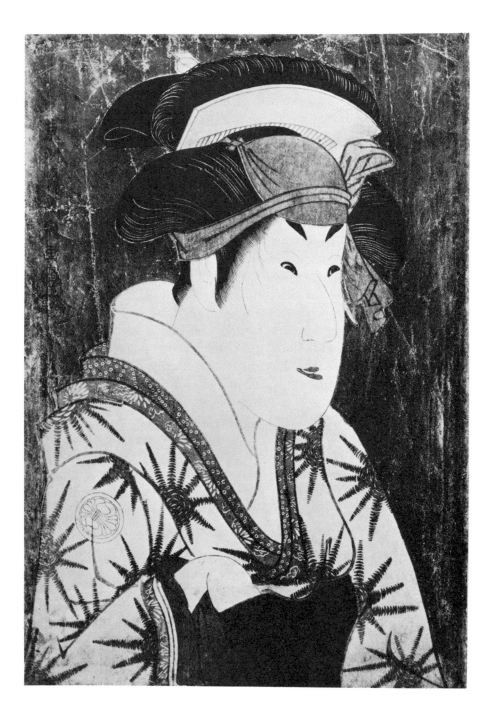

4

Segawa Tomisaburō II as Yadorigi, the wife of Ōgishi Kurando whom we shall see depicted in the following number.

The outer kimono being held by the actor at his shoulder is black and is decorated with chrysanthemums in various colors. There is a rose under kimono, and the innermost one is in white.

To western critics this print seems one of the most malicious, or shall we say, most scornful of Sharaku's portraits; and the weasel face, the effectively distorted eyebrows, the expression of utterly banal vulgarity, are all the more striking when one remembers that these actors of the Segawa line had been famous for generations for their impersonations of women and the supreme grace which had marked with distinction every motion of their flowing draperies. Kiyohiro and Shunshō had been stirred by Segawa actors to their loveliest creations; Bunchō had made one of them immortal in prints whose beauty he never reached again; and here Sharaku, emphasizing as is his wont the animal characteristics, the littlenesses of conceit and vulgarity in an actor, breaks through the dream and dispels it in a realism that has gone on into satire. It is no wonder that the earliest comment on his work speaks of it as filled with exaggeration. But notice the eyebrows, not only here but in many of the other bust-portraits as well. Has any other artist ever made eyebrows play so important and so varied a part in his compositions? The print is a master-piece from whatever point of view it may be judged, and we are fortunate in having at least one of the four impressions in America so perfect in condition.

The very fine impression reproduced in plate 184 of the large catalogue of the Moslé Collection and now in Chicago, is somewhat trimmed at the top and is rephotographed by Kurth, Noguchi and Nakata. The Koechlin impression in the Vignier-Inada Catalogue, number 272, which also is trimmed at the top, is reproduced again as Rumpf number 21. The impression in the Louvre, reproduced in color by Benesch, is, like the one we exhibit, untrimmed at the top but is slightly longer than ours at the bottom.

Ōban. Dark mica ground. Signed: Tōshūsai Sharaku.

Museum of Fine Arts (Spaulding Collection).

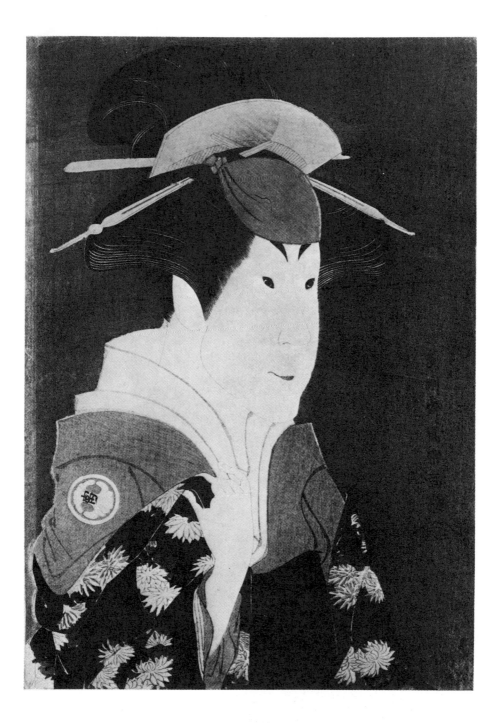

5

Sawamura Sōjūrō III as Ōgishi Kurando. From his dress he is obviously a man of position and from his name it is conjectured that his prototype was the famous hero of the Chūshingura story, who in various versions has various similar names such as Ōgishi Kunai, Oishi Kuranosuke, etc.

The actor is dressed in a violet kimono, now somewhat faded, and is holding a pale green fan decorated with a white water design. The shaven part of the head is in very faded light blue.

The subject is one not often seen and only three impressions were found in America. No variations have been noted and we refer merely to reproductions in the usual places—Vignier-Inada Catalogue, number 278, Rumpf number 19, Kurth, Noguchi and Nakata. The one in Noguchi is in color.

Ōban. Dark mica ground. Signed: Tōshūsai Sharaku.

The Art Institute of Chicago (Buckingham Collection).

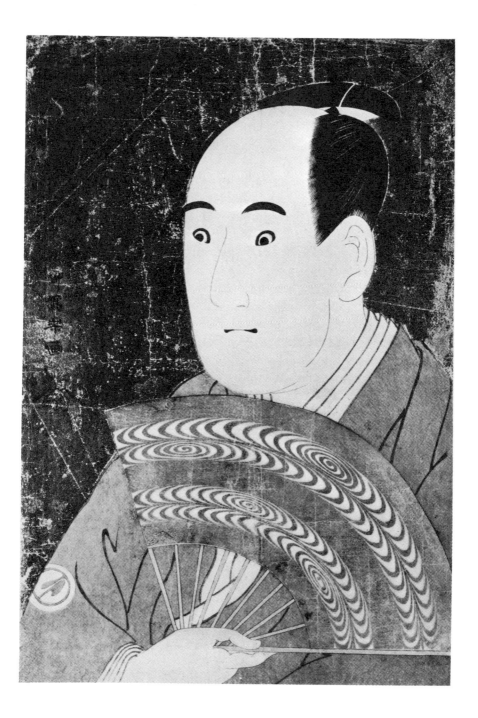

6

Bandō Mitsugorō II as Ishii Genzō, the brother-in-law and chief aid of the two brothers who in accomplishing their vendetta gave a theme for the play.

The robe worn by the actor is elaborately patterned in white on white with darker tones of dull rose and black to set it off. The handle of his sword is in pale green and yellow.

Kurth, the Vignier-Inada Catalogue, number 266, Rumpf number 9, Noguchi and Nakata all reproduce an impression which was considerably trimmed at the bottom and which lacked the signature, the publisher's mark and the censor's seal. The print, however, was inscribed with the date of the ninth month of 1794 which we discuss in connection with number 2 and elsewhere. An uninscribed impression which had the signature and the seals of the publisher and censor was described in the Vignier-Inada Catalogue under number 266 *bis,* and this print was illustrated later in the catalogue of prints in the Louvre. The subject is one of the rarer bust-portraits by Sharaku, a fact which may indicate a comparative lack of popularity when it was issued; there are, however, three impressions in America.

Ōban. Dark mica ground. Signed: Tōshūsai Sharaku.

Museum of Fine Arts (Spaulding Collection).

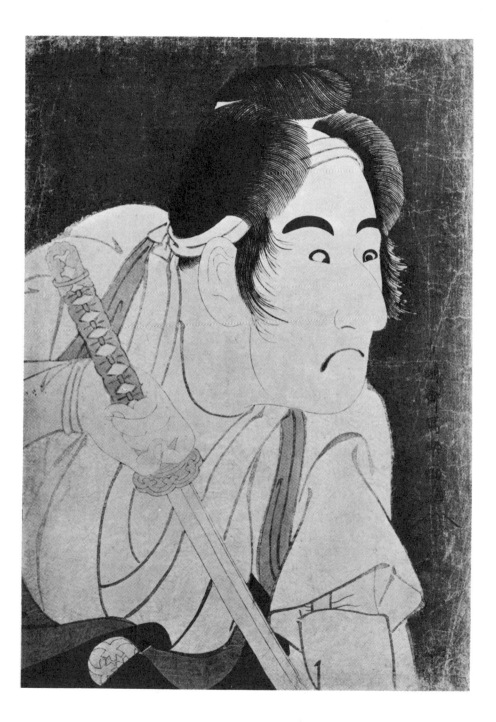

7

Sakata Hangorō III as the villain of the piece, Fujikawa Mizuyemon, on whom the hero of the play who is portrayed in the preceding number, and the two brothers took revenge.

The coloring of the costume is gray with touches of green about the sleeves and black at the neck.

This subject is one of the least rare of Sharaku's bust-portraits on dark mica grounds, but different impressions vary considerably in their printing. The color blocks about the eyes seem always to have been used, but sometimes there is tinting about the jowl and in the middle of the line of the lips, and sometimes there is not. Such differences, however, merely indicate that a considerable number of impressions were demanded and that in the more hurried and less careful printing of some of these one or two of the less important color blocks were omitted; they do not show that any new blocks were cut. There are seven examples of this print in America.

See Vignier-Inada Catalogue numbers 276 and 276 *bis,* Rumpf number 11, Kurth, etc.

Ōban. Dark mica ground. Signed: Tōshūsai Sharaku.

The Art Institute of Chicago (Buckingham Collection).

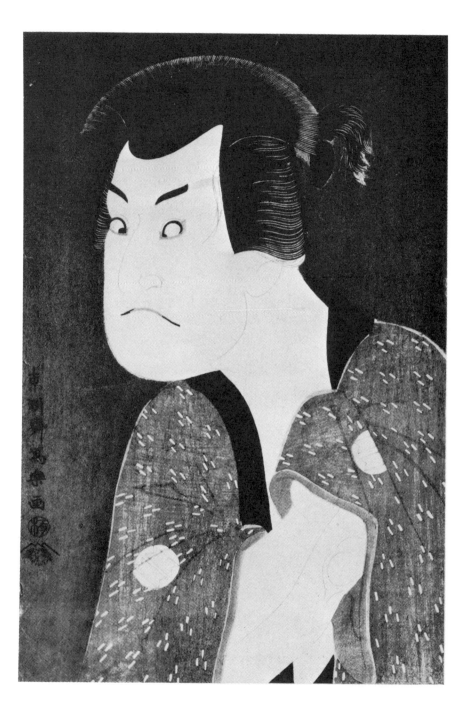

8

Arashi Ryūzō as the money lender Ishibe no Kinkichi.

The chief color-tone of the costume is reddish orange, over which is printed a check pattern in red and greenish gray.

Like the preceding number this is one of the most frequently seen of Sharaku's bust-portraits on dark mica grounds, but impressions vary only in the occasional, if not usual, omission of the blue tinting above the tonsure. The one in the Spaulding Collection is inscribed. There are six in America.

The subject is reproduced in the Vignier-Inada Catalogue, number 271, from which Rumpf number 10 and Noguchi copy it. The impression reproduced by Kurth and in the Straus-Negbaur Sale Catalogue, appears again in Nakata.

Ōban. Dark mica ground. Signed: Tōshūsai Sharaku.

The Art Institute of Chicago (Buckingham Collection).

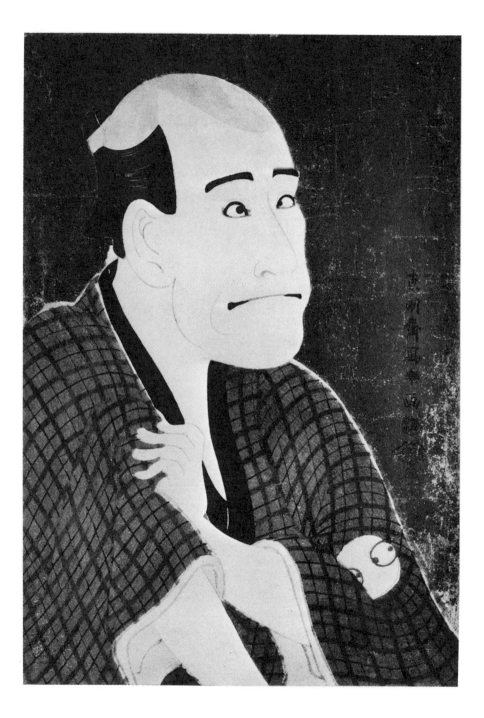

9

Segawa Tomisaburō II as Yadorigi, the wife of Ōgishi Kurando,—the same rôle as that represented in number 4, and Nakamura Manyo as her maid-servant, Wakakusa.

Tomisaburō on the right wears a kimono that once was blue, over another of pale rose patterned in blue-green. A red under garment shows at the neck and sleeve. Manyo is in blue-green over an under kimono of red and violet. Both have yellow combs and head cloths of faded violet.

As this is the first to be catalogued here of the bust-portraits on dark mica grounds that show two actors instead of one alone, this seems an appropriate place in which to say that only five of these survive and there is nothing to show that any others were designed. All that we have are connected with plays produced in the same month and if the series had pleased the public it is not likely that it would have been so promptly discontinued. By us, however, who live a hundred and fifty years later, at least three of the five two-figure bust-portraits are ranked as among Sharaku's finest prints, and in this opinion contemporary Japanese critics agree with those of the Occident.

In the impression we have chosen from three in America for exhibition, Tomisaburō's comb is translucent so that the black hair shows dark behind part of it, whereas those previously reproduced, except for one in the Morrison Catalogue of 1909, do not show this detail—a fact which quite possibly may not be due to a second and less careful printing of the originals themselves, but is worth recording as a guide to future students of Sharaku. The reproduction in the Vignier-Inada Catalogue, number 287, was rephotographed for Rumpf number 28 and by Noguchi; Kurth and Nakata use a different impression. The print we exhibit is slightly trimmed at the bottom, the one in the Vignier-Inada Catalogue shows more of Manyo's fingers.

Ōban. Dark mica ground. Signed: Tōshūsai Sharaku.

The Art Institute of Chicago (Buckingham Collection).

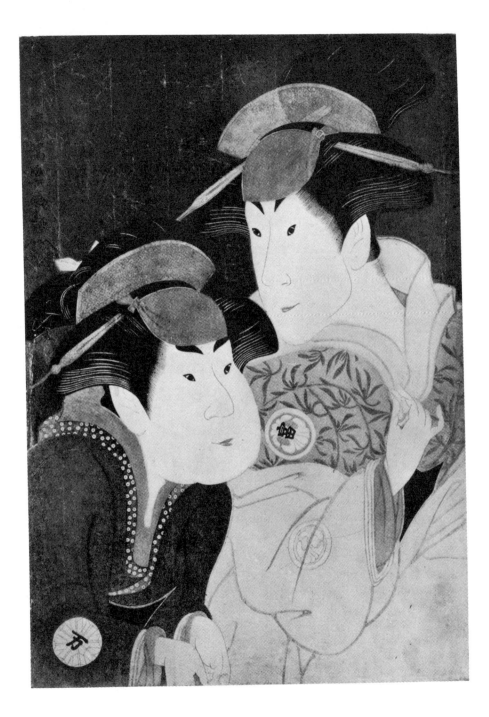

IO

$\bar{\text{O}}$tani Tokuji as Sodesuke, a *yakko* or man-servant of a *samurai*.

The outer kimono is purple with a dull yellow lining; the under kimono, now faded, apparently once was light blue. The sword scabbard is a strong rose, with the tassel and wrappings in the same color as that of the under kimono. The tonsure is pale blue.

There seem to be two states of this print which show at least one difference so marked and so peculiar that with the print chosen from seven in America we would have shown, if we could have found it, an impression or even a modern reproduction of the state which Rumpf rephotographs as his number 20, from the Vignier-Inada Catalogue, number 262. In that impression what appears to be a triangular tuft of black hair sticks up above the left side of the actor's partially shaven head, alone and irrelevant. It does not improve the composition, and the quite usual hair arrangement shown in the normal state of the print is complete without it. The color scheme as reported by Rumpf is also quite different from that of all the impressions we have seen.

A duplicate of the state shown by us, which is in a Tokyo collection and is reproduced by Kurth, has one of those hand-written date inscriptions of the ninth month of 1794 to which frequent reference has been made. Among others that are like the one we show and like the rest of those in America, may be mentioned one reproduced in the large Moslé Catalogue as plate number 183. We cannot explain the state reproduced in the Vignier-Inada Catalogue and rephotographed from it by Rumpf and others who take their illustrations from it, but not having seen the original we hesitate to express doubt of its authenticity.

Ōban. Dark mica ground. Signed: Tōshūsai Sharaku.

The Art Institute of Chicago (Buckingham Collection).

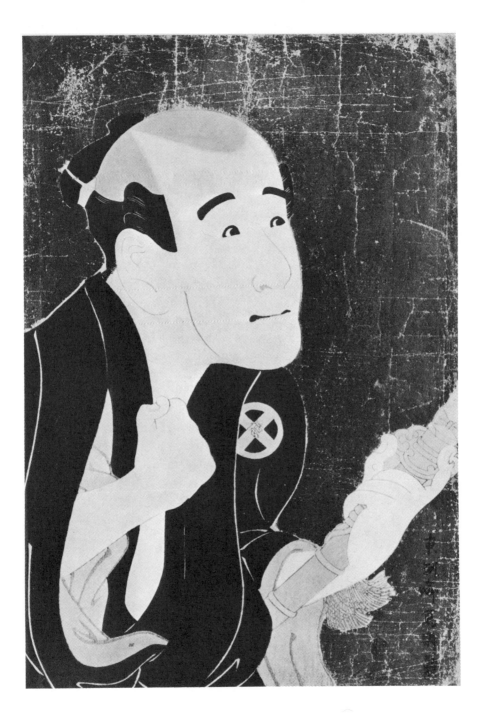

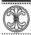
I I

Sanogawa Ichimatsu III as O-Nayo, a courtezan of Gion Street.

The outer robe is in faded violet with violet and white squares on the collar and cuffs. The under kimono is rose with its squares in red-orange and white. The robe that shows beneath the others is white. The obi is in white and two tones of green. The head cloth and the hair ornament at the back repeat the violet and the red-orange of the two kimono.

The impression exhibited, which is the only one in America, bears a hand-written inscription giving merely the name of the actor, and it has the Wakai and Hayashi Collection seals in the upper right hand corner. It was shown with other fine prints by Sharaku in the notable exhibition held in 1909 by the Fine Art Society of London and is illustrated in the catalogue by Morrison. Two other impressions have been reproduced. The one in the Vignier-Inada Catalogue, number 280, reappears as Rumpf number 25, in Noguchi and in *Ukiyo-ye Taika Shūsei,* etc. The other was in a Tokyo collection when Kurth reproduced it and was photographed again by Nakata and in a Japanese auction catalogue of 1917. This Tokyo impression must once have belonged to the early enthusiast who inscribed the other Sharaku bust-portraits in his possession as he did this one, with the date of the ninth month of 1794.

Ōban. Dark mica ground. Signed: Tōshūsai Sharaku.

Museum of Fine Arts (Spaulding Collection).

I 2

Sanogawa Ichimatsu III as O-Nayo and Ichikawa Tomiyemon as Kanisaka Tōda. Ichimatsu is here shown in the same rôle and the same costume as that in which he is seen alone in the preceding print.

Tomiyemon on the right is in a kimono of yellow with green checks which has broad black bands at the neck and sleeves. His tonsure is light blue and there are touches of rose around his eyes. Ichimatsu has an outer kimono of violet and a red under garment. His head cloth and comb are the usual violet and yellow.

We exhibit the only impression of the print in America, and in this connection would say again that Sharaku's bust-portraits with two figures do not seem to have been popular when they were issued. If there had been a demand for more impressions of them in 1794, we would be likely to have more of them now. Two other copies of the subject have been recorded and have been the originals from which various reproductions have been taken. Rumpf's number 29 rephotographs a print once in the Mutiaux Collection and reproduced as number 284 in the Vignier-Inada Catalogue. Kurth and those that follow him use an original in the Kunstgewerbemuseum in Berlin which is more strongly printed and slightly larger than the other. It is a little larger and in better condition than the one we exhibit, and like ours it shows the hair through the comb and a tinting of Tomiyemon's tonsure, neither of which details is visible, at least in the reproductions of the Mutiaux impression.

Ōban. Dark mica ground. Signed: Tōshūsai Sharaku.

The Art Institute of Chicago (Buckingham Collection).

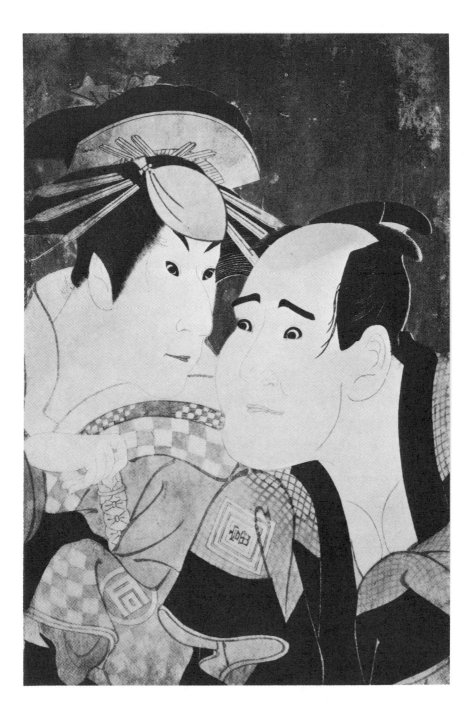

Koinyōbō Somewake Tazuna

OR

THE LOVED WIFE'S PARTI-COLORED LEADING-ROPE

AND THE FINAL PIECE PLAYED IN THE SAME PRODUCTION

YOSHITSUNE SENBON-ZAKURA

or

YOSHITSUNE OF THE THOUSAND CHERRY-TREES

KAWARAZAKI-ZA, FIFTH MONTH OF 1794

NUMBERS 13 TO 22A

OUTLINE OF THE PLOT

Loyalty is the chief motive of the Japanese stage and in a large proportion of the Kabuki plays the dramatic conflict is between devotion to a feudal lord and that more personal devotion which centers upon wife or child or mistress. The women in these plays are bound by loyalty as the men are, and when a man wrecks himself for that virtue the women go uncomplainingly down the road of sorrow with him.

Nearly a hundred years before the time of Sharaku the distinguished dramatist Chikamatsu had written the story of Yosaku and Shigenoi for the puppet stage. It became very popular, and was adopted into the Kabuki repertory—as usual with changes.

The early versions are comparatively simple. The husband and wife, Yosaku and Shigenoi, love one another, and Yosaku, who had been reduced to earning his living as a driver of pack-horses, symbolized the intertwining of his life with that of Shigenoi by using a leading-rope of different colored strands inextricably intertwined. The dramatic conflict centered around the character of Shigenoi, who was torn between personal devotion to her husband and her own son on the one hand, and, on

74

the other, loyalty to the daughter of her lord, whose wet-nurse she had been and with whom she had been sent to a distant province.

Kabuki audiences, however, had a taste for melodrama and complicated plots, and so more characters and episodes were added. In the present version there are two villains, the Washizuka brothers, Kwandayū and Hachiheiji. Kwandayū, the elder, by the theft of three hundred golden *ryō* entrusted to Yosaku, causes him to be disgraced and so lose his position as the chief retainer of his lord; he also is responsible for the death of Shigenoi's father. Hachiheiji, among other evil deeds, kills Yosaku's half-brother when he comes to replace the amount that had been stolen. Further details need not be given, save to say that virtue is properly triumphant in the end.

We introduce first the husband.

I3

Ichikawa Monnosuke II as Date no Yosaku, husband and lover of Shigenoi.

He is dressed in an outer kimono of pale violet with under kimono of white, dark rose, and yellow-green. The color of his tonsure has now decomposed, but originally must have been pale blue.

This print is one of the less exaggerated ones in the series of bust-portraits; even the eyebrows are tame.

We have located six impressions in American collections and as there are no special problems connected with them we refer merely to the usual places of reproduction—Vignier-Inada Catalogue, number 283, Rumpf number 14, Kurth, Noguchi and Nakata.

Ōban. Dark mica ground. Signed: Tōshūsai Sharaku.

The Art Institute of Chicago (Buckingham Collection).

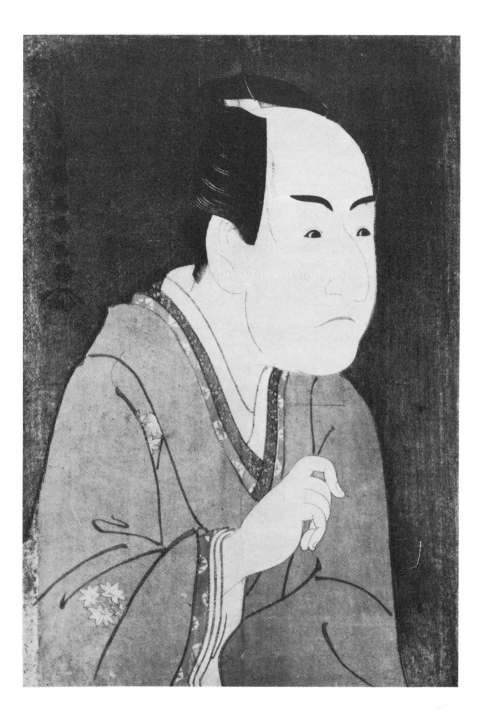

14

Iwai Hanshirō IV as Chichinohito (Wet-nurse) Shigenoi, the wife of Date no Yosaku who is represented as Monnosuke portrayed him, in the preceding number.

This impression bears a hand-written inscription giving the name of the actor.

The outer robe is in faded violet with a lining of rose. Below that the actor wears a white kimono patterned in rose. The collars of the three under garments now are mainly white but perhaps once were edged with color. The obi is black, the amulet bag is in red-orange and yellow. The covering of the tonsure is the faded violet of the outer robe.

In some carelessly printed impressions the black of the hair does not show through the translucent comb as it does in the one exhibited and as it should do. It does not show in the reproduction in the Vignier-Inada Catalogue, number 269, or in the rephotographing of this as Rumpf number 12, and by Noguchi. It does show in the impression used by Kurth and Nakata and in the one from the Camondo Collection in the Louvre which is reproduced by Benesch. The inscribed print here exhibited was reproduced in 1909 in Morrison's Catalogue of the London Fine Art Society Exhibition of that year, and was chosen by us from six in America.

Ōban. Dark mica ground. Signed: Tōshūsai Sharaku.

Museum of Fine Arts (Spaulding Collection).

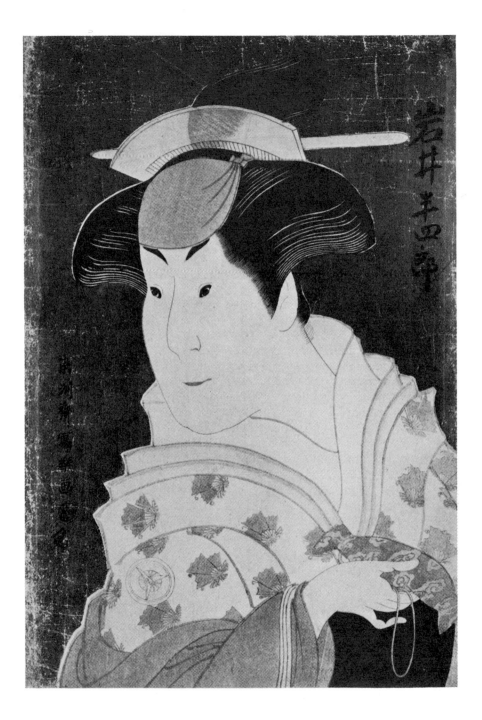

15

Tanimura Torazō as Washizuka Hachiheiji, a lesser villain and brother of the chief villain of the piece, Washizuka Kwandayū, whose portrait follows.

Beneath the black outer garment is a kimono which now can only be described as of faded straw color. The cuff and the lacings of the sword hilt are in green. The tonsure is pale blue. The color block about the eyes was printed in red.

The authors of the Vignier-Inada Catalogue call attention to the fact that while in the impression they reproduce, number 281, the actor is dressed in a salmon colored robe, they exhibit also, as 281 *bis,* one in which the robe is printed in green and in which the color block around the eyes is omitted. Of course the omission of a block generally indicates a hurried and later printing; and it has been suggested that the apparent demand for a second edition of so many of these bust-portraits on dark mica was motivated by the Government edict against the further issuance of prints on mica grounds. Such a law would be sure to stimulate the sale of those that recently had been issued, and demand from customers naturally would induce the publisher to hurry his printer and get a fresh supply on hand. However, the collector who inscribed so many prints, as he did this one, with the date of the ninth month of 1794, often seems to have been so fortunate as to find early impressions. In the present instance he wrote down the name of the actor as well as the date.

Only three examples of this subject were found in America and the one of these that was chosen was reproduced in 1909 by Arthur Morrison in his catalogue of that exhibition of the Fine Art Society in London which contained so many exceptionally fine prints by Sharaku. The impression reproduced in the Vignier-Inada Catalogue, number 281, has been rephotographed as Rumpf number 15, and by Noguchi. Another in the first state which now is in Chicago is reproduced by Kurth and Nakata. Still a third appears in the Matsukata Catalogue; but we do not find any reproduction of the recorded state in which the block about the eyes was omitted.

Ōban. Dark mica ground. Signed: Tōshūsai Sharaku.

Museum of Fine Arts (Spaulding Collection).

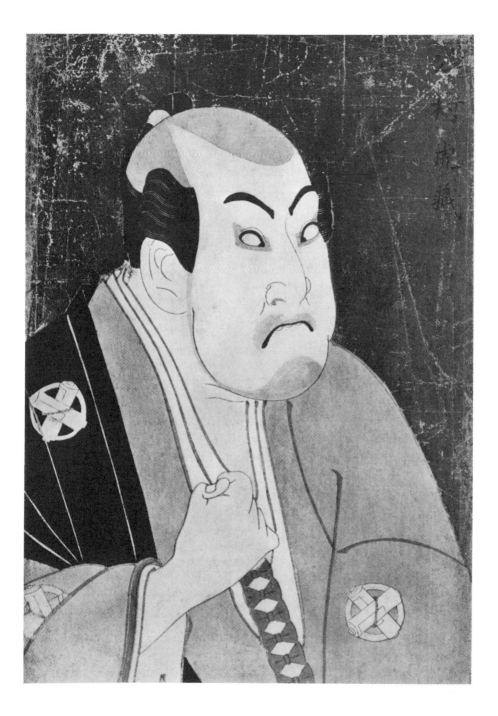

16

Ichikawa Ebizō IV probably as Washizuka Kwandayū, the villain of the play.

Ever since Sharaku first became famous in the Occident a controversy has raged as to the part in which Ebizō is depicted in this print. For years the rôle was identified as that of the pompous, cowardly, treacherous, lecherous villain Moronao whose misdeeds gave the faithful forty-seven Ronin something to avenge, and the print was assigned to some indefinitely dated production of CHŪSHINGURA. Then, because the costume is not appropriate to the rôle of Moronao, the actor was said to be playing Kudō Suketsune in a Soga play, a part which he has been found to have taken before and after 1794, but not during the year in which Sharaku's bust-portraits were produced. The next identification called the rôle that of Sadanoshin, a Nō player and the father of Shigenoi, the heroine of the piece we now are considering. Contemporary publications refer to Ebizō as Sadanoshin, and in the complete absence of a play-bill showing exactly what other parts he may have taken, the last-mentioned attribution seemed satisfactory until a discovery was made in Boston of play-bills of other productions of the same piece which give pictures of Sadanoshin as slightly built, comparatively young, and in general, a frail looking person with a totally different hair arrangement.

In the print under consideration the hair arrangement is appropriate to the rôle of a villain of not too exalted station, which is why Moronao and Suketsune first were thought of; and although the actual text of the play in which Ebizō appeared in the month when these bust-portraits were issued is known to us only through outline references, we do know that Washizuka Kwandayū was the arch villain of it, that we have no other portrait which could represent him, and that Ebizō, who was a great character actor, sometimes took as many as four different parts in one production but was especially noted for his representations of the base and treacherous people he loved to portray. Even if the hair arrangement did not combine with the apparent age and build of the character shown by Sharaku to forbid identification of the rôle as that of Sadano-

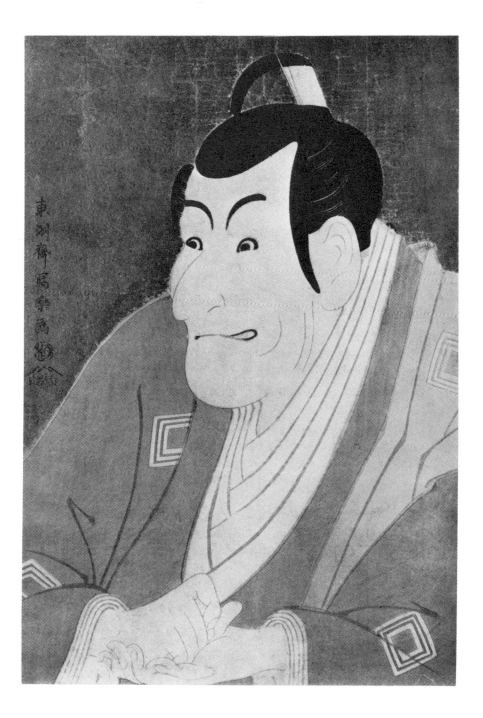

shin, a slight and youngish man who was murdered in the first act, the portrait itself would suggest the malefactor whose evil deeds overtook him to the delight of the spectators at a later stage of the dramatic action of the play.

As a possible argument against our attribution we must mention an undocumented statement in the *Edo Shibai Nendaiki* which refers to the part of Washizuka Kwandayū as taken by Ōtano Oniji. We have not been able to check the correctness of this statement, but even if it can be proved to be true it would not necessarily mean that Ebizō did not play Kwandayū, for there are several instances in which, because of illness or for some other reason, a rôle was transferred from one actor to another during the run of a performance.

This subject has been more generally admired than any other print by Sharaku and the admiration of it seems to have been as keen in 1794 as it is today.

There are several states which appear to be practically contemporary with the publication of the supposed first edition, and the reprints made with intent to deceive are almost as numerous as the frank copies. Rumpf mentions two variations, the more important of which is the presence or absence of visible teeth in the partially open mouth of the actor; he does not, however, refer to the fact that in some impressions, perhaps about as early as those which may be considered of the standard and presumably first state, there are noticeable differences in the calligraphy of the upper part of the signature.

In this catalogue it seems best to describe, without definite assertion as to all variations, that impression of the supposed first and standard state which is here reproduced and which is identical, line for line, with the impressions of undoubted authenticity in the Art Institute of Chicago and in the Bigelow Collection in the Museum of Fine Arts, as well as with the one from the Mansfield Collection now in the Metropolitan Museum of Art which bears one of those date inscriptions discussed in the preface and under number 2 of the catalogue.

The chief characteristics of the presumably first state here exhibited are: The main part of the costume is printed in a dull red-orange—not lemon yellow. Teeth are visible in the partially open mouth of the actor. The

background is dark, not white, mica and this background appears in the space formed by the curving over of the actor's top-knot as well as elsewhere. The *kamishimo* visible at the left shoulder probably was printed in blue in all impressions of this state, though in most cases it shows now, through the action of time or otherwise, either as solidly dull yellow or as a blue that still is in process of completing its change to the other tone. A color block around the eyes appears never to have been used in this subject; but those who have an opportunity to study impressions in different coloring from that of the supposed first state which we have attempted to describe, and which are not so recent as to have been made with the help of photography, are advised to observe the drawing of the hands. In any case the variations in the calligraphy of the signature show that at least one new block was cut, probably very soon after the first appearance of the print and certainly long before the later copies were made.

We have before us reproductions in nineteen different books and catalogues, but in most of them it is impossible to tell which state is represented, especially in the calligraphy; and for this reason we refer only to Rumpf number 16, the Vignier-Inada Catalogue, number 264, Kurth, Nakata, Noguchi and *Ukiyo-ye Taika Shūsei* which illustrates the subject in what we consider the proper color.

Ōban. Dark mica ground. Signed: Tōshūsai Sharaku.

Ledoux Collection.

17

Iwai Kiyotarō as Fujinami, the wife of Sagisaka Sanai whom we shall see in the following print, and Bandō Zenji as Ozasa, the wife of Washizuka Kwandayū, the villain of the piece, whom we have seen in the preceding one. Bandō Zenji seldom took the role of a woman but it is recorded in a contemporary notice that he did so on this occasion.

The one known impression is in the collection of Freiherr von Simolin of Berlin who very graciously has had it rephotographed for this catalogue. The print seems to have been somewhat trimmed. It has been reproduced previously as Rumpf number 30, where the coloring and other details are described as follows: Kiyotarō at the left in a green outer garment with black obi and a rose-colored collar. Bandō Zenji at the right with a blue-green outer garment, white under robe, black obi and white collar.

Ōban. Dark mica ground. Signed: Tōshūsai Sharaku.

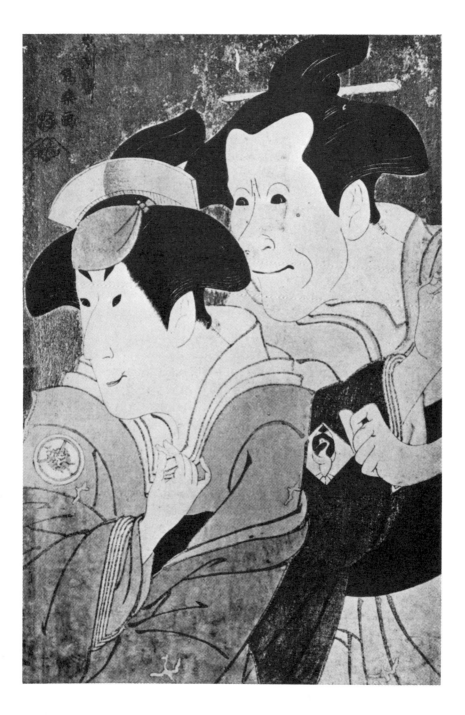

18

Bandō Hikosaburō III as Sagisaka Sanai.

In most cases we do not call attention to new identifications first stated in this catalogue, but in the present instance we would note that the attribution given above was suggested by Rumpf and then confirmed by the original play-bill which shows the actor in the rôle and with his lantern in his hand.

The outer robe is red-orange with some patterning in faded yellow. The under one is in faded violet. The lips are red.

There are two states of the print in which actual differences in blocks are apparent. Both are listed in the Vignier-Inada Catalogue, numbers 265 and 265 *bis,* and the one of these that did not find reproduction there was reproduced 15 years later in the sale catalogue of the Javal Collection. The differences are most apparent in the lines of the ear. The reproduction in Kurth is clearer than the one in the Vignier-Inada Catalogue, later rephotographed by Rumpf for his number 23; and the print we exhibit closely resembles the one Kurth used. It differs from the Javal impression, but we cannot pass on the authenticity of that from a cut—however good—in a sale catalogue. The state we show is again reproduced by Benesch from the Camondo impression in the Louvre. On the other hand no tinting of the tonsure appears in Kurth's reproduction, though this is visible in the Camondo one, in the one reproduced in the Vignier-Inada Catalogue, and in the inscribed one we have chosen for exhibition from the four that are in America.

Ōban. Dark mica ground. Signed: Tōshūsai Sharaku.

Museum of Fine Arts (Spaulding Collection).

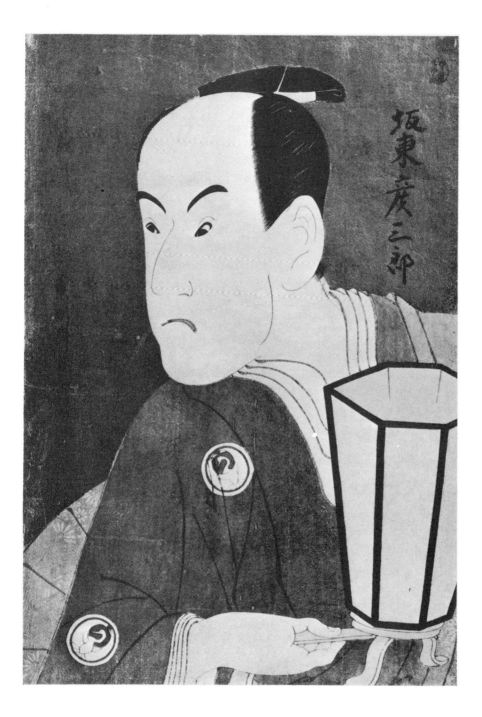

坂東彦三郎

19

Ōtani Oniji III as Edohei, a *yakko* or man-servant of a type often used by *samurai* masters—at least on the stage—to perform deeds of violence.

The outer kimono is a dark orange-brown with yellow stripes and a yellow-green lining. The under kimono is strong pink. The tonsure is in blue.

There is no longer any dispute as to the identification of the rôle, but the troublesome questions of different states remain. There are two impressions in America, the one we exhibit and one in the Spaulding Collection which has a hand-written inscription giving the name of the actor but no date. Both of these have the contour of the figure printed in gray, but in the one we did not select the tinting on the chin and cheek was omitted. The Vignier-Inada Catalogue, number 261 and 261 *bis*, lists both states, but in reproducing only the one without tinting it calls attention to the outline in that impression being in black, whereas the one that had the tinting but was not reproduced is described as of the first state with the contour lines of the figure in gray.

Rumpf number 18 rephotographs from the Vignier-Inada Catalogue as do Noguchi and the *Ukiyo-ye Taika Shūsei*. Kurth shows a different impression which may or may not be the same as the one in Nakata; but none of these, including the one reproduced in color by Morrison, is of the supposed first state shown here, and described but not chosen for reproduction in the Vignier-Inada Catalogue.

Ōban. Dark mica ground. Signed: Tōshūsai Sharaku.

The Art Institute of Chicago (Buckingham Collection).

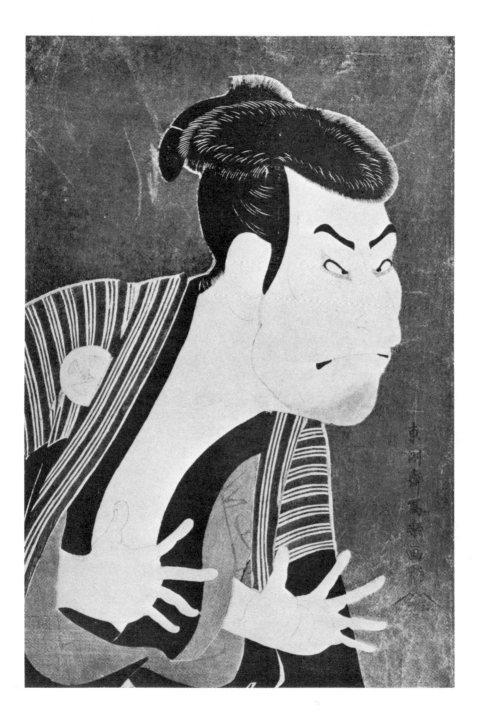

20

Ichikawa Omezō as Ippei, another *yakko* or man-servant, who acts as a not too successful guardian for the young son of Yosaku and Shigenoi while they are away.

The outer robe is rose and has a black collar. The band of textile at the waist is in yellow, red-orange and green. The sword-hilt is in green and yellow. The tonsure has been tinted in blue.

Impressions seem to differ in the amount and color—gray or red—of the printing about the eyes; but we believe that there is a misprint in the Vignier-Inada Catalogue and that the one of the two impressions exhibited which was reproduced, was 279 *bis* instead of 279. The Camondo impression now in the Louvre is reproduced by Benesch and obviously is the same as the one illustrated in the Vignier-Inada Catalogue, whereas the one formerly owned by M. Doucet we think now to be in an American collection and to have been one of the five from which the impression here exhibited and reproduced was chosen. Rumpf number 17 rephotographs from the Vignier-Inada Catalogue. The color plates in Noguchi and *Ukiyo-ye Taika Shūsei* show red about the eyes, but no difference in the blocks is positively discernible and we do not find any reproduced impression in which this printing is entirely omitted.

Ōban. Dark mica ground. Signed: Tōshūsai Sharaku.

Museum of Fine Arts (Spaulding Collection).

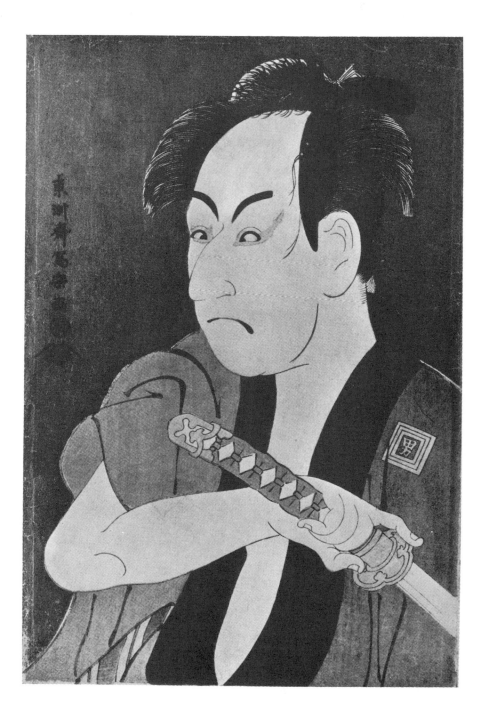

2 1

Osagawa Tsuneyo II probably as Ayame, the wife of Sadanoshin and the mother of Shigenoi.

This attribution is distinctly doubtful, as the full play-bill is missing and we do not know who took the part of Ayame. We do know, however, that someone did and that Tsuneyo acted in the production; and the costume and make-up shown here seem more appropriate to Ayame than to any other listed rôle.

The outer robe is faded blue; the inner one rose. The obi is in black and the head cloth is faded violet.

The subject is not a rare one as there are six copies of it in America, but Rumpf rephotographs for his number 13 from the Vignier-Inada Catalogue, number 282, and while Kurth uses a different impression the various Japanese books simply copy again the two prints reproduced in the Occident.

Ōban. Dark mica ground. Signed: Tōshūsai Sharaku.

Museum of Fine Arts (Spaulding Collection).

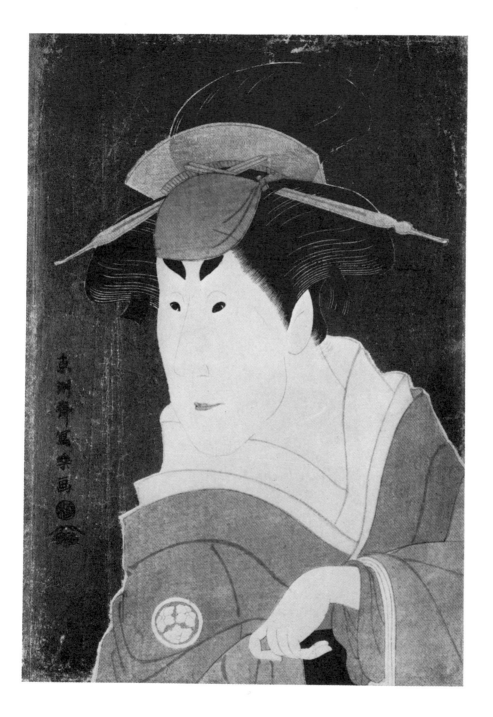

The print that follows records a scene from the finale of this production, which bore the separate title of YOSHITSUNE SENBON-ZAKURA, or Yoshitsune of the Thousand Cherry-trees. The action had to do with the journey of the beautiful dancing girl Shizuka, to Yoshino—a place famous for its cherries—in order to join there her banished lover, the hero of romance and famous general, Yoshitsune.

22

Bandō Zenji as Onisadobō, a Namazu-bōzu, or priest who looks like a catfish, and Sawamura Yodogorō II as Kawatsura Hōgen, in the episode called YOSHITSUNE SENBON-ZAKURA which was played as the finale after KOINYŌBŌ SOMEWAKE TAZUNA in the performance at the Kawarazaki-za in the fifth month of 1794.

Yodogorō, on the right, is dressed mainly in green and purple; Zenji, on the left, in black, yellow and rose.

Some Japanese collector of the long ago has written on the print the name Bandō Zenkō and as, according to a book by Jippensha Ikku published in 1803, Bandō Zenji began using Zenkō as his "poetry name" when he took the stage name of Bandō Hikozayemon in 1801, the inscription could not have been written before the last mentioned date.

There is another state of the print which shows many variations in the blocks, two of the most obvious of which are that in it one of the fingers in the outstretched hand of the figure on the left is doubled over and the line inside the sleeve of the actor on the right extends upward to his wrist. The subject is reproduced in the state shown here from an impression formerly in the Camondo Collection and now in the Louvre, in the Louvre Catalogue, number 36, and by Benesch, color plate number 1. Another impression in the same state is reproduced in the sale catalogue of the Collection of M. C. ... (Chavarse) Paris 1922. The three impressions found in America are all of this state and it may be noted that the one in the Louvre also has a hand-written inscription which unlike that on the print we show gives the name of the actor appearing with Yodogorō as Bandō Zenji, not Zenkō. For the other state see the following number.

Ōban. Dark mica ground. Signed: Tōshūsai Sharaku.

Ledoux Collection.

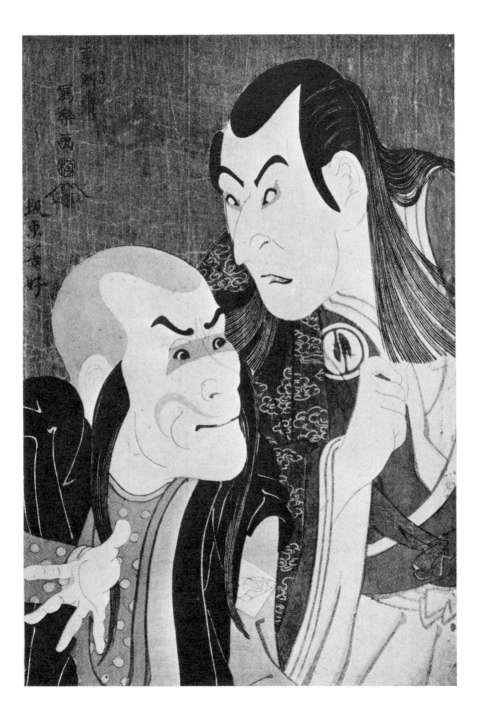

22a

A frank modern reprint of the other state of number 22.

The publisher of this reprint says that he made it from a print in the Matsukata Collection, and if he made it accurately the original he used cannot be the trimmed one reproduced in the Vignier-Inada Catalogue, number 285, and rephotographed from that by Rumpf for his number 26 and in *Ukiyo-ye Taisei,* Vol. VIII, number 42. We would not exhibit a reprint of the state shown by the Vignier-Inada Catalogue and by Rumpf if we were able to find an original, or if the difference in the blocks were less conspicuous and less important.

Ōban. Dark mica ground. Signed: Tōshūsai Sharaku.

Katakiuchi Noriai-Banashi

OR

A MEDLEY OF TALES OF REVENGE

INCLUDING THE *jōruri* EPISODE

HANAAYAME OMOI NO KANZASHI

OR

THE IRIS HAIR ORNAMENT OF REMEMBRANCE

KIRI-ZA, FIFTH MONTH OF 1794

NUMBERS 23 TO 29

OUTLINE OF THE PLOT

No text for this play, KATAKIUCHI NORIAI-BANASHI, is known to have survived but the title, which may fairly be translated as "A Medley of Tales of Revenge," when considered with the lists of the *dramatis personae* available, suggests that the play was a composite drawn from three vendetta stories which had common characteristics. In each of the three, two children avenged their father: the brothers Jirō and Gorō in the Soga story; the sisters Miyagino and Shinobu in GO TAIHEIKI SHIRAISHI BANA-SHI; and Taminosuke and his sister O-Teru in HANA-IKADA GANRYŪ-JIMA.

That part of the action of the piece which has to do with the characters represented by Sharaku is outlined in an old play-bill: Shiga Daishichi, an evil minded retainer of Minamoto no Yoriiye, kills his virtuous fellow retainer Matsushita Mikinojō, and a companion of Daishichi named Sasaki Ganryū kills Shinoda Sayemon. The two daughters of Mikinojō, the courtezans Miyagino and Shinobu, are in the licensed quarter when Daishichi and Ganryū come there with the worthies shown in print number 29. Gorōbei, the fishmonger, whose place of business is at Sanya near the Yoshiwara, helps the two girls and in the end their vendetta is accomplished.

23

Matsumoto Yonesaburō in the rôle of the courtezan Kewaizaka no Shōshō, who is connected with the Soga story. Yonesaburō also is listed in the play-bill as taking the part of Shinobu, the younger sister of Miyagino, in this production; but actors often took more than one part in a play, and the rôle represented here is believed to be that of Kewaizaka no Shōshō.

The costume is mainly in rose and white with a darker rose above and a white collar. The obi bears an elaborate design of black on black.

There are impressions in which the design in black on the black obi is omitted or has become invisible.

The print bears a hand-written inscription giving the name of the actor.

The subject is reproduced in the Vignier-Inada Catalogue, number 267, as Rumpf number 24, and by Noguchi from one impression; Kurth and Nakata use another. The inscribed copy we exhibit is reproduced in the Morrison Fine Art Society Catalogue of 1909. There are three others in America.

Ōban. Dark mica ground. Signed: Tōshūsai Sharaku.

Museum of Fine Arts (Spaulding Collection).

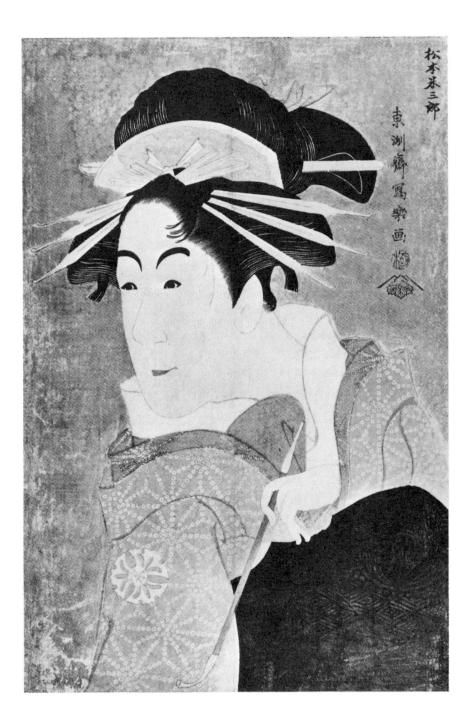

24

Nakayama Tomisaburō as the courtezan Miyagino who was the older sister of Shinobu and the daughter of Matsushita Mikinojō whom we shall see portrayed in the following number.

The print has been damaged by time and dampness, and the outer kimono now is a rather dull pale blue. The kimono which shows at the neck was printed in purple and white; the intermediate one is in white and rose. The still lovely obi bears a design in yellow against a ground of weathered brick.

The Vignier-Inada Catalogue describes a state of the subject in which the floral pattern was not printed in the obi, and reproduces as number 263 an impression like the one we exhibit which shows this pattern. Another like our own is in the Matsukata Collection and is reproduced as plate 43 of that catalogue. Rumpf for his number 22 rephotographs from the Vignier-Inada Catalogue, but Kurth uses a much trimmed print from his own collection which, however, is of the same state.

The three other impressions in America are in no better condition than the one exhibited, and although the mica background has flaked off or has been washed so that the superimposed signature no longer is visible, we may assume that when the print was issued it was signed as the other known impressions of the subject are, Tōshūsai Sharaku.

Ōban. Dark mica ground.

Fuller Collection.

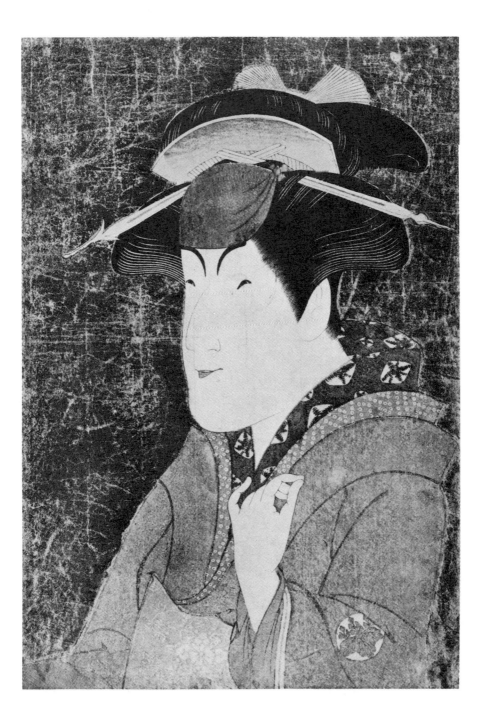

25

Onoye Matsusuke I as Matsushita Mikinojō, the father of Miyagino, a portrait of whom we have seen in the preceding number.

It has been said that the white hair which is so conspicuous in this print, and so unusual, must indicate that the character portrayed could only be Hakuhatsu, or White-Haired, Ganryū, another rôle which Matsusuke played in the same production; but the collection of theatrical documents in Boston contains illustrated play-bills showing that Ganryū's white hair was worn combed back and reached down to his shoulders. We hope that the new identification which now seems the only possible one, may not be pounced on by some other fact that, for all we know, may be lurking somewhere, crouched and ready to spring.

The robe of the actor is in dark green with a lighter green at the wrist. In the sword hilt there are touches of rose and yellow and the last-mentioned of these colors appears again in the wooden part of the closed fan.

The inscription is supposed to have been written by Ueyda Shikibuchi (1819-1879). It describes the resourcefulness of Matsusuke as a man and speaks of his fame as an impersonator of old women, the intriguing Iwafuji, male malefactors of rank and rich men addicted to high living. The actor died in 1815 and therefore could not have been known personally to the writer who, however, may have found the print in his father's collection and heard all about Matsusuke as the family were huddled about their *hibachi* on some winter evening long ago.

In less careful impressions the shading on the chin and elsewhere is omitted. In some, the word "Matsu" in Matsusuke's *mon* is covered by the green used for the kimono. The one shown here was picked from seven in American collections, and was last reproduced as number 41 of the Jacquin Catalogue. The subject has been reproduced in the Vignier-Inada Catalogue, number 273, as Rumpf number 3, by Kurth, Nakata and Noguchi, and in several other books and catalogues.

Ōban. Dark mica ground. Signed: Tōshūsai Sharaku.

The Art Institute of Chicago (Buckingham Collection).

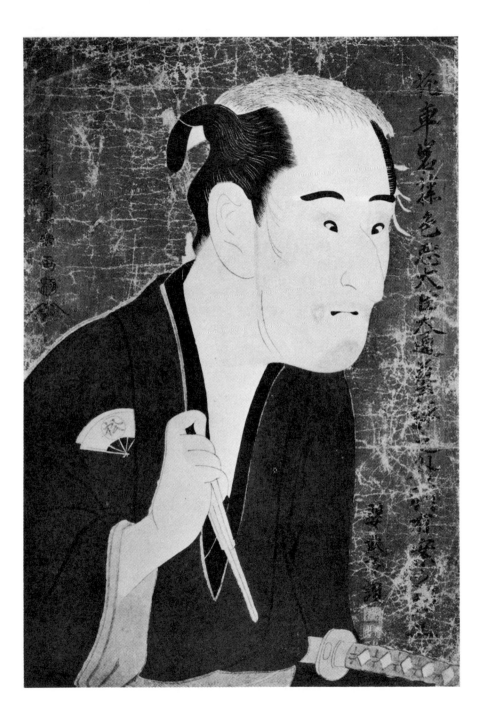

26

Ichikawa Komazō II as Shiga Daishichi, who is known to have been disguised as the palanquin bearer Hototogisu no Gorōhachi in some part of the play, and to have appeared there as a companion to Uguisu no Jirōsaku, who is portrayed in number 28. Obviously Daishichi is not so disguised in this print. In fact the illustrated play-bill shows him dressed as he is here attacking Mikinojō whose portrait we have seen in the preceding number; and those who have been observing attentively the arrangement of prints in the exhibition or their juxtaposition in the catalogue reproductions, will notice once more how characters brought together in the action of the plays have been drawn by Sharaku so that they would continue to face one another.

The actor is robed in black with touches of color in his under kimono and sword-hilt.

The print chosen from six in America for this exhibition was last reproduced in the catalogue of the Jacquin Collection ("Distinguished French Connoisseur"). Other impressions which have the signature placed at a lower level than that of the tip of the actor's nose have been illustrated in the Vignier-Inada Catalogue, number 274, Rumpf number 4, *Ukiyo-ye Taika Shūsei,* Vol. 14, color plate 6, and the large Moslé Catalogue plate 182. An impression with the signature placed considerably higher is reproduced by Kurth and again in the Straus-Negbaur Sale Catalogue, number 271. As is frequently the case in prints of this series a touch of red around the eyes appears in some impressions, as it does here, and is omitted in others. As the signature was the last thing printed and comes on top of the mica its position could easily be varied slightly when the design permitted, but such a marked variation as this may indicate a second edition.

The print shown by us bears one of those hand-written inscriptions discussed in our preface and in connection with number 2, which gives the name of the actor and the date of the ninth month of 1794.

Ōban. Dark mica ground. Signed: Tōshūsai Sharaku.

Metropolitan Museum of Art (Mansfield Collection).

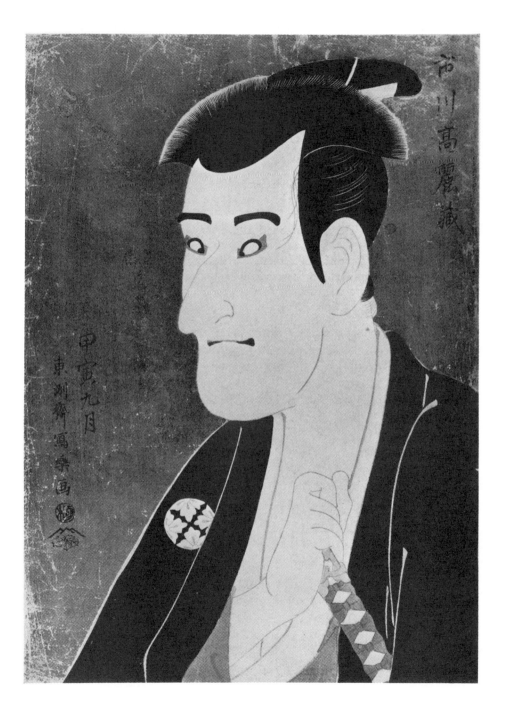

27

Matsumoto Kōshirō IV as the Fishmonger Gorōbei, or, to give him his full name and title in proper Japanese fashion, Sanya no Sakanaya Gorōbei.

The costume is blue with white checks. The green of an under kimono shows at the sleeves, and the black collars are coated with lacquer. The blue of the tonsure has now faded, but strong touches of pink remain about the eyes. The pipe is rose and yellow.

The subject is one of the least rare of Sharaku's bust-portraits on mica and seven impressions of it were found in American collections. It has been reproduced in the Vignier-Inada Catalogue, number 270, as Rumpf number 5 and by Kurth, Noguchi, Nakata and others. The earliest reproduction, however, is on a fan which a young girl is carrying in a pillar-print by Chōki—one of Sharaku's most famous contemporaries.

Ōban. Dark mica ground. Signed: Tōshūsai Sharaku.

The Art Institute of Chicago (Buckingham Collection).

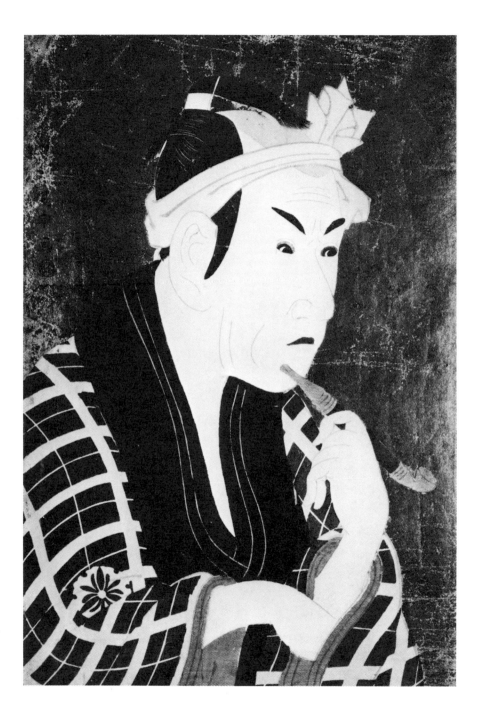

The two prints that follow appear to be connected with a *jōruri* episode entitled HANAAYAME OMOI NO KANZASHI. A play-bill which is extant makes it evident that the theme of this *jōruri* was drawn from the well-known story of the *modori kago,* or returning palanquin. The action probably showed Miyagino (see number 24) as the passenger, while Uguisu no Jirōsaku (see number 28) and Hototogisu no Gorōhachi, who is in reality the Shiga Daishichi of number 26, but disguised, are the bearers. In their conversation each boasts about the gay quarter of his or her native city, and while he is so doing Daishichi, the villain, discloses his identity.

28

Morita Kanya VIII in the rôle of the sedan chair or palanquin (*kago*) bearer Uguisu no Jirōsaku, or Jirōsaku the Bush-warbler, who presumably played opposite Gorōhachi, the little Cuckoo, referred to under number 26.

The Musée des Arts Décoratifs in that exhibition of which the third volume of the Vignier-Inada Catalogue is the monumental record, showed two impressions of this subject but reproduced only, though in full color, the one that was in the color scheme of the print now being catalogued. It is unfortunate that financial limitations and the cost of printing in America prevent our reproducing color-prints as they should be reproduced—in color; and for those who see merely this catalogue and not the exhibition, we can say only that the print here shown is mainly in blue and purple though there are impressions mainly in green. Variations in line, however, are what really count in the determination of second states, and although the blocks for the print exhibited were very carefully cut there are impressions in which a less careful cutting and perhaps a greater freedom of brush-work seem to be apparent. We do not consider the differences of sufficient importance to warrant exhibition of both of the so-called states, and call attention merely to reproductions in the volumes to which this catalogue usually refers—Rumpf number 6, Vignier-Inada Catalogue, number 268 *bis,* Kurth, Nakata and Noguchi.

Ōban. Dark mica ground. Signed: Tōshūsai Sharaku.

Ledoux Collection.

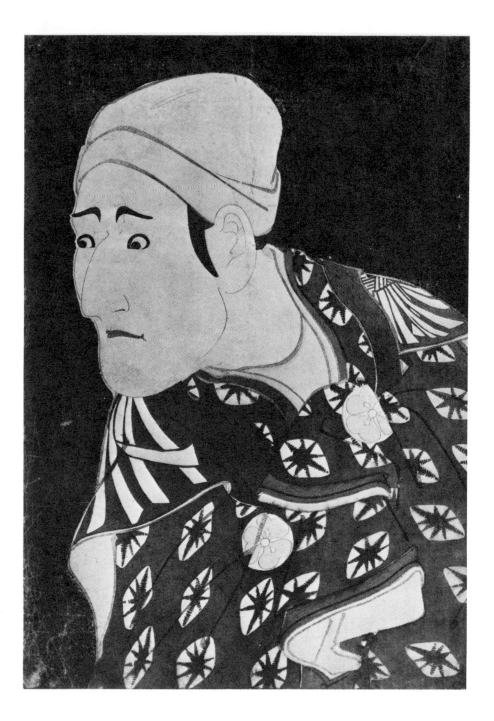

29

Nakamura Konozō as the homeless boatman Kanagawaya no Gon being cursed by Nakajima Wadayemon who is playing the part of Bōdara no Chōzayemon, or Chōzayemon the Dried Codfish.

This is one of Sharaku's most masterly characterizations, and it is to be regretted that recent findings make it impossible to call the print any longer by the old, felicitous title: A Wrestler Being Cursed by His Manager. The types are the same; but one has grown accustomed to imagining happily what the supposed wrestler had done or failed to do, and now it is necessary to follow thought down strange new alleys that lead to all the possible malefactions of boatmen.

The main part of Wadayemon's costume is in brick red. Over his shoulders is a material of red and yellow stripes. The textiles below are dull rose and black. Konozō is in a green, gray and white check and is holding a yellow box. The tonsures are in sky blue. In some impressions there is a red band of make-up above the eyes of Wadayemon and a tinting of pink on his ear. The print chosen from four in America lacks this extra coloring but otherwise seemed more satisfactory for exhibition.

Reproductions may be studied in the Vignier-Inada Catalogue, number 286, Rumpf number 27, the Catalogue of Prints in the Louvre, Noguchi, etc.; besides which the subject has been reproduced in color as the frontispiece to Kurth, in the Straus-Negbaur Sale Catalogue, in *Ukiyo-ye Taika Shūsei* Vol. XIV, number 3 and Nakata color plate 2, but all the reproductions we have found in the books and catalogues listed above and elsewhere appear to be from only three originals, and that one of the much rephotographed three which is exhibited and again reproduced here is the one that first was illustrated in the Vignier-Inada Catalogue.

Ōban. Dark mica ground. Signed: Tōshūsai Sharaku.

Ledoux Collection.

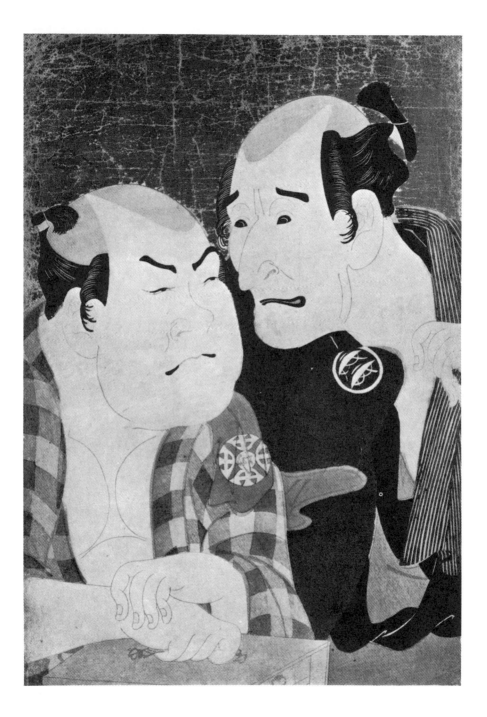

Nihonmatsu Michinoku Sodachi

OR

THE COUNTRYMAN FROM NIHONMATSU

IN THE NORTH

INCLUDING THE *jōruri*

KATSURAGAWA TSUKI NO OMOIDE

OR

RECOLLECTIONS OF THE MOON

AT THE KATSURA RIVER

KAWARAZAKI-ZA, SEVENTH MONTH OF 1794

NUMBERS 30 TO 39

OUTLINE OF THE PLOT

The text of NIHONMATSU MICHINOKU SODACHI is lacking, but a contemporary play-bill leads one to infer that the plot was practically identical with that of a known drama, DATE KURABE OKUNI KABUKI, except for an episode entitled "Fuwa-Nagoya" which had been replaced in the production with which we are concerned by one called "Motonobu-Tōyama."

The gist of the main story is that Ashikaga Yorikane, Lord of the Northern Provinces, becomes infatuated with the renowned courtezan Takao. Partly because of this infatuation and partly as a result of the plotting of disloyal retainers, he is forced to retire and his great position is passed on to his infant son, Tsuruchiyo-maru. Attempts are made to poison the young lord and put a usurper in his place, but a faithful nurse and others who are loyal protect him, until in the end the conspirators are annihilated and right prevails.

In the course of the action the faithful retainer Tomita Sukedayū is killed by the disloyal Kawashima Jibugorō on whom vengeance is taken in Nihonmatsu by Tomita Hyōtarō, the son of Sukedayū, with the aid of Tōfuya Saburobei.

We show first one of the portraits of Hyōtarō.

30

Ichikawa Omezō as Tomita Hyōtarō. The original play-bill shows him carrying his lantern as he approaches the place where his father has just been killed.

We find another representation of the same character in less formal attire in number 32.

In the present print the actor is dressed in a pale violet kimono with a *hakama* or divided skirt of dark yellow-green. The tonsure once was blue. The lantern, sandals and other appurtenances are yellow.

Impressions of prints by Sharaku in the narrow hosoye form are considerably more scarce than those of his ōban, single figure bust-portraits, and we would call attention to the fact that those which record scenes from the production at the Kawarazaki-za in the seventh month of 1794 are about the rarest of them all. Not one of them is known to exist in more than two impressions and some seem to have survived in one alone.

The print we exhibit is the only impression known of this subject and is reproduced by Rumpf as his number 68. It is trimmed at the left, and the signature which reads merely Tōshūsai is so placed that the remaining characters of the usual signature could not have followed vertically below those that are seen. Presumably they appeared on the part that has been cut off.

Hosoye. Gray ground. Signed as described above.

The Art Institute of Chicago (Buckingham Collection).

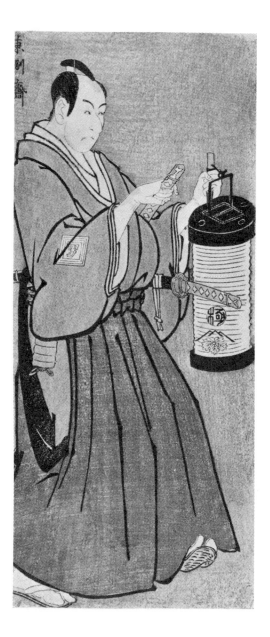

3 1

Ōtani Oniji III as Kawashima Jibugorō, the villain of the piece. In this performance the same actor also played the part of Ukiyo Tohei, a rôle in which he is shown in number 32.

Of the two known impressions of the print one is said to be on a yellow ground and the other is recorded as on a gray ground. Kurth describes the one he reproduces as on yellow ground, but the Vignier-Inada Catalogue, after calling attention to the apparent difference, re-produces as number 317 the one on gray ground which we have re-photographed as Rumpf did for his number 65. We have chosen this impression for reproduction because it would photograph more clearly than the other, although a number of extra lines around the hair have been added to it, apparently by hand.

None of the books referred to mentions the coloring of the costume.

The impression described in the Vignier-Inada Catalogue as on gray ground now is in the Matsukata Collection. The present whereabouts of the other is not known.

Hosoye. Signed: Tōshūsai Sharaku.

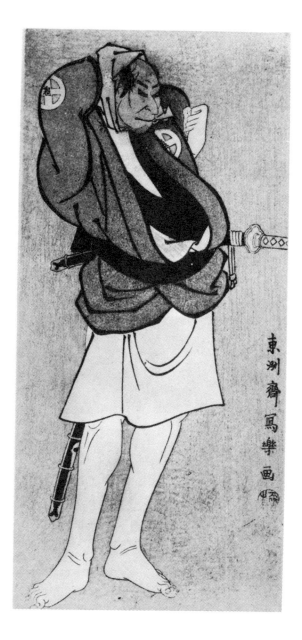

32

Ichikawa Omezō as Tomita Hyōtarō and Ōtani Oniji III as Ukiyo Tohei.

Omezō, kneeling at the right, has on a blue kimono with under kimono of rose and pale blue. His obi is green and yellow and is bound with a purple sash. Oniji is in dark orange-brown with a black check, and green showing at the waist.

This is the first to be catalogued here of the series of superb designs which show two figures at full length against grounds of white mica. Only seven survive and five of these have to do with plays produced in the seventh month of 1794. The other two are connected with a production of the following month at the Kiri-za which may have been delayed as that theatre did not produce anything new in the month before. Shortly afterwards the edict against mica grounds went into effect; but the unpopularity of the series may be assumed from the extreme rarity of impressions, the fact that only seven subjects for it are known to have been designed and the general statement of a contemporary that the prints of Sharaku were not liked. At least that one of the seven subjects which now is under discussion certainly appeared in two editions, for the impression we exhibit differs in three ways from the one reproduced in the Vignier-Inada Catalogue, number 330, and rephotographed from it in Rumpf number 36 etc., as well as from the inscribed copy used by Kurth and others: The signature is at the left instead of at the right, the calligraphy in it differs, and the seals are differently cut.

The two impressions of the print in America are alike, and two others have been reproduced as indicated above.

Ōban. White mica ground. Signed: Tōshūsai Sharaku.

The Art Institute of Chicago (Buckingham Collection).

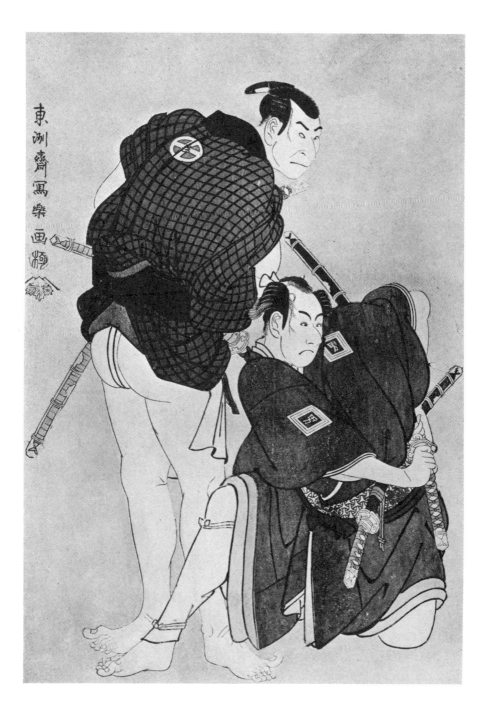

33

Tanimura Torazō probably in this play and as Tomita Sukedayū.

Below the publisher's mark and presumably written in by hand is a character apparently to be read as the word *Toku,* Special.

Ihara attributes this print to the rôle of Washizuka Hachiheiji in KOIN-YŌBŌ SOMEWAKE TAZUNA. Certainly comparison with number 15 shows similarities of costume and the presence in both of three visible teeth. The hair arrangement, however, seems different and as no other hosoye appears to be connected with that play we place the subject here with the further word of warning that the *banzuke* illustration of Torazō as Sukedayū fails to give positive evidence for this identification.

This print, like some others concerned with the production whose scenes as recorded by Sharaku we now are listing, looks as though it would fit into the composition of a triptych, and since a number of those that have survived exist only in one, or at most two impressions, it is not unreasonable to suppose that others may have been completely lost.

The only known impression of this one was at one time in the Vever Collection and was reproduced in the Vignier-Inada Catalogue, number 325, from which we have rephotographed it as Rumpf did for his number 67, and as others have done. The original now is in the Matsukata Collection. The coloring of the costume has not been described except that the outer robe is said to be black.

Hosoye. Yellow ground. Signed: Tōshūsai Sharaku.

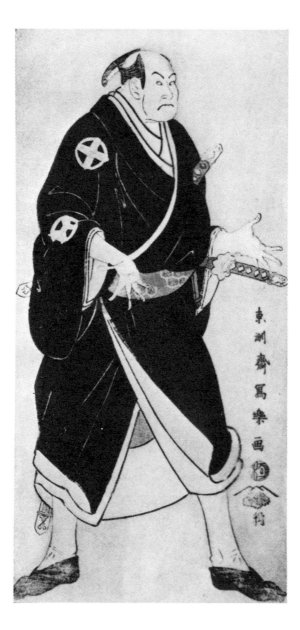

34

Ichikawa Ebizō IV as Ranmyaku no Kichi.

Despite the fact that Ebizō took four different parts in the production now under consideration there is no dispute about the identification of this print; nor is there another known impression of it. We reproduce this and the following number as two sheets of a possible triptych, the left-hand part of which is unknown.

We have rephotographed from the Vignier-Inada Catalogue, number 327, as Rumpf did for his number 66 and as the Japanese have done for their books on Sharaku. The print now is in the Matsukata Collection. The coloring of the costume has not been described.

Hosoye. Yellow ground. Signed: Tōshūsai Sharaku.

35

Iwai Kiyotarō possibly as O-Toki, the wife of Saburobei.

We place the print here tentatively on the right of number 34.

What may be the only surviving impression was at one time in the Bullier Collection in Paris and has now been rephotographed from the beautiful color reproduction in the Vignier-Inada Catalogue number 313. It is also reproduced in Rumpf number 93, etc. The impression reproduced in the Catalogue of the Matsuki Zenyemon Collection which now is owned by Mr. Saito of Sendai may be the same print, as a large part of the Bullier Collection went to Japan, but we are not certain of the identity. The coloring in the Vignier-Inada reproduction shows the stripes of the outer robe alternately yellow with black and solid red. The obi is in three tones of green.

Hosoye. Yellow ground. Signed: Tōshūsai Sharaku.

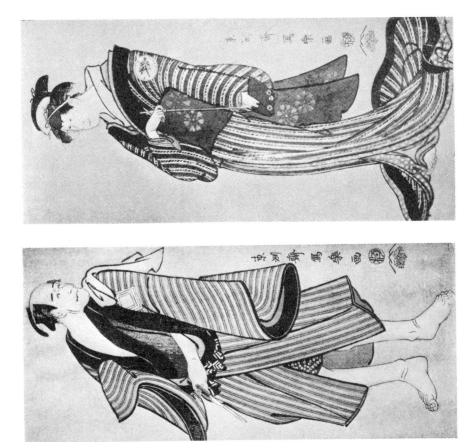

The four following prints record scenes from the *jōruri* KATSURAGAWA TSUKI NO OMOIDE, Recollections of the Moon at the Katsura River, which was played as part of the same production.

The plot is that of a well known love story which relates the infatuation of Chōyemon, a middle aged shop-keeper, with a very young girl named O-Han. Her parents refused to allow the unsuitable marriage, and O-Han, who in her turn had become infatuated with her elderly suitor, refused an elopement which would have been even more against the wishes of her father and mother. The only way in which the lovers could be together was in death, and they went out to perform double suicide beside the Katsura River where the moon alone was witness of their end. After death O-Han and Chōyemon were transformed into cats, and they are frequently represented in that shape, seated side by side, each with a paw about the other—faithful and protecting.

36

Iwai Hanshirō IV as Shinanoya O-Han, the girl loved by Chōyemon whose portrait we shall see in the print that follows.

We place this as the left-hand sheet of a triptych, the central and right-hand parts of which are numbers 37 and 38. In the ōban number 39 we find O-Han once more, but with her lover; and in that print she is shown with the same hair arrangement and the same design in her under kimono and her obi, though the outer kimono has been changed.

The only recorded impression of the subject now under discussion is in the Kunstgewerbemuseum in Berlin. It has been reproduced by Kurth from whom we have rephotographed it, as Rumpf did for his number 76, and as others have done. Rumpf describes the coloring as outer kimono gray with stripes, under kimono rose and white, obi orange-red and white.

Hosoye. Yellow ground. Signed: Tōshūsai Sharaku.

37

Bandō Hikosaburō III as the obi-seller Chōyemon, the same rôle as that in which we shall see him again, but somewhat differently dressed, in number 39.

This is the central sheet of the triptych of which the preceding and the following prints form the remaining parts.

The outer robe is in black with green stripes and it bears the actor's *mon* in blue and white. The kimono below that is in blue with green stripes. On the innermost one, however, the stripes are black against a ground of yellow. The obi is green and yellow. The pipe is rose and yellow, and there is a touch of rose in the lining of one sleeve.

There are no vexing problems about this print and we have only to add that both of the known impressions now are in America. The other, after being reproduced in the Vignier-Inada Catalogue, number 326, has been rephotographed by Rumpf for his number 75, and elsewhere.

Hosoye. Yellow ground. Signed: Tōshūsai Sharaku.

Museum of Fine Arts (Spaulding Collection).

38

Osagawa Tsuneyo II as O-Kinu, the wife of Obiya Chōyemon, whose portrait we see in numbers 37 and 39.

This is the right-hand sheet of the triptych whose central and left-hand portions we have just seen.

The only known impression was at one time in the Mutiaux Collection in Paris and this has been rephotographed here from the Vignier-Inada Catalogue, number 322, as Rumpf rephotographed it for his number 77. It is reproduced in various Japanese publications as well as in the Occidental ones mentioned. Its present location is unknown. The coloring, except for the black obi, has not been described.

Hosoye. Yellow ground. Signed: Tōshūsai Sharaku.

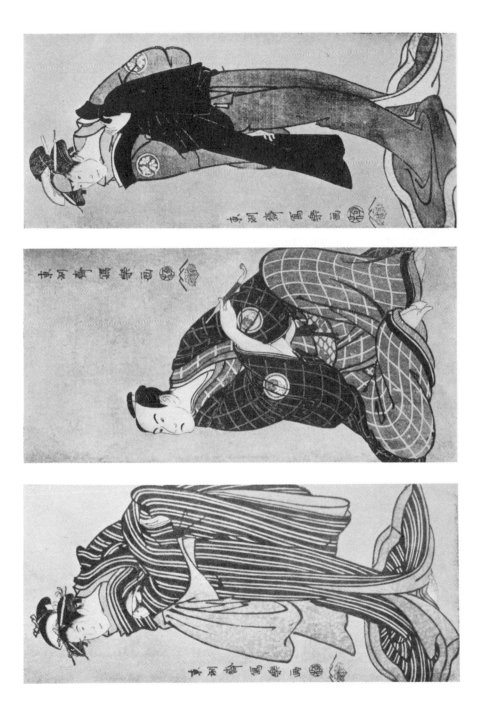

39

Bandō Hikosaburō III as the obi-seller Chōyemon whose portrait in a different costume is shown as number 37, and Iwai Hanshirō IV who is enacting the part of Shinanoya O-Han, as he was in number 36.

Hikosaburō is dressed in an outer kimono of black and yellow stripes and an under one of sage green. His obi is purple and white. The white under garment is embossed. Hanshirō's costume is in sage green with touches of coral and a second design in blue and white. The obi is white on a ground of purple and the under kimono is rose and white.

The print we exhibit was at one time in the Rouart Collection of Paris and was reproduced in the Vignier-Inada Catalogue, number 332, from which Rumpf rephotographed it for his number 37. No other impression has been reproduced but there are two others in America.

Ōban. White mica ground. Signed: Tōshūsai Sharaku.

Fuller Collection.

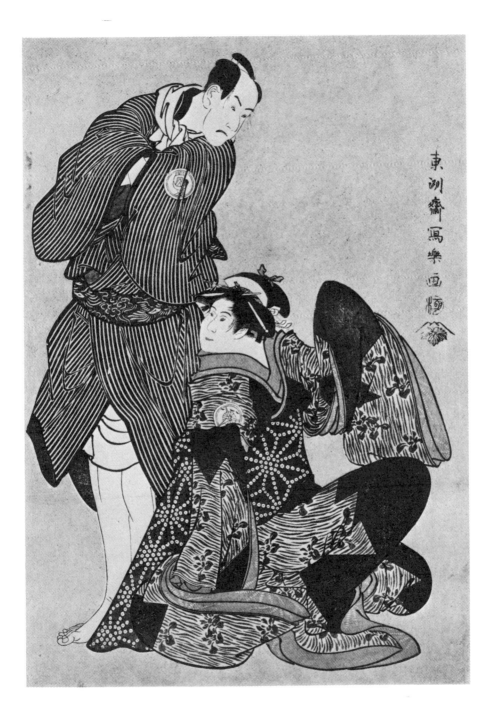

Keisei Sanbon Karakasa

OR

THE LADY OF PLEASURE AND THE

THREE UMBRELLAS

MIYAKO-ZA, SEVENTH MONTH OF 1794

NUMBERS 40 TO 55

OUTLINE OF THE PLOT

Nagoya Sanzayemon is killed by his enemy Fuwa no Banzayemon, and his son Nagoya Sanza has no clue as to who did the deed but does know that the sword his father cherished and had always worn had disappeared at the time of his death.

Sanza, seeking information that would disclose the identity of the man who had killed his father, begins frequenting the licensed quarter where all the brawling spirits of the city were likely to be met, and on his visits there he falls in love with a girl named Katsuragi. Fuwa Banzayemon, the villain of the piece, also frequents the licensed quarter and while there he loses his heart to the same girl who, however, returns the affection of Sanza and not of Banzayemon. Naturally enough, a quarrel arises and when Banzayemon draws his sword, the young hero of the piece Sanza, who was noted for his swordsmanship, recognizes the weapon of his father and accomplishes the vendetta with double satisfaction. The secondary threads of the action of the play need not be described here and we will say only that among the minor characters whom Sharaku portrayed as he saw them enacted, Fuwa Banzaku is the son of the arch-enemy, Fuwa Banzayemon, while Tosa no Matahei and Ukiyo Matahei are *yakko* attached to the opposing sides.

40

Ichikawa Danjūrō VI as Fuwa Bansaku, son of Fuwa Banzayemon the villain of the piece.

The outer garment is decorated in purple and white on a green ground. The kimono below it is rose-colored.

So many of the actor prints in hosoye form by Sharaku, Shunshō and others were designed to go together in sets of three that one might expect this print and eleven of the twelve hosoye that follow it to make four triptychs. All represent scenes from the same play, and all are on yellow grounds. They do not, however, fall surely into groups and as it is possible that some of Sharaku's designs for this production have been lost it seems better to state that our arrangement of those that remain is tentative. We group this print and the two that follow as a possible triptych, with this one at the left.

The impression chosen for exhibition from three that are in America bears a hand-written inscription giving the name of the actor. This inscription, with others in the same hand, will be fully discussed under number 100 and we will merely say now that the writer of these inscriptions is believed to have been Shokusanjin, one of the compilers of the original notebook mentioned in our preface, in which contemporary references to Sharaku have been found. Fourteen prints inscribed by that owner came early to Germany and are reproduced, as this one is, in a dealer's advertisement in the first edition of Kurth's book.

One of the two other impressions now in American collections is illustrated in the Vignier-Inada Catalogue, number 308, and was rephotographed by Rumpf for his number 69, as well as by Noguchi.

Hosoye. Yellow ground. Signed: Tōshūsai Sharaku.

Ledoux Collection.

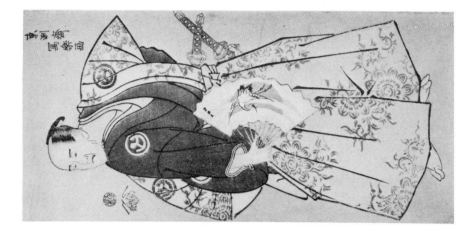

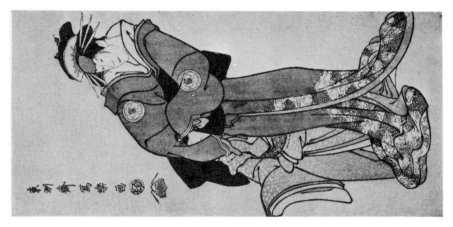

Segawa Tomisaburō II as the courtezan Tōyama, sheltering a child.

This print must belong either with this play or with HANAAYAME BUN-ROKU SOGA because of the way it is signed and because Segawa Tomi-saburō II was appearing at the Miyako-za. We eliminate the other of the two possibilities partly because Sharaku's representations (numbers 4 and 9) of the actor in the earlier production show the different hair ar-rangement appropriate to a totally different type of character. Inciden-tally the records of KEISEI SANBON KARAKASA list Tomisaburō as having taken the part of Tōyama and no other rôle in this play and they show that several children appeared during the course of the action; but which of them is being protected in the picture under discussion we cannot say. In any case as there are no hosoye that can be assigned definitely to fifth month productions this one presumably belongs here.

We place the print tentatively as the central sheet of a triptych.

The costume worn by the actor is purple over rose, that of the child is rose and white.

There are two impressions in American collections. The subject was unknown to the compilers of the Vignier-Inada Catalogue and was de-scribed but not reproduced by Kurth. Rumpf for his number 62 repro-duces the inscribed impression known to Kurth in the dealer's advertise-ment to which we have made reference under the preceding number. No other seems to have been recorded.

Hosoye. Yellow ground. Signed: Tōshūsai Sharaku.

Ledoux Collection.

42

Yamashina Shirōjūrō as Nagoya Sanzayemon whose demise early in the action furnished a motive for the revenge finally accomplished by his son. In the print he is wearing the sword that is seen again in number 46 being drawn by the man who killed him.

He is shown in a kimono of yellow-green worn under a *kamishimo* once pale blue on which are flowers in bluish green. The white fan has a design in deep rose and what seemingly was once pale blue. The all-important swords he wears have hilt wrappings of blue-green, mountings of golden yellow and scabbards of deep rose.

We place the print as the right-hand sheet of a possible triptych.

Like two or three of the other subjects described in the preceding pages, there was no impression of this print in Paris when the Vignier-Inada Catalogue was compiled; but the copy inscribed with the actor's name which first came to notice in the dealer's advertisement to which reference has been made, remained in Germany and was reproduced in Kurth, Rumpf number 91, various Japanese books and the Straus-Negbaur Sale Catalogue. This impression is now in Chicago. In it the hair is somewhat better printed than it is in the impression we exhibit, but to those of us who made the difficult choice between two excellent prints—and no third is known—the color in the one selected seemed of a finer tone.

Hosoye. Yellow ground. Signed: Tōshūsai Sharaku.

Metropolitan Museum of Art (Church Collection).

43

Segawa Kikunojō III as the courtezan Katsuragi, the heroine of the play, and Sawamura Sōjūrō III as Nagoya Sanza, the hero. For separate portraits of these actors in the same rôles see the two following prints.

Kikunojō wears a black robe over an under kimono of rose and violet. Sōjūrō's outer kimono shows alternate squares of red-brown and greenish gray. His obi is rose and yellow with touches of a color now decomposed but apparently once light blue, which appears also in other parts of the print.

As we noted in our discussion of number 4, Sharaku seems to have taken an especially malicious delight in making the actors of the Segawa line, who were famed for their grace and beauty, just as unattractive and banal as possible, and in maliciousness this portrait is almost the equal of the other. Still a third that is quite as bad as its predecessors will be noted under number 45.

This subject is the least rare of any of Sharaku's seven surviving designs for full length figures on mica grounds, and there are four good impressions of it in America alone. The one reproduced in the Vignier-Inada Catalogue, number 333, has been reproduced again as Rumpf number 34 and elsewhere. A much trimmed impression reproduced by Kurth is copied by Nakata, and still another is reproduced in color by Noguchi.

Ōban. White mica ground. Signed: Tōshūsai Sharaku.

The Art Institute of Chicago (Buckingham Collection).

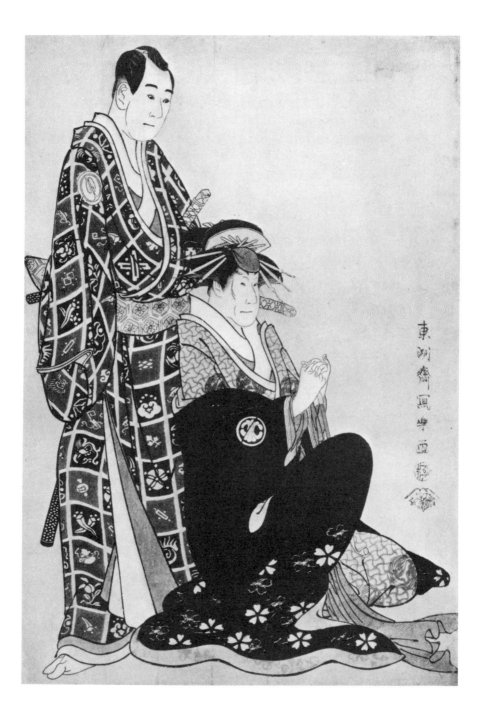

44

Sawamura Sōjūrō III as Nagoya Sanza, the hero of the play and a young man who was as much praised for his good looks as for his swordsmanship. For another portrait of the actor in the same rôle, but differently equipped except for his swords in their mottled scabbards, see the preceding number.

Here he is dressed in a black outer robe which is decorated in the lower part with a green and white design of bush clover *(hagi)*. His under kimono is rose-colored and below that he wears a gray and white garment with a lozenge design.

We place the subject as the left-hand sheet of another probable triptych, and would add that we feel much more sure of the propriety of bringing together the three prints now being considered than we did in the juxtaposition of numbers 40, 41 and 42.

Sōjūrō has his back to his enemy, but is clearly on guard, and his eyes are intent on the quarter from which attack is expected. Such a posture is in the best *samurai* tradition for the swordsman hero of a play.

The print we exhibit has been reproduced in the Vignier-Inada Catalogue, number 320, in the Catalogue of the Mutiaux Sale, by Noguchi and as Rumpf number 63. There are two others in America.

Hosoye. Yellow ground. Signed: Tōshūsai Sharaku.

Ledoux Collection.

45

Segawa Kikunojō III as the courtezan Katsuragi who was loved by the hero of the play and who loved him in return.

Another and even less flattering portrait of the same actor in the same part but differently robed except for the repetition of the cherry blossoms, may be seen in number 43.

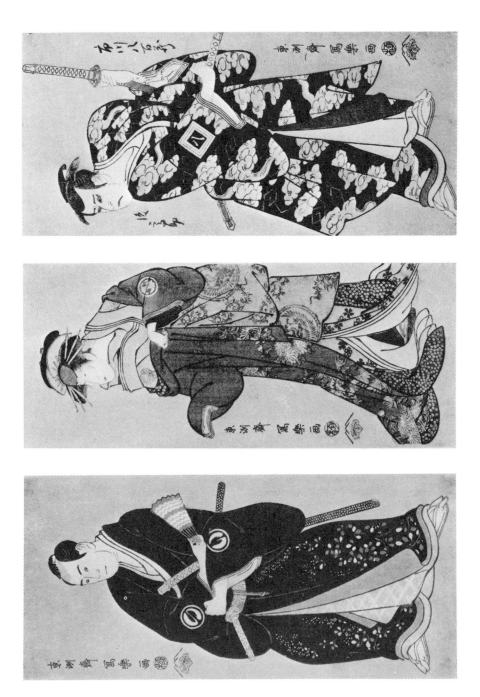

The elaborate outer kimono is violet, decorated with green stemmed chrysanthemums in yellow and two tones of rose. It has a deep rose tie-dyed lining. The under kimono is pale rose and there is a deep rose under garment. The obi is in two tones of green.

The dealer's advertisement referred to under number 40, reproduces an impression of this subject with two names of the actor inscribed on it, and the only other that has been reproduced is rephotographed from the Vignier-Inada Catalogue number 316, as Rumpf number 70 and by Noguchi. There is one other in America.

We place this print as the central sheet of a triptych showing Katsuragi between her two lovers, the hero and the villain of the play.

Hosoye. Yellow ground. Signed: Tōshūsai Sharaku.

The Art Institute of Chicago (Buckingham Collection).

46

Ichikawa Yaozō III as Fuwa Banzayemon, the villain of the piece. Here he is shown drawing the fateful sword which we saw in number 42 being worn by its rightful owner, Sanzayemon.

For another portrait of Yaozō in the same rôle see the following number.

The print now under discussion is one of the most admired designs by Sharaku in the hosoye form.

The outer kimono is black with yellow and white cloud forms and the jagged design of the so-called lightning pattern which is in rose. The lining of the kimono is in the same rose and the under robes are in white. The scabbards of the swords are in pink and yellow.

We place the print as the right-hand sheet of a triptych.

This is the impression inscribed with the actor's name which was reproduced in the dealer's advertisement referred to under number 40 and more fully discussed under number 100. It is in very brilliant condition.

The subject is not quite so rare as some others, (there are three in America) but for reproductions we refer only to the Vignier-Inada Catalogue number 315 which has been rephotographed for Rumpf number 71 and elsewhere.

Hosoye. Yellow ground. Signed: Tōshūsai Sharaku.

The Art Institute of Chicago (Buckingham Collection).

47

Ichikawa Yaozō III as Fuwa Banzayemon and Sakata Hangorō III as Kosodate-no-Kwannon-bō, that is, a priest of Kwannon the Child-protector.

For separate portraits of these two actors in the same rôles see numbers 46 and 50.

A comparison of the way in which the lightning and the cloud designs in the costumes worn by Yaozō are treated in number 46 and in the print now under discussion is of considerable interest. Here he wears a *kamishimo* printed in orange, two tones of green, strong rose and violet, over a kimono of brown and under kimono of white and what once was light blue. The sword has blue hilt wrappings and yellow mountings, and the scabbards are deep rose, as in number 42. Hangorō stands in a gray robe held by a blue sash; above his waist is seen an under robe which is white with an embossed pattern of now faded light blue.

There are two impressions of this print in America, neither of which we believe to have been reproduced hitherto, as all previous reproductions of the subject can be traced back to two other originals both of which once were in Paris. The one formerly in the Bullier Collection of that city appears as Vignier-Inada Catalogue number 335, Rumpf number 33 where the color is differently described, and as plate 42 of the catalogue of the Matsukata Collection. The other, which once was owned by Pierre Barboutau appears as number 737 in his two-volume catalogue of 1904, in Kurth, Noguchi and Nakata.

Ōban. White mica ground. Signed: Tōshūsai Sharaku.

The Art Institute of Chicago (Buckingham Collection).

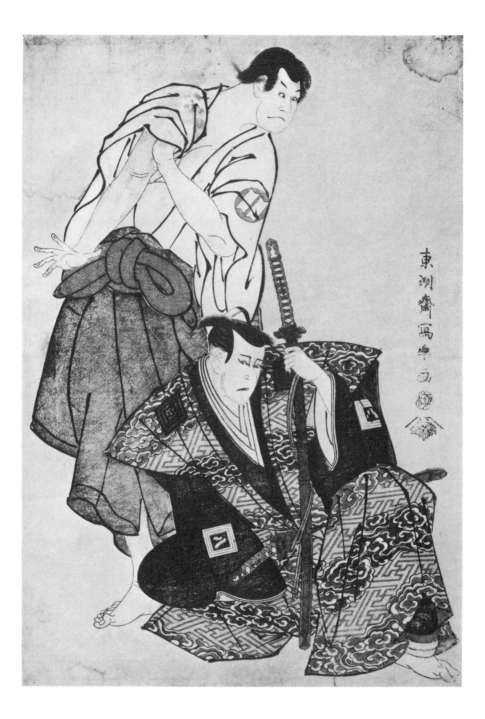

48

Ōtani Tokuji probably as Monogusa Tarō, disguised as a farmer and carrying a spade.

The outer robe which has been let down is mainly in dull purple and gray, with a greenish yellow lining. The garment at the waist is in deep rose. The under kimono which appears above the waist is light blue.

This print might possibly be connected with the fifth month production at the Miyako-za but it is much more likely to represent the actor in the rôle mentioned above which he played in KEISEI SANBON KARAKASA. We place it as the left-hand sheet of a triptych.

The impression we exhibit is the only one in America. Another, which is somewhat trimmed, is reproduced in the Vignier-Inada Catalogue number 304, and as Rumpf number 55. A third appears in Nakata.

Hosoye. Yellow ground. Signed: Tōshūsai Sharaku.

Museum of Fine Arts (Bigelow Collection).

49

Ichikawa Tomiyemon probably as Inokuma Monbei, disguised as a farmer and carrying a mattock.

The outer kimono which has been let down is in white and oxidized orange stripes against a ground of blue. The under garment, showing below, is in red-brown. The inner kimono now is pale gray with a tie-dyed pattern embossed in white.

Like the last number, this print may possibly be connected with HANA-AYAME BUNROKU SOGA, and it must be admitted that the costume and hair arrangement are much like those with which Tomiyemon is represented in number 12. There are, however, no hosoye which can be definitely assigned to that play and the records of the production we are now listing give seemingly appropriate parts to both actors. We place the print as the central sheet of a triptych.

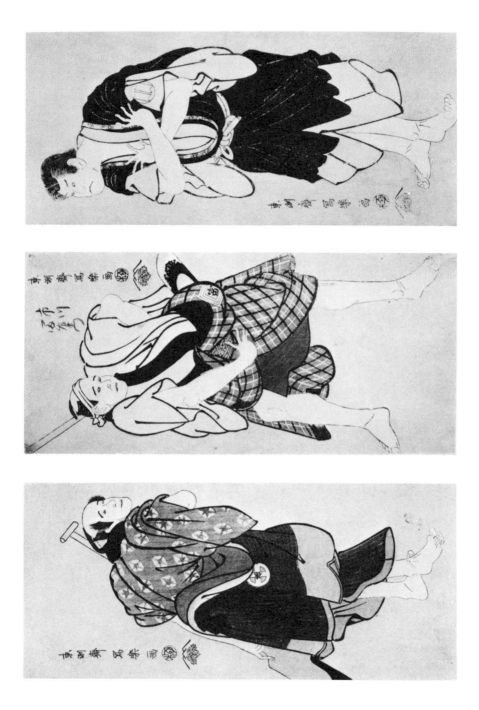

There are three impressions in America. The one we exhibit bears a hand-written inscription giving the name of the actor and it has been previously reproduced in the dealer's advertisement to which reference has been made under number 40 and elsewhere. The Vignier-Inada Catalogue, number 304, shows another impression which is reproduced again as Rumpf number 56.

Hosoye. Yellow ground. Signed: Tōshūsai Sharaku.

Colburn Collection.

50

Sakata Hangorō III as a Priest of Kwannon, Protector of Children (Kosodate-no-Kwannon-bō).

For another portrait of him in the same rôle see number 47.

Here his outer robe is black, his kimono pale gray, and between them is a band having a pattern of deep rose. His shaven cheek and chin as well as the background of his *mon* are in a color now decomposed but apparently once light blue.

We place the print tentatively with the two that precede it, as the right-hand sheet of a triptych.

The only impression previously recorded is reproduced as Rumpf number 72 and is the one with an inscription in the dealer's advertisement referred to under number 40. The remaining one that is known to exist is in an American collection but is in less good condition than the impression shown here.

Hosoye. Yellow ground. Signed: Tōshūsai Sharaku.

The Art Institute of Chicago (Buckingham Collection).

51

Bandō Mitsugorō II as the farmer Asakusa no Jirōsaku.

The actor is dressed in dark red over green and carries on his back a bundle of yellow straw.

The subject has been reproduced in the Vignier-Inada Catalogue, number 307, and Rumpf number 61 from one impression. Noguchi uses the one we exhibit and reproduce here but shows it as it once was, heavily oxidized. There is one other in America.

We place the print as the left-hand sheet of one of the tentative triptychs we have formed from some of the yellow ground hosoye that record the production of this play.

Hosoye. Yellow ground. Signed: Tōshūsai Sharaku.

Ledoux Collection.

52

Ōtani Hiroji III as Tosa no Matahei, a *yakko* in the service of Nagoya Sanza.

The costume is mainly in sage green patterned in white and dull brick-red. The sword hilt and scabbard are in rose, yellow and gray.

There is no other impression of this print in America and the only one that has been reproduced hitherto appears as Rumpf number 73 and in the Vignier-Inada Catalogue, number 305, where it is placed as the left-hand sheet of a diptych formed of this subject and the following one. In our opinion these two prints are the central and right-hand sheets of a triptych which we have been able to complete by adding the hitherto missing section.

The two actors shown separately in this print and the next may be seen together in number 54.

Hosoye. Yellow ground. Signed: Tōshūsai Sharaku.

Museum of Fine Arts (Bigelow Collection).

53

Arashi Ryūzō as Ukiyo Matahei, a minor malefactor in the service of Banzayemon, the villain of the play.

The two Matahei are shown together in number 54.

Here Ryūzō is in black with a white pattern and his skirt is deep rose, patterned in yellow-green. The collar is white with a design of yellow-green bamboo. The under collar is black. Though the coloring differs slightly, the costume is the same as that which he is wearing in the following number.

We place the subject as the right-hand sheet of a triptych.

The print has been very badly trimmed and the missing portions have been painted in by copying the reproduction of a more nearly intact impression from the Vignier-Inada Catalogue, number 305. Rumpf in his number 74 rephotographs the Vignier-Inada impression, and only these two are known to survive.

Hosoye. Yellow ground. Signed: Tōshūsai Sharaku.

The Art Institute of Chicago (Buckingham Collection).

54

Ōtani Hiroji III as Tosa no Matahei and Arashi Ryūzō as Ukiyo Matahei. For separate portraits of these two actors in the same parts see the immediately preceding numbers. It is interesting to observe the similarities in the drawing of the heads as well as in the textiles.

The costumes are the same as those in which we have just seen the two actors represented separately; and the coloring of the subject now under discussion has been described as follows: "Hiroji is in a green outer garment patterned in white. His collar is yellow and red. He wears red under garments with a black collar. His obi is red and green with wistaria sprays. Ryūzō is in brown with a white pattern and his skirt is red, patterned in yellow. The collar is white with green bamboo, the under collar is black."

The two known impressions of this print now are in Japan. One is reproduced in the Vignier-Inada Catalogue, number 329, Rumpf number 35, and the catalogue of the Matsukata Collection, plate 41, from which we have rephotographed it. The other is reproduced in the catalogue of the loan exhibition of 1930 of prints from the collection of Mr. A. S. Mihara of Tokyo. The Mihara print is less trimmed than the Matsukata one, but the reproduction of it would be harder to photograph.

Ōban. White mica ground. Signed: Tōshūsai Sharaku.

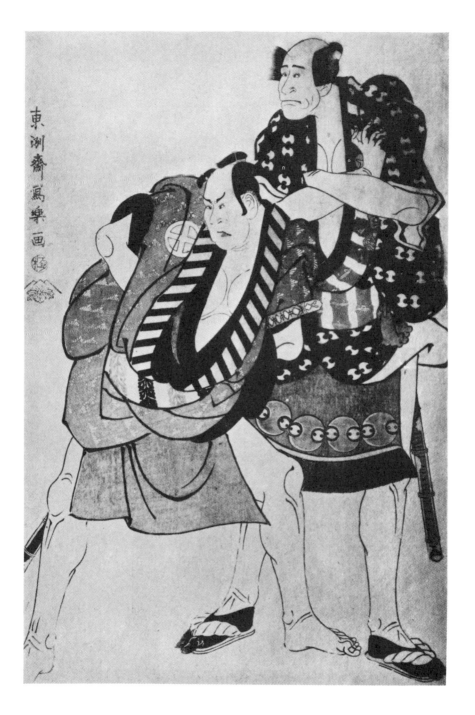

55

Sanogawa Ichimatsu III probably as Sekinoto, the wife of Banzayemon.

We believe that we are correct in placing this print here and in identifying the rôle as that of Sekinoto. It is fair, however, to call attention to the fact that the actor is represented in numbers 11 and 12 with a similar hair arrangement and in a costume in which the so-called "Ichimatsu design" of white squares is equally prominent.

The only known impression has been reproduced in the dealer's advertisement to which we have referred so often, and as Rumpf number 64. The present whereabouts of the print is unknown and we have been obliged to rephotograph the very small cut in Rumpf's book. The coloring of the costume has been described as black and red. The hand-written inscription gives the name of the actor, and before leaving the somewhat controversial question of the proper placing of this print and the two others, numbers 48 and 49, which might possibly have to do with the fifth month production at the Miyako-za, it may be not wholly irrelevant to add that eight out of the fourteen inscribed hosoye which came together to Germany and are reproduced in the dealer's advertisement seem to be connected in subject with KEISEI SANBON KARAKASA, while the six others belong with even later plays.

Hosoye. Yellow ground. Signed: Tōshūsai Sharaku.

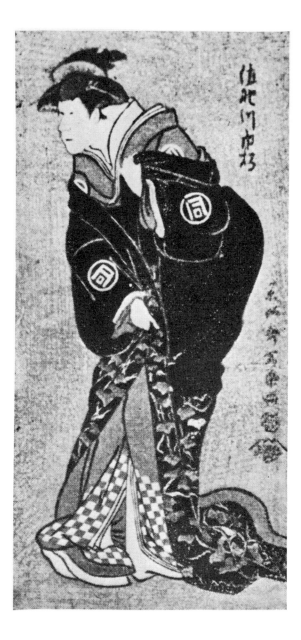

Shinrei Yaguchi No Watashi

OR

THE MIRACLE AT THE YAGUCHI FERRY

WITH THE INDEPENDENT AND SEPARATELY NAMED PIECE

PLAYED AFTER IT IN THE SAME PRODUCTION

YOMO NO NISHIKI KOKYŌ NO TABIJI

OR

THE HOMEWARD JOURNEY TO THE

BROCADE COUNTRY*

KIRI-ZA, 20TH OF THE EIGHTH MONTH OF 1794

NUMBERS 56 TO 66

OUTLINE OF THE PLOT

During part of the 14th Century there were two rival Emperors in Japan, one of whom was backed by the powerful Ashikaga family under Ashikaga Takauji. The other Emperor had among his partisans the Nitta clan, and after their leader Nitta Yoshisada had been killed, the remainder of the army that he had commanded was led by his son Nitta Yoshioki. In the play by Hiraga Gennai entitled SHINREI YAGUCHI NO WATASHI the pertinent episodes of Yoshioki's career are given somewhat as follows.

When he had become head of the house and was preparing to leave his fief and go out to the war he entrusted his castle, his wife, and his child to the guardianship of a faithful retainer named Yura Hyōgono-suke, and he ordered a younger brother, Yoshimine, who was to remain in attendance on the Emperor, to take special care of two famous arrows that were among the most prized and most coveted heirlooms of the Nitta family.

* i.e., toward Nara

When Yoshimine had been left behind he began leading a life of dissipation; the precious arrows were lost and the young man fell under the influence of one of Ashikaga Takauji's followers to such an extent that he persuaded his brother to give this man a position of trust in the army that in the end enabled him to bring about the tragic catastrophe and compass the death of Yoshioki at the ferry of Yaguchi. In despair because the arrows entrusted to his care had not been properly guarded, Yoshimine set out with his sweetheart to search for them and when he himself was about to be murdered, as his brother had been, at the Yaguchi Ferry, they came suddenly flying through the air and lodged in the throats of the two men with whom he was fighting. That is the miracle which took place at the ferry, and we have described the subsidiary action which has to do with Yoshimine and the arrows merely to explain the title of the play. There are no prints by Sharaku representing this part of the story and we return now to the main plot.

When Yoshioki had gone to the war, Yura Hyōgonosuke, whom he had left in charge of his wife and child and castle, realizing the rashness and inexperience of the young general, turned over the guardianship to another faithful retainer, Minase no Rokurō Munezumi, and set out in disguise to join his lord and guard him from his own too reckless valor as well as from his enemies. It is to be admitted that Hyōgonosuke took rather forceful methods of exercising restraint, and when his identity was disclosed, Yoshioki, furious, sent him home in disgrace. Then Yoshioki was murdered at the ferry, and the tale of the loyalty of his retainers—a theme invariably dear to the Japanese—goes on through the wanderings of the wife and child, ever led and protected by Hyōgonosuke and Munezumi, until the latter is killed by their enemies and the former sacrifices his own son in order to save the son of his dead lord.

We show first Sharaku's portrait of Hyōgonosuke.

56

Morita Kanya VIII as Yura Hyōgonosuke.

He wears a kimono of light violet, over which is a *kamishimo* tinted in light tones of blue, rose and green, and lined with pale rose.

This impression, which is the only one in America, has a hand-written inscription giving the name of the actor; it also bears an additional note stating that "afterwards" he called himself Bandō Yasosuke II; and as he did not take this name until 1801 the inscription could not have been written before that date. The print was first reproduced with a number of other inscribed Sharaku prints in a dealer's advertisement in the first edition of Kurth. A different and somewhat trimmed impression is reproduced in the Vignier-Inada Catalogue, number 309, and again by Rumpf number 59, Noguchi, etc.

Hosoye. Yellow ground. Signed: Tōshūsai Sharaku.

The Art Institute of Chicago (Buckingham Collection).

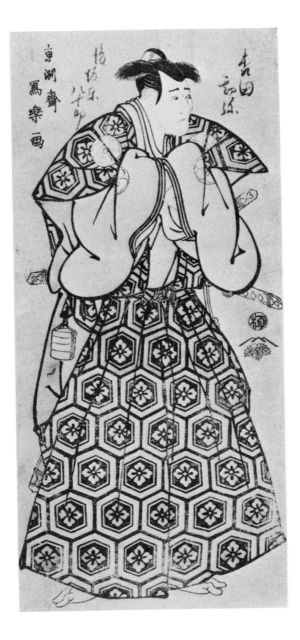

57

Ichikawa Komazō II as Minase no Rokurō Munezumi, who was the companion of Hyōgonosuke in loyalty and sorrow, and who shared with him the guardianship of Nitta Yoshioki's family and castle.

We have rephotographed from the Vignier-Inada Catalogue, number 312, as Rumpf rephotographed for his number 88. The present whereabouts of this print we do not know, nor have we been able to trace the only recorded duplicate, which is said to have been inscribed with the name of the actor. The coloring has not been described.

Hosoye. Yellow ground. Signed: Sharaku. If a corner of the print had not been torn away, the full signature Tōshūsai Sharaku presumably would be seen on it.

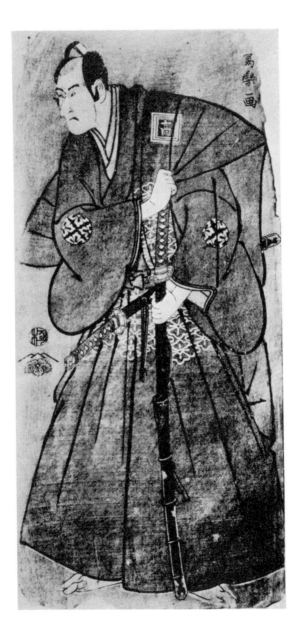

58

Ichikawa Komazō II, again as Minase no Rokurō Munezumi, but this time disguised as a pilgrim. From his staff he has drawn a sword.

This print looks as though it had been designed as the right-hand sheet of a triptych, and if that was the fact, the remaining portions probably showed some one of the sudden dangers with which the little band of disguised fugitives were confronted while Munezumi and Hyōgonosuke were trying to lead Yoshioki's wife and child to a place of safety, beyond the reach of Ashikaga Takauji.

The subject was reproduced in the Vignier-Inada Catalogue, number 321, from an impression then in the Vever Collection and now in that of Mr. Matsukata, from plate 39 of whose catalogue we have rephotographed it. The same print appears again as Rumpf number 58. No other impression is known, nor has the coloring been described.

Hosoye. Yellow ground. Signed: Tōshūsai Sharaku.

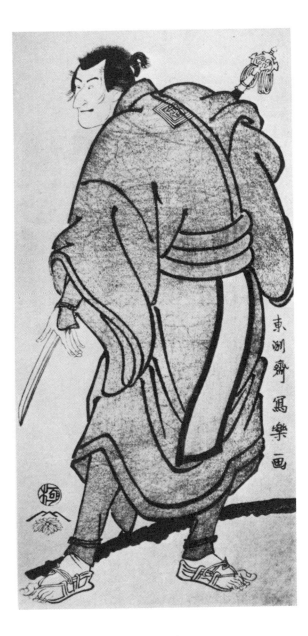

59

Nakamura Kumetarō II as Minato, the wife of Yura Hyōgonosuke.

The outer robe is black with a design in white, green and yellow. The kimono below it is in rose.

Recent identifications enable us to present a triptych of which this is the left-hand sheet.

The hand-written inscription gives the name of the actor as Nakayama, rather than Nakamura, Kumetarō, and this serves to identify the print as the one reproduced in the Straus-Negbaur Catalogue and in color by Kurth, from whom it was rephotographed by Nakata.

Of the two other impressions now in America, one was rephotographed by Noguchi and by Rumpf for his number 89 from the Vignier-Inada Catalogue, number 319, where it was shown as the left-hand sheet of a diptych. No other impressions have been recorded.

Hosoye. Yellow ground. Signed: Tōshūsai Sharaku.

Metropolitan Museum of Art (Mansfield Collection).

60

Nakajima Kanzō as the pack-horse man Neboke no Chōzō. In some books this character has been called Negoto no Chōzō, but the original play-bill writes the name as above.

The actor wears a red apron and an upper garment of gray-blue with white checks. About his waist is a yellow cord. His gloves and leggings are in gray-blue.

The impression exhibited, which is one of two in American collections, is reproduced as the right-hand sheet of a triptych improperly put to-gether in the Vignier-Inada Catalogue, number 304. It appears again in

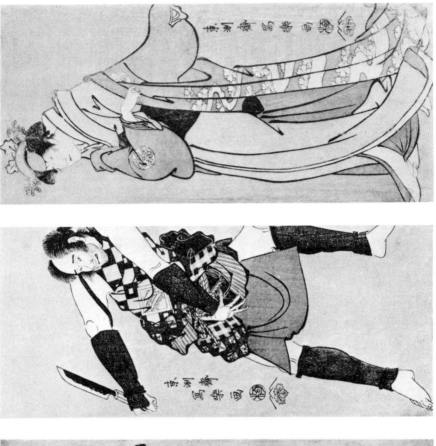
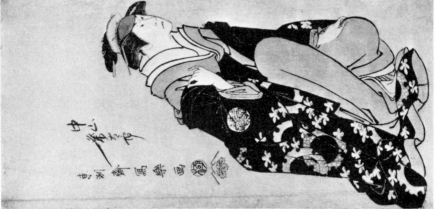

the Jacquin ("Distinguished French Connoisseur") Catalogue, number 33, and as Rumpf number 57.

We place it as the central sheet of a triptych to which the preceding and the following prints belong.

Hosoye. Yellow ground. Signed: Tōshūsai Sharaku.

Museum of Fine Arts (Spaulding Collection).

61

Nakayama Tomisaburō as Tsukuba Gozen, the consort of Nitta Yoshioki.

This is the right-hand sheet of the triptych.

The outer robe is violet with the stream pattern in what was once light blue, and with touches of rose in the cherry blossoms. The lining is deep rose, and the under kimono pale rose with a pattern in white reserve.

The subject is reproduced in color in the Vignier-Inada Catalogue, number 319, plate 94, and under the same number in black and white. Rumpf rephotographs that impression for his number 90; and one with an inscription indicating that the actor was thought of as "floppy" *(gunya)*, is reproduced by Kurth and Nakata.

Hosoye. Yellow ground. Signed: Tōshūsai Sharaku.

The Art Institute of Chicago (Buckingham Collection).

The following five prints record scenes not in the main play of the production with which the preceding six were concerned, but in the independent and separately named after-piece, YOMO NO NISHIKI KOKYŌ NO TABIJI, or "The Homeward Journey to the Brocade Country."

Yomo No Nishiki Kokyō No Tabiji

OUTLINE OF THE PLOT

The story of the love and death of Chūbei and Umegawa was popular on the Kabuki stage, and was so well known, especially in the version by Chikamatsu called MEIDO NO HIKYAKU, which has been translated by Asataro Miyamori, that any part of it could be presented with assurance that the audience would be familiar with what had gone before or would come after, and would feel the emotions aroused by the whole tragic tale. An outline of the action was in their minds and it is an outline that we need here.

Magoyemon, when his wife died, married again; and chiefly because of the step-mother in the home, he arranged to have his son Chūbei go to another province and become the adopted son of a widow there whose long-established business he became able to manage for her. The young man fell in love with a girl of the Pleasure Quarter named Umegawa who returned his affection, and when another admirer offered to ransom her from the proprietor of the house in which she served, Chūbei stole money entrusted to him by his clients, so that he might buy the freedom of Umegawa himself and make her his bride. One of these clients, Tambaya Hachiyemon, went to a tea-house where Umegawa and other girls were gossiping and told the story of the theft, but Umegawa already had been freed and although her rejoicing was turned to sorrow, she decided to be loyal to Chūbei and fled with him on a night of storm, planning to reach if possible his boyhood home so that they might die there together.

Pursuit was evaded until they reached the village where Chūbei's father Magoyemon still dwelt; but when they came to the outskirts of it they realized that arrest was imminent and took shelter in a house from which they hoped to send word to him. While they waited the old man was seen passing, quite unconscious of their presence, and as they watched he slipped and fell, breaking the strap of his straw sandal as he did so. Chūbei remained in hiding, but Umegawa, concealing her identity, rushed out

and helped him into the house and was kind to him and repaired his broken sandal. Magoyemon, who had heard the story of the son he had put aside, soon realized who she was and that Chūbei, unseen for years, and now suddenly loved again, must be near and in immediate danger. He gave money to the girl and instructions as to the only possible way of escape; but a few moments later the lovers were brought back to him under arrest and ready for death, which when met nobly and in repentance wipes out disgrace. Since then the names of Umegawa and Chūbei have remained "upon the roll of those whom passion has made its prey."

We present first Sharaku's picture of Umegawa mending the broken sandal of Chūbei's father, Magoyemon.

62

Matsumoto Kōshirō IV as Magoyemon and Nakayama Tomisaburō as Umegawa.

For other portraits of these two actors in the same parts see numbers 63 and 66.

Tomisaburō is dressed in a black outer robe with a design of white blossoms, and in a gray-green obi with a ground pattern of flowers and tendrils in rose and green. Kōshirō's coat and *tabi* are in a purple-brown and the design on his coat is in black. His other garments are in gray-green and olive with touches of white and the same purple-brown used elsewhere.

The only impression of this print that has been reproduced hitherto is the more trimmed one rephotographed in Rumpf number 32, and in various Japanese books from the Vignier-Inada Catalogue, number 334. It is a rare subject but there are two other impressions in America, both of which are fine though neither is in quite such superb condition as the example shown.

Ōban. White mica ground. Signed: Tōshūsai Sharaku.

Fogg Art Museum (Duel Collection).

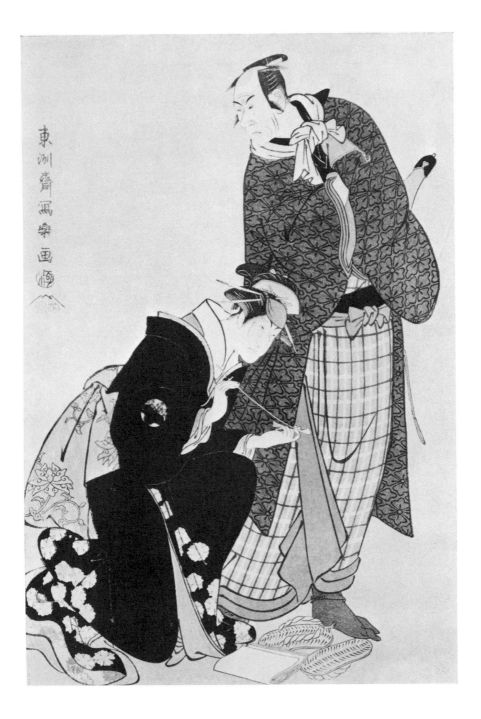

63

Matsumoto Kōshirō IV as Magoyemon, the father of Chūbei.

For another portrait of him in the same rôle and the same costume see the preceding number.

His coat is soft reddish lilac; his kimono pale blue, now faded, with brownish red and white checks; the lining of the kimono and the under robe are yellow and the tobacco pouch is bright rose.

We place this print separately in spite of strong temptation to consider it the left-hand sheet of a triptych with the two that follow forming the other portions. Magoyemon's posture, and particularly the downward direction of his gaze would indicate that placing, but it is decidedly unusual to have one character in a triptych of a different sex from the other two and not in the center of the composition; and furthermore we doubt if the old gentleman was present in the tea-house when the story of his son's theft was being told.

This beautiful print is thought to be the only surviving impression of the subject, and as it was unknown to the authors of the Vignier-Inada Catalogue and to Rumpf, it has not been described or reproduced hitherto.

Hosoye. Yellow ground. Signed: Tōshūsai Sharaku.

The Art Institute of Chicago (Buckingham Collection).

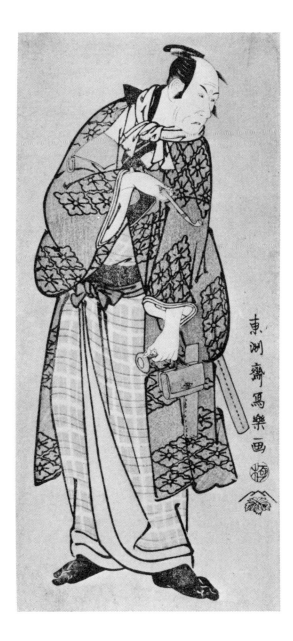

64

Nakajima Wadayemon as Tambaya Hachiyemon, one of Chūbei's clients from whom he had stolen money, telling the story of the theft.

We owe the identification to the documents in Boston; and we might add that the papers visible in the picture are those which prove Chūbei's guilt.

This print seems to have formed the central sheet of a triptych with number 65 at its right. The left-hand sheet probably showed another female figure, but may possibly have been the portrait of Magoyemon which we have placed separately as number 63.

The impression here reproduced is rephotographed from the Vignier-Inada Catalogue, number 311, as Rumpf rephotographed it for his number 60, and as others have done. It was once in the Mutiaux Collection in Paris. Its present location is unknown. The coloring has not been described.

Hosoye. Yellow ground. Signed: Tōshūsai Sharaku.

65

Matsumoto Yonesaburō as O-Tsuyu, a waitress in a tea-house.

We place this print with the one that precedes it as the right-hand sheet of a triptych, the left end of which is lost or not definitely identified.

Neither of the two recorded impressions is in America and we have rephotographed from Kurth, as Noguchi did, the one in the Kunstgewerbemuseum of Berlin which Benesch reproduces in color, showing a black obi and neckpiece over a brick red outer kimono above which is a yellow apron patterned in white. The yellow of the under kimono and of the stand carried by the girl is of a different tone from those used in the apron and for the background of the print. The other known impression is in poor condition but is reproduced in the Vignier-Inada Catalogue, number 310, as Rumpf number 78, and by Nakata.

Hosoye. Yellow ground. Signed: Tōshūsai Sharaku.

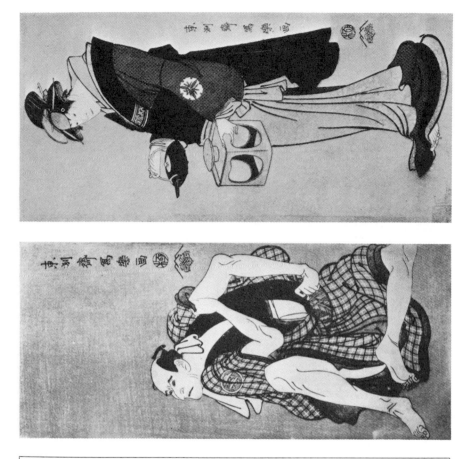

66

Ichikawa Komazō II as Kameya Chūbei, the hero of the play, and Naka-yama Tomisaburō as Umegawa, the heroine.

Number 62 shows Umegawa with Chūbei's father. Here we have her with Chūbei himself as they go out in the night to begin their flight to the village in which the tragic story ends.

Both outer kimono are violet above rose under garments. The woman's obi and the man's sash and collar are black. The umbrella is yellow and there are touches of that color elsewhere.

This is one of the rarest as well as one of the finest of Sharaku's great series of prints which depict two figures at full length against a ground of mica which in the other subjects is white but here is dark because the action represented took place at night. We can only regret that whatever the cause may have been, there are no more of these superb designs; and it is to be regretted to an almost equal extent that each of the seven subjects which do exist is so excessively rare. Only one other original impression of this print is to be found in all the collections of America, and the only one that has been reproduced hitherto is rephotographed in Rumpf number 31 and elsewhere from the Vignier-Inada Catalogue, number 331. There are at least two rather good modern reprints.

Ōban. Dark mica ground. Signed: Tōshūsai Sharaku.

Museum of Fine Arts (Spaulding Collection).

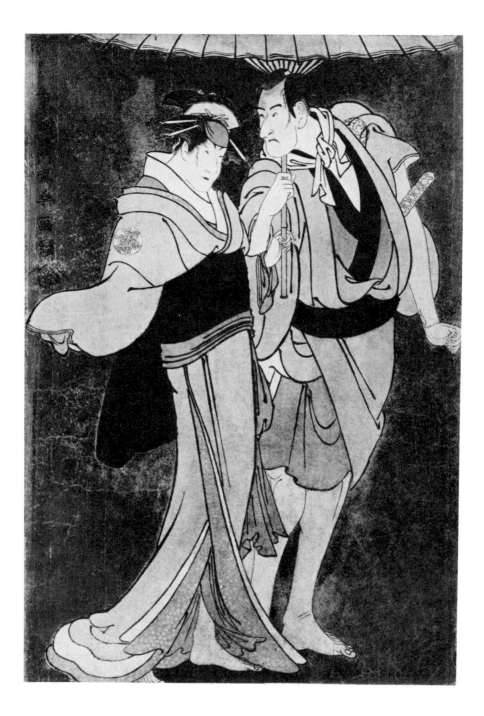

Matsu Wa Misao Onna Kusunoki

OR

STEADFAST AS A PINE TREE IS A WOMAN

OF THE KUSUNOKI,

WITH VARIOUS EPISODES SUCH AS

KAGURAZUKI IWAI NO IROGINU

OR

THE COLORED FESTIVAL CLOAK OF THE

SACRED MUSIC MONTH

(I.E., ELEVENTH MONTH)

AND A *shibaraku* SUBJECT FROM THE SAME PRODUCTION.

KAWARAZAKI-ZA, ELEVENTH MONTH OF 1794

NUMBERS 67 TO 80

OUTLINE OF THE PLOT

The text of this play, or series of loosely connected episodes, is not known to have survived, but as we have a list of the characters portrayed by the various actors who took part in the production, and as a number of these are well known celebrities of the fourteenth century, we can say something about them. Furthermore an old play-bill gives a general outline of at least one thread of the action. The episodes presumably were fanciful and freshly composed as well as strung together for the occasion.

The part of the plot which can be learned from the *banzuke,* was that when the design of Ashikaga Takauji to put a rival emperor on the throne was discovered by Shinozuka Gorō Sadatsuna, who is represented in the print that follows, the loyalist general Nitta Yoshisada disguised himself as a court gardener and, after disguising two loyal women as his assistants, went secretly on guard in the palace grounds. This scene is shown in numbers 70 to 72.

Hata Rokurōzayemon, who is Yoshisada's retainer, assumes a different name and through the "go-between" O-Roku arranges to marry Sakurai, the sister of Kusunoki Masashige, who is posing as the country girl O-Toma. At this point, however, Ōyamada Tarō who is in league with the disloyal plotters, appears and with the aid of a supposed landlord tries to marry the same girl. These two men seem to have been Ashikaga spies who were attempting to kill Yoshisada, but the faithful Rokurō-zayemon disposes of Ōyamada Tarō, the villain; the palace of the Emperor is saved from attack, and once again virtue is triumphant. The five characters in the part of the action which we have just described are represented in the pentaptych, numbers 73 to 77.

Nitta Yoshisada was the father of Nitta Yoshioki, some of whose adventures, historical and legendary, we have recounted in the outline of the action of SHINREI YAGUCHI NO WATASHI.

Yoshida no Kaneyoshi, who is better known as Kenkō Hōshi, was a person of considerable social and literary prominence whose compilation of original observations and maxims, *Tsurezura-gusa,* is one of the most famous and enduring books in Japanese literature. Among his reflexions is one which seems apposite: "Lovers who wish to meet and are prevented from doing so often are happier than those who do meet." In the Kabuki theater Kaneyoshi's younger sister, Chihaya, is represented as loved by Kusunoki Masashige, whose family name became because of him a symbol of loyalty, so that the phrase "female Kusunoki" was equivalent to "loyal women." Some part of the action of the present play seems to have had to do with the wanderings of Chihaya in search of Masashige. Sharaku's portrait of her is number 70. Sakurai, the sister of Masashige, was played by the same actor and she is shown in numbers 75, 78 and 79.

We might add that in addition to the rôles depicted here it is known that Matsumoto Kōshirō played the parts of Masashige and of Bingo Saburō, and that the part of Ashikaga Takauji was taken by Onoye Matsusuke.

67

Ichikawa Komazō II in a *shibaraku* interlude, as Shinozuka Gorō Sadatsuna, the discoverer of the plot against the Emperor.

The actor wears the brick-red outer robe with the Ichikawa *mon* in white which was traditional, as was the make-up of the face, for *shibaraku* rôles. The other parts of the costume are black, orange, yellow and green.

As there are at least three known impressions of this print with the Sharaku signature, and none has been found signed differently, the design must be by the artist whose work we are cataloguing; but the fact should be recorded that Rumpf is not alone in thinking that the drawing resembles the work of Toyokuni.

The subject is reproduced as Rumpf number 130 from Kurth's *Geschichte des japanischen Holzschnittes,* and not elsewhere.

One further note must be made: None of the other surviving prints by Sharaku that have to do with this play and are in hosoye form has a yellow ground. A *shibaraku* rôle, however, is apt to be shown alone and unrelated.

Hosoye. Yellow ground. Signed: Tōshūsai Sharaku.

Museum of Fine Arts (Spaulding Collection).

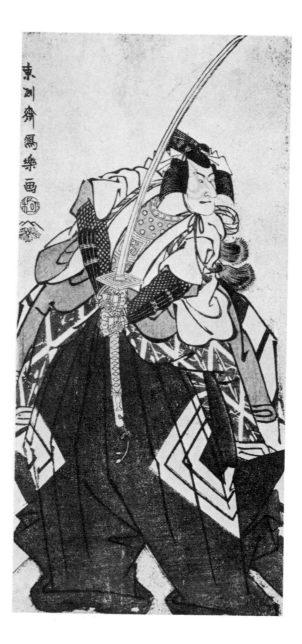

68

Onoye Matsusuke I as the Namazu-bōzu (catfish priest) Magoroku Nyūdō.

This is the second print that we have been able to add to the previously known works of Sharaku. It is the left-hand sheet of a diptych representing an interpolated dance performed by Matsusuke who is shown here, and Hanshirō who appears opposite to him in the following number. The account of this dance in the contemporary *Yakusha Ninsō Kagami* states that Matsusuke was particularly amusing in it.

The white rats in the costume are on yellow tiles. The rice bales are yellow and black. The bottle is yellow. The other colors have faded but the ground of the over-mantle seems once to have been purple with the under garments in tones of rose and pink.

We would note that this print is the first to be catalogued of those in which the background is neither yellow nor gray but is the natural tone of the paper, and without decoration.

Hosoye. Untinted ground. Signed: Tōshūsai Sharaku.

Museum of Fine Arts (Bigelow Collection).

69

Iwai Hanshirō IV as O-Hina (Miss Doll), bearing a pilgrim's hat and staff.

In order to dance opposite Matsusuke, who was garbed as a priest in an interpolated *jōruri* episode, Hanshirō has here assumed temporarily some of the attributes of a pilgrim. The description of this dance quoted under the preceding number from the *Yakusha Ninsō Kagami* enables

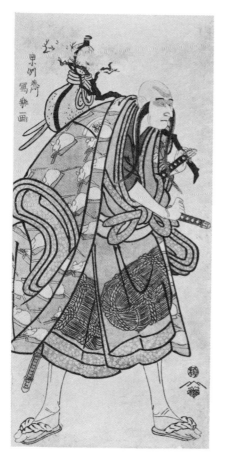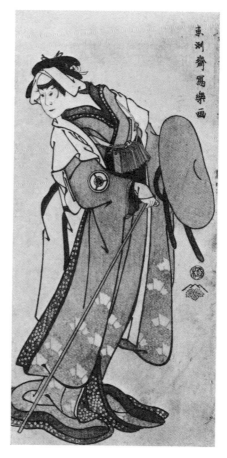

us at last to identify definitely a subject that has long been in dispute. The print is the right-hand sheet of a diptych.

The costume is faded violet over rose and white, with a black obi. The hat, staff, etc. are in bright yellow.

There are two impressions of the subject in America.

A considerably trimmed one is reproduced in the Vignier-Inada Catalogue, number 324, from which it was rephotographed for Rumpf's number 92 and by Noguchi.

Hosoye. Untinted ground. Signed: Tōshūsai Sharaku.

Museum of Fine Arts (Spaulding Collection).

70

Iwai Hanshirō IV as Chihaya, the younger sister of Kaneyoshi and a loyalist, here disguised as an assistant in the palace gardens.

This print and the next two represent a scene from the *jōruri* episode KAGURAZUKI IWAI NO IROGINU. They form a triptych and are the first in which Sharaku has used any decorative accessories, such as branches or curtains, in the background.

The colors in the print have faded and changed with time, but the outer kimono once was purple below an over-mantle of white and bore a design of yellow iris. The obi is yellow with medallions in black. The under kimono now is a dull rose.

Hanshirō must have been especially admired in this performance, or, perhaps, was expected to be, for we have five portraits of him in it by Sharaku and a very notable one by Toyokuni.

There are two impressions in America. Another is reproduced in the Vignier-Inada Catalogue, number 291, by Rumpf number 96 and elsewhere.

Hosoye. Untinted ground with decoration of maple leaves. Signed Tōshūsai Sharaku.

Museum of Fine Arts (Bigelow Collection).

71

Ichikawa Komazō II as the loyalist general Nitta Yoshisada disguised as a court gardener.

There are no impressions in America of the middle and right-hand sheets of this triptych, and we have been obliged to rephotograph the print now being discussed from the Vignier-Inada Catalogue, number 291, as

Rumpf did for his number 97, and as Noguchi has done. The coloring has not been described.

Hosoye. Untinted ground with decoration of maple leaves. Signed: Tō-shūsai Sharaku.

72

Osagawa Tsuneyo II as Kojima, the wife of Bingo Saburō, disguised as an assistant gardener.

This is the right-hand sheet of the triptych and it should be noted that the publisher's seals on the three show marked differences in size and drawing.

As in the case of the preceding number we have rephotographed the only recorded impression from the Vignier-Inada Catalogue, number 291, as Rumpf did for his number 98, and as Noguchi has done. The coloring has not been described.

Hosoye. Untinted ground with decoration of maple leaves. Signed: Tō-shūsai Sharaku.

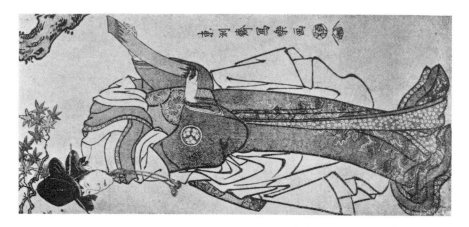

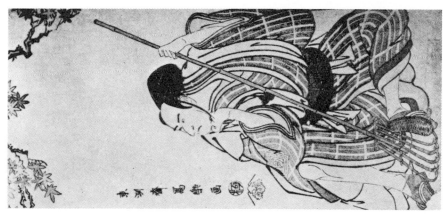

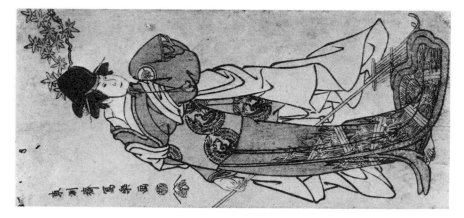

This catalogue lists the prints of Sharaku in the closest approximation to an exact chronological sequence that present knowledge permits, and it is interesting to observe that while all those described thus far have borne the signature "Tōshūsai Sharaku," all that follow are signed merely "Sharaku."

73

Nakajima Wadayemon as Migawari no Daizō, or Daizō the Substitute.

This print and the four that follow it form a pentaptych in which this is the left-hand sheet.

The *haori* and *tabi* are red-brown; the kimono is faded pale blue with lines of black crossed with fine white lines which are almost invisible now and a lining of faded rose. The trousers are faded pale blue and the sash faded rose.

An inscribed impression of the print is reproduced in the Vignier-Inada Catalogue, number 298, and rephotographed as Rumpf number 123 and by Noguchi. Kurth uses a different one which is used again by Nakata. Both are in America. We have chosen the one that Kurth rephotographed from the two-volume Barboutau Catalogue, in spite of its stains, because the other is somewhat trimmed, and less fine in color.

Hosoye. Ground filled with design. Signed: Sharaku.

The Art Institute of Chicago (Buckingham Collection).

74

Matsumoto Kōshirō IV as the loyal retainer Hata Rokurōzayemon disguised as a bridegroom carrying dried fish and other things to eat at the wedding, and pretending to be Minagawa Shinzayemon.

His kimono is in two shades of red-brown and his *kamishimo* is a faded blue with white dots.

This is the second sheet of a five-sheet set, the other numbers of which precede and follow it.

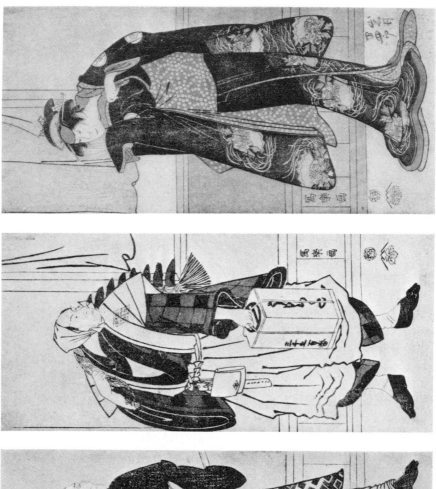
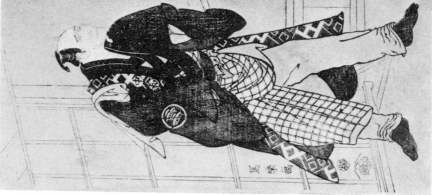

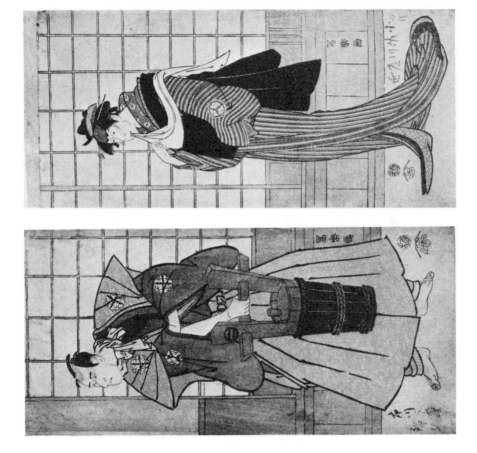

The Vignier-Inada Catalogue, number 299, Rumpf number 124, and Noguchi reproduce a much inscribed impression which gives the past names of the actor and includes one that he did not take until 1801, seven years after the print was issued. Kurth and Nakata rephotograph one from the Barboutau Catalogue. There are two impressions in America.

Hosoye. Ground filled with design. Signed: Sharaku.

Portland Art Museum (Mary Andrews Ladd Collection).

75

Iwai Hanshirō IV as Sakurai, the sister of Masashige, disguised as the country girl O-Toma.

In describing the scene represented in this set the *Yakusha Ninsō Kagami* refers to Hanshirō's fine affectation of embarrassment at the appearance of two bridegrooms. One of these is shown in the preceding print and one in the print that follows.

In print number 70 we saw Hanshirō as Chihaya disguised as a woman gardener, and in numbers 78 and 79 we shall see him again in the rôle of Sakurai.

Here his kimono is of an intense black, shading to thin black in the lower part of the skirt and sleeves, with a pattern of yellow fans and peonies in rose and green, and touches of faded blue at the hem. The under kimono is rose and the obi and head-cloth are violet.

The impression we reproduce is the only one that has been recorded and it bears an inscription giving the name of the actor.

The print is the central sheet of a pentaptych.

It has been reproduced previously in the large Moslé Catalogue, plate 181, as Rumpf number 125, and by Kurth, Nakata and Noguchi. The subject was unknown to the compilers of the Vignier-Inada Catalogue.

Hosoye. Ground filled with design. Signed: Sharaku.

The Art Institute of Chicago (Buckingham Collection).

76

Ichikawa Komazō II as Ōyamada Tarō disguised as a bridegroom carrying saké to be drunk at his wedding. In other episodes of this production we have seen Komazō as Nitta Yoshisada disguised as a gardener and as Shinozuka Gorō Sadatsuna. Here he is the villain of the piece.

The coloring of the costume has changed mainly to tones of gray, but perhaps originally was at least partly in blue with the touches of white that still remain. The bucket carried by the actor is black in its lower portion and pink above.

The print is the fourth sheet of a pentaptych.

The impression we exhibit bears an inscription giving the name of the actor. It was reproduced in the Vignier-Inada Catalogue, number 298, and rephotographed for Rumpf number 126, and by Noguchi.

Hosoye. Ground filled with design. Signed: Sharaku.

Fuller Collection.

77

Osagawa Tsuneyo II as the hairdresser O-Roku, possibly a disguise of Kojima, the wife of Bingo Saburō, whom we have seen differently disguised in number 72. Here the rôle is that of a "go-between" arranging a marriage.

The outer kimono now is in a gray and white stripe. The rose of the under kimono has faded to dull pink. The collar still is clear purple with white lozenges.

This print is placed as the right-hand sheet of the five-sheet set we have been listing.

It bears an inscription giving the name of the actor and has been reproduced in the Vignier-Inada Catalogue, number 298, as Rumpf number 127, and by Nakata and Noguchi.

Hosoye. Ground filled with design. Signed: Sharaku.

Fuller Collection.

78

Iwai Hanshirō IV not here in the rôle of Chihaya, younger sister of Kaneyoshi, in which he appears in number 70, but as in number 75 playing the part of Masashige's sister Sakurai.

This attribution is based on the fact that Toyokuni in his famous series of actor portraits called "Yakusha Butai no Sugata-ye" shows Hanshirō in the same pose, with the same hood and the same dark background in the upper half. As the prints are approximately of the same date, the same rôle undoubtedly is depicted. The Toyokuni print differs from this one in that the design on the skirt of the kimono is the "Kiku-sui"— chrysanthemums over water—which was the crest of the Kusunoki family to which Sakurai belonged.

The color of the costume has been described merely as having the hood in black and the kimono in green.

The only known impression appears as plate 14a in Kurth's *Geschichte des japanischen Holzschnittes* and is rephotographed from that as Rumpf number 129, and by Noguchi from whom we have rephotographed it.

Hosoye. Gray ground oxidized. Signed: Sharaku.

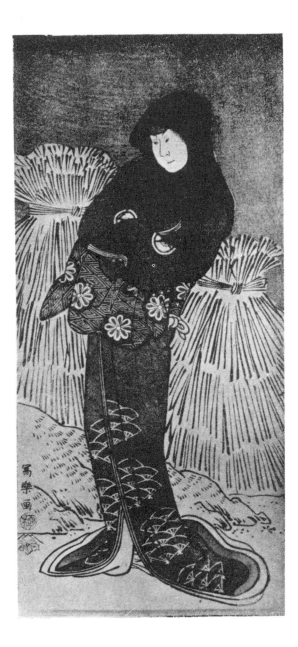

79

\mathbf{A}gain we have a portrait of Iwai Hanshirō IV, but now disguised as a peasant girl. It is probable that the rôle is that of Sakurai, as in numbers 75 and 78, but this may be one of the disguises of Chihaya who is portrayed in number 70. Hanshirō played both parts and the available records throw no light on which of the two is represented here.

Here his outer kimono is in stripes of brick red and yellow with fine orange lines. The black collar is coated with lacquer. The obi and under collar are rose with white reserve. The under garment is deep rose, the head cloth is violet, now somewhat faded, and the comb is white with yellow teeth.

This is the first to be catalogued here of the series of bust-portraits on yellow grounds which Sharaku began to issue about the time when the edict against mica ground prints went into effect. Upholders of the legend to which reference was made in our introduction, call attention to the tameness and lack of exaggeration in these prints as compared with the bust-portraits on dark mica grounds with which Sharaku has conquered posterity, even if he did not captivate his contemporaries. On all of the yellow-ground bust-portraits the house names and poetry names of the actors are given in cartouches with the appropriate personal *mon* above, and in this case Hanshirō is described as Yamatoya Tozaku.

The subject now under discussion is the only one of the set not known to the compilers of the Vignier-Inada Catalogue and the only previous reproduction of it is rephotographed as Rumpf number 49 from a Japanese periodical. There is no other impression in America.

Aiban. Yellow ground. Signed: Sharaku.

The Art Institute of Chicago (Buckingham Collection).

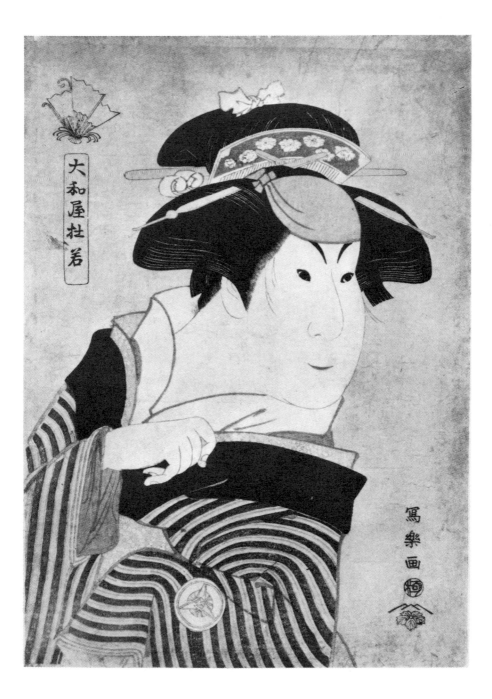

8o

Ichikawa Komazō II as Ōyamada Tarō, the same part as that in which he is shown in Number 76.

In the cartouche below the personal *mon* of the actor are his house and poetry names Kōraiya and Kinshō.

The coloring of the kimono is now a fading violet. The under robe is rose, with a sleeve lining of yellow-green. The coloring of the tonsure has now decomposed, but originally was light blue.

There has been some doubt as to the proper attribution of the print, but in our opinion the question is settled by the peculiar and distinctive hair arrangement which also appears in the other portrait of Ōyamada Tarō referred to above.

There is no other impression in America, but another has been reproduced in the Vignier-Inada Catalogue, number 253, and as Rumpf number 51.

Aiban. Yellow ground. Signed: Sharaku.

The Art Institute of Chicago (Buckingham Collection).

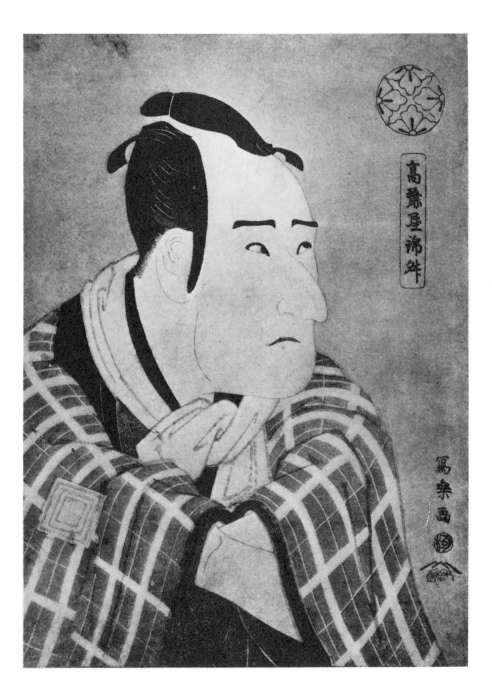

Otokoyama O Edo No Ishizue

OR

MOUNT OTOKO, THE FOUNDATION STONE

OF GREAT EDO

INCLUDING THE *tokiwazu jōruri* EPISODE

SHINOBU KOI SUZUME IRO TOKI

OR

SECRET LOVE WHEN THE SPARROWS MATE,

THE SHOSA, TSUKAIJISHI

OR

LION DANCE

AND A *shibaraku* SCENE

KIRI-ZA, ELEVENTH MONTH OF 1794

NUMBERS 81 TO 101

OUTLINE OF THE PLOT

Many of the heroes of the *Kabuki* stage had taken actual parts in the mediaeval wars of Japan, but successive generations had embroidered the historical narratives of their lives with purely legendary exploits until their stories became, like those of Roland and the other Paladins of Occidental story, embellished with an accretion of entirely fanciful events.

Minamoto no Yoshiiye, the hero of the present play, was an eleventh century general who in his youth conducted against the rebellious Abe clan of Northern Japan a series of campaigns in which he distinguished himself through skill and bravery. He was known as Hachimantarō, which has the implications of The War-God Boy. In these campaigns the Minamoto, at least in theory, were defending the Emperor, and this fact combined with Yoshiiye's personal qualities and his known gener-

osity to his troops to make his side in popular imagination that of the hero, while all those connected with his opponents, the Abe, were correspondingly thought of as villains. The play is constructed about episodes which probably had little or no basis in fact.

The main action represented in the prints that follow centers around Abe no Sadatō's attempt to murder Yoshiiye by coming in the disguise of an envoy. Yoshiiye is saved because his place has been taken voluntarily by Gengō Narishige, a formerly disgraced retainer who had been living as a fisherman and calling himself Sazanami Tatsugorō, and whose wife —to add to the complication—was Abe no Sadatō's sister.

We present first the hero, Yoshiiye.

81

Ichikawa Yaozō III as Hachimantarō Yoshiiye. In the cartouche below his personal *mon* are written his house name, Tachibanaya, and his poetry name, Chūsha.

His outer kimono is patterned in light violet and white with green medallions. The under kimono is rose and the white collars show edges of faded light blue—a tone that appears again in the tonsure. The fastener of the head-dress is light violet. There are touches of rose around the eyes, in the ears and on the lips.

The actual deeds of Yoshiiye are justly famous, but his legendary exploits, like those recounted in this melodrama, give him an even more enduring fame. The mere twang of his terrible bow sent frightened demons scuttling away to safer places; and as he became one of the stock characters of the popular theatre the print-makers loved to show him in poses that would suggest his prowess.

Here he is represented in a comparatively inactive moment, garbed in the stage dress appropriate to his high social position and with the hair arrangement traditional for young men of the nobility, which we see again in the following number.

No other impression of the print is known to be in existence. This one is reproduced in the Vignier-Inada Catalogue, number 254, and as Rumpf number 50.

Aiban. Yellow ground. Signed: Sharaku.

The Art Institute of Chicago (Buckingham Collection).

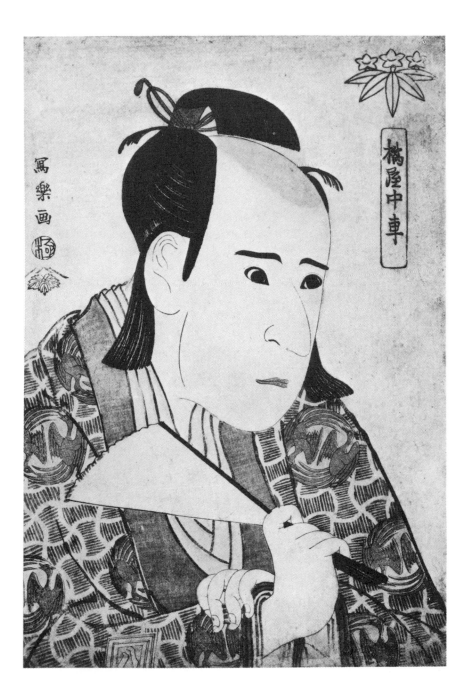

82

Ichikawa Yaozō III as the false Yoshiiye, who is murdered by Abe no Sadatō. After the body had been removed Yaozō made a reappearance in the part of the real Yoshiiye, announcing: "The man you have killed is not I, but one who has been known as Sazanami Tatsugorō, a fisherman. His real name is Gengō Narishige, and he died to save me."

The outer kimono is violet with patterns in yellow and white and is lined with pale rose. The under kimono is red with a white pattern. The other under garments and the fan are white. The obi is greenish yellow. The sword fittings and the lattice above are yellow against white.

This print may at one time have formed the central part of a triptych, with number 83 on the right and another which has not survived on the left. It is the only known impression and was rephotographed by Rumpf for his number 107 from a Tokyo catalogue.

Hosoye. Yellow ground. Signed: Sharaku.

Metropolitan Museum of Art (Mansfield Collection).

83

Ichikawa Ebizō IV as Abe no Sadatō, but not in the same disguise as that in which he appears in the following print, for here he is pretending to be Kamakura no Gondayū Kagenari, an envoy to Yoshiiye. According to the account in the *Kabuki Nendaiki,* Sadatō seizes this opportunity and tries to kill his host, believing him to be the person shown in the companion piece, number 82. We place this print as the right-hand sheet of a triptych, only two parts of which have survived.

The sleeves of the costume still are in moss green at the top with a pattern in rose and white against the gray-green of the lower portions, but the *kamishimo* and the trousers have faded and show now mainly as mottled oyster-white. The sword remains in clear rose.

The contemporary *Yakusha Ninsō Kagami,* "The Mirror of Actors' Faces," describes Ebizō's dress on this occasion and goes on to say that when he made his entrance as the false envoy he was unsurpassable. As a matter of fact Ebizō was particularly good at playing the villain, and the print now under discussion should be compared with Sharaku's more famous portrait of the same actor in a somewhat similar rôle, number 16. It might also be noted that the hair arrangement with the horizontal wings of the *ende kazura* was traditional on the stage for the characterizations of plotting noblemen.

The print we exhibit is the only impression that is known to exist, and we would pause a moment to tell something of its recent history. When Kurth reproduced it and it was rephotographed by Nakata and as Rumpf number 106, it was in the collection of the Kunsthalle of Bremen and was heavily oxidized as may be seen in all three reproductions. In November 1922 it was reproduced still oxidized, in the catalogue of prints from the Bremen Museum that were to be sold at the Walpole Galleries in New York, and at that sale it passed into the collection of the late Arthur B. Duel, a surgeon with very deft hands whose skill was turned in moments of leisure to the cleaning of his prints with the result that we see here.

Hosoye. Yellow ground discolored by cleaning. Signed: Sharaku.

Fogg Art Museum (Duel Collection).

84

Ichikawa Ebizō IV again as Abe no Sadatō, the villain of the piece, but in a different disguise from that in which we saw him in the preceding print, for here he is shown disguised as Ryōzan, supposedly a peaceful pilgrim. On the portable shrine at his back is written "Nippon Kaikoku Shugyō Rokujū-roku . ." indicating a country-wide pilgrimage in which the principal temple in each of the 66 provinces is visited. He is grasping a *shaku-jō* or mercy-staff with rings that jingle so that insects will get out of his path and not be trodden on. It is against the law of Buddha to take the life of even the least of sentient beings, but in this case the mercy-staff, like the pilgrim who holds it, is a sham for it contains a sword.

The shrine is in black and greenish yellow. The actor wears a gray outer kimono, an under kimono of greenish yellow, and a rose-colored girdle. His collar is in rose and black.

This print may have been designed as the right-hand sheet of a triptych, the other two sheets of which have been lost.

The subject has been reproduced from a badly trimmed impression in the Vignier-Inada Catalogue, number 321, from which it was rephotographed by Noguchi as well as for Rumpf number 84. There are three impressions in America.

The seal of Tsutaya, the publisher, is in the smaller and less usual form which appears also in numbers 88 and 89. Probably this form of the seal indicates the work of some special block-cutter.

Hosoye. Untinted ground. Signed: Sharaku.

Museum of Fine Arts (Bigelow Collection).

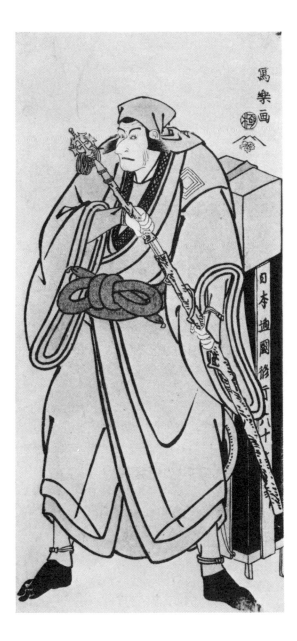

85

Nakayama Tomisaburō as O-Hide, sister of Abe no Sadatō, and wife of Gengō Narishige who was killed by him and who is shown in number 82.

In the cartouche below the actor's personal *mon* are his house and poetry names, Ōmiya and Kinsha.

Here he is dressed in an outer kimono of light and dark violet stripes and a black collar coated with lacquer. The under kimono is strong rose with a white collar mica-coated. The obi is light blue and the *mon* on the towel is white on blue. The covering of the tonsure is printed in violet. The lips are touched with rose. The comb is mainly in white with yellow teeth.

It should be noted that Herr Rumpf has suggested that the rôle depicted is that of Goyemon's wife in the play TOKIWA IMA KURUWA NO HANA-MICHI, which was performed at the Kiri-za in the third month of 1795. As far as can be told from the print itself it might depict either rôle, but we are placing it here because we can find no other print that we think should be attributed to the later play and because the outer kimono shown in it resembles in pattern and in color that which Tomisaburō is wearing in the following print which certainly has to do with the production now under discussion.

Another impression, much trimmed, has been reproduced as Rumpf number 47, and in the Vignier-Inada Catalogue, number 252. There is one other in America.

Aiban. Yellow ground. Signed: Sharaku.

The Art Institute of Chicago (Buckingham Collection).

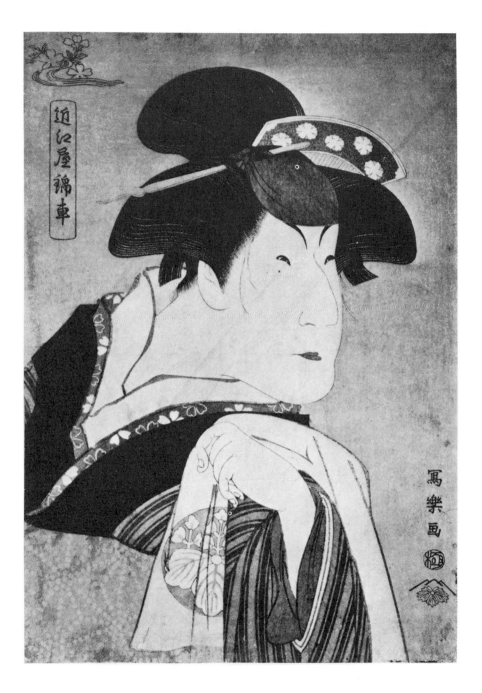

86

Nakayama Tomisaburō as O-Hide, sister of Abe no Sadatō and wife of Gengō Narishige, the same rôle as that of number 85.

The outer kimono is white with stripes of faded violet. The under ki-mono is dull rose, the obi black. The straw rain-coat is in pale yellow, as is the foreground.

This print and the next are two of the subjects which we have the good fortune to add to the previously known works of Sharaku. They form the central and right-hand sheets of a triptych, the left-hand sheet of which has failed to survive even in a single impression.

The print now being considered came into the Doucet Collection in time to be mentioned in a footnote of the Vignier-Inada Catalogue, but too late to be exhibited or reproduced. Rumpf records it from that note under his number 134, as a print of which he had heard but which he could not describe or reproduce. The seal of the Doucet Collection identifies the impression we show as the same one, and apparently there is no other.

Hosoye. Gray ground. Signed: Sharaku.

Fuller Collection.

87

Morita Kanya VIII as Kawachi Kanja, disguised as Genkaibō, (Ajari Genkai), and acting as a spy.

On the post is written "Inasegawa" which is the name of the river shown in the background. The scene has to do with a struggle for the possession of a seal that had been hidden in or near Inamura-ga-saki and that the actor here is holding in his mouth.

Kanya is wearing a gray kimono under a tattered over-robe of black. The

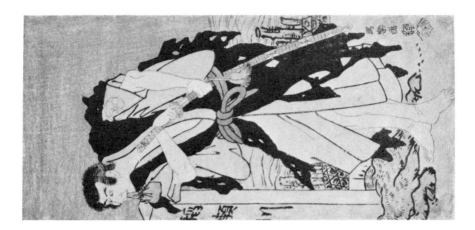

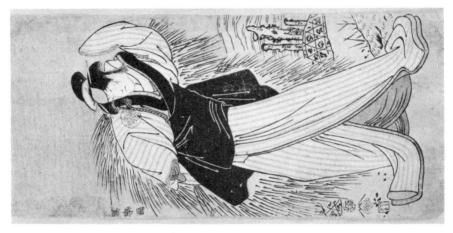

scabbard of his sword, his waist-band, and the bundle he is holding in his mouth are of varying tones of red-orange. The post and foreground are in tones of yellow and the river probably once was in that peculiarly evanescent blue which so seldom remains unchanged.

This design by Sharaku has been entirely unrecorded hitherto, and no other impression of it is known. On the back of the print there is a collector's seal reading Hō Sū Kaku. We reproduce it with number 86 as part of a triptych, the left-hand sheet of which does not appear to have survived.

Hosoye. Gray ground. Signed: Sharaku.

Ledoux Collection.

88

Sakata Hangorō III as Abe no Munetō, brother of the chief villain of the piece Abe no Sadatō. As here shown he is standing in the snow and is disguised, probably as the packman *(umakata)* Abumizuri Iwazō.

He is dressed in red-brown with an under garment, now faded, which was once pale rose with a pale blue collar. His hat and the fringe on his apron are orange, and his body is a pale flesh color.

This print is the left-hand sheet of a triptych of which number 89 is the center. The right-hand sheet is unknown. Both prints that have survived have the small simplified form of the Tsutaya leaf-seal, also found on number 84.

The subject has not been reproduced in any Occidental books except as Rumpf number 86, where it seems to have been rephotographed from Inouye Kazuo, and does not show the snow covered ground. The impression we exhibit is the only one in America.

Hosoye. Gray ground. Signed: Sharaku.

The Art Institute of Chicago (Buckingham Collection).

89

Yamashita Kinsaku II as the *okujochū* (lady-in-waiting in a noble family) Tsumaki, in a snow storm.

Apparently this is one of the disguises of Abe no Sadatō's wife Iwate, but the account in the *Kabuki Nendaiki,* here our main source of information, is not clear on this point. It does, however, mention the snow scene. For other portraits of Iwate see numbers 90 and 91.

221

Now the outer garment is in faded violet. The obi is brocaded on a green ground with a design in yellow, rose, green, black and white. There are touches of rose elsewhere. The umbrella is yellow and black.

We place the print next to number 88 as the central sheet of a triptych the right-hand sheet of which has not survived.

The subject has been reproduced from one impression in the Vignier-Inada Catalogue, number 318, Rumpf number 87, and by Noguchi. The one we exhibit is the only one in America.

Hosoye. Gray ground. Signed: Sharaku.

Museum of Fine Arts (Spaulding Collection).

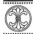 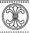
90

Yamashita Kinsaku II as Iwate, the wife of Abe no Sadatō, here disguised probably as the *nakai,* or maid, O-Kane.

The actor's house and poetry names as given under his private *mon* in the cartouche are: Tennōjiya and Rikō.

For other portraits of Kinsaku in this play see numbers 89 and 91.

In this print he wears a kimono and tonsure covering of light violet. His under kimono is rose and white. The collar is coated with mica. The comb is in soft yellow and there are touches of rose at the corners of the eyes.

The slightly trimmed impression reproduced in the Vignier-Inada Catalogue, number 256, appears again as Rumpf's number 46. Kurth and Nakata use a different one. There are three in American collections.

Aiban. Yellow ground. Signed: Sharaku.

The Art Institute of Chicago. (Buckingham Collection).

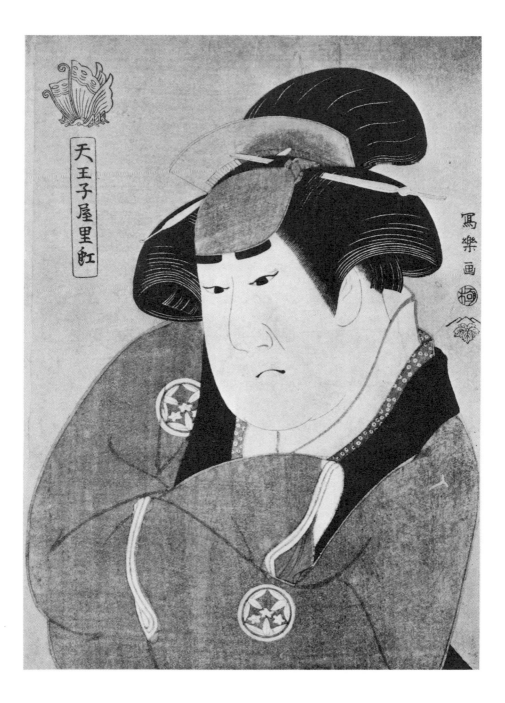

91

Yamashita Kinsaku II as Iwate, the wife of Abe no Sadatō, but probably in one of her disguises. See numbers 89 and 90.

The tree under which the actor kneels is printed in yellow with blossoms in clear rose. His under kimono is in clear rose with a design in white. The outer kimono, where plain, is in dark green, and the patterns in its lower part are in yellow, rose and white. The obi is black with a pattern in yellow, red and light green. The comb is yellow and the covering of the tonsure red.

The print bears a hand-written inscription giving the name of the actor. It is somewhat trimmed, but is the only known impression and has been reproduced as Rumpf number 102 as well as by Kurth and Nakata. It looks as though it might once have been part of a triptych.

Hosoye. Untinted ground with decoration of plum tree. Signed: Sharaku.

Metropolitan Museum of Art (Church Collection).

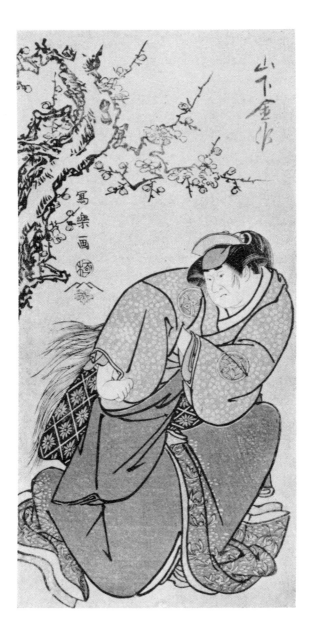

92

Ichikawa Yaozō III as Saegi Kurandō.

The coloring and costume design are: kimono, rose; *kamishimo,* light lilac with white *manji* pattern and peony medallions with flowers in rose with green stems against a yellow ground; sword hilt blue; *tabi* yellow.

The records are not complete enough to allow us to determine whether this is a separate part or a disguise adopted by Yoshiiye. It is of interest, however, that the *Kabuki Nendaiki* mentions Yaozō five times in connection with the performance of OTOKOYAMA O EDO NO ISHIZUE. He is spoken of once in this part, once as the real Yoshiiye, once as the false Yoshiiye, once as Sanekata in the episode SHINOBU KOI SUSUME IRO TOKI, and once as having taken part in a *shosa* or dance interlude. We are fortunate in having prints by Sharaku showing him in all these rôles. The others are numbers 81, 82, 96, and 101.

This is another of the prints that we are able to add to the previously known works of Sharaku. It has a hand-written inscription in calligraphy that we shall soon see again in numbers 94 and 95, and that in the present instance gives the name of the actor with a note that he later called himself Takasuke, a name that he took ten or fifteen years after the date of the production. The three other sheets of the pentaptych of which numbers 94 and 95 form a part, exist with inscriptions in the same hand, but different impressions of them are shown here. Comparison of the calligraphy discussed in connection with the history of numbers 100 and 101 is invited.

Hosoye. Untinted ground. Signed: Sharaku.

The Art Institute of Chicago (Buckingham Collection).

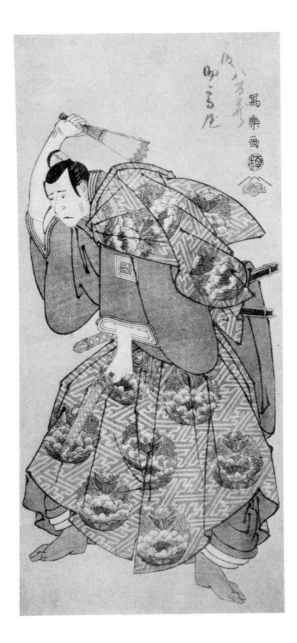

93

Ichikawa Ebizō IV as Kamakura Gongorō Kagemasa. He is here appearing in one of the *shibaraku* or "wait-a-moment!" interludes which were traditionally associated with the Ichikawa actors.

Ebizō also appeared in the main play as Abe no Sadatō (numbers 83 and 84) and then, when he was disguised as an envoy, he bore a somewhat similar name, Kamakura Gondayū Kagenari, which should not be confused with the name of the *shibaraku* rôle. In the present print the warrior represented was on the side of Yoshiiye and famous because of a story that when an arrow had pierced his eye during one of the fights against the Abe clan he merely broke off the shaft and leaving the barb where it was, drew his own bow and killed his man. This *shibaraku* was especially popular because it had been the first of them all—an unrehearsed interpolation by Danjūrō II in the year 1714.

Here Ebizō is depicted with the make-up of the Ichikawa actors and dressed in the voluminous over-mantle of brownish-red with white *mon* which was traditional for *shibaraku* parts. Under this his costume is patterned in white on green with a red scarf. His fan is white. The scabbard of his sword is in black and faded red.

One of the two impressions of the print now in American collections was reproduced in the Vignier-Inada Catalogue, number 306, as Rumpf number 85 and by Noguchi. The other we reproduce here.

Hosoye. Untinted ground. Signed: Sharaku.

Fogg Art Museum (Duel Collection).

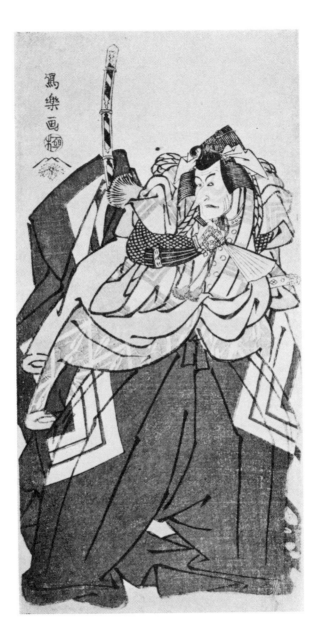

The pentaptych that follows as numbers 94 to 98 is thought to represent a scene from the *Tokiwazu jōruri* episode SHINOBU KOI SUZUME IRO TOKI, which was given with OTOKOYAMA O EDO NO ISHIZUE as part of the production with which we now are concerned.

94

Nakayama Tomisaburō as O-Fude, a cowherd.

The outer kimono is black with a design in yellow and white; the under one is in somewhat faded rose. The obi is faded violet. The tree trunk and the foreground are in yellow.

This print and the four that follow form a pentaptych.

In the dealer's advertisement printed in the first edition of Kurth's *Sharaku* the print now under discussion, which should be placed at the left end of the set, was reproduced with the four other subjects, all in impressions which were inscribed by hand. The inscription on this sheet records the name of the actor and his nickname *Gunya* (Floppy or Boneless) Tomisaburō. The only other impression that is known to exist has been reproduced as Rumpf number 108, in the large Barboutau Catalogue, by Kurth and by Nakata.

Hosoye. Untinted ground with decoration of maple leaves. Signed: Sharaku.

Museum of Fine Arts (Spaulding Collection).

95

Sakata Hangorō III as the *yakko*, Yahazu no Yatahei.

The actor is dressed in a red-brown kimono with a green lining, and a blue apron with a yellow fringe. His under kimono is in rose. His collar is striped blue and white. His tonsure is pale blue and the face and body are pale rose. The hilt and tassel of his sword are blue. His *tabi* are black.

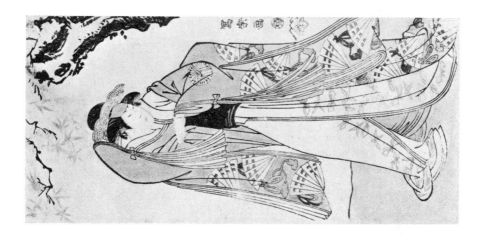

He is seen under a branch of autumn maple leaves printed in rose. The ground on which he stands and the rock behind him are in faded yellow.

This is the second sheet of a pentaptych, and as in the preceding print there is an inscription giving both the actor's professional name and his nickname Kumajū, which is an abbreviation of his personal name, Kumajūrō. On the rock at the left of this print and the right of number 94 is written in large characters the name of Sanekata, whose ghost is shown in the adjoining sheet, number 96.

There are two known impressions. The one which we reproduce appears in the Vignier-Inada Catalogue, number 300, Rumpf number 109, Noguchi and the dealer's advertisement to which we have referred so often. The other, which is wider on the left, is reproduced by Kurth and by Nakata.

Hosoye. Untinted ground with decoration of maple leaves. Signed: Sharaku.

The Art Institute of Chicago (Buckingham Collection).

96

Ichikawa Yaozō III as a birdseller, really the ghost of Chūjo Sanekata.

He wears a kimono of green and white and an under garment of faded rose. On the faded light blue sleeveless outer garment there is a design of birds in red-brown, and this tone appears again in the cap. The foreground is faded pale yellow; the maple leaves above are in faded rose.

This is the central sheet of a five-sheet set. The two that come on its left are numbers 94 and 95.

The impression illustrated in the dealer's advertisement referred to above had an inscription giving the actor's name, Yaozō, as well as a

second name, Takasuke, which he is not known to have used until at least ten years after the date of this performance. The impression we show is the only known duplicate and is the one reproduced in the Vignier-Inada Catalogue, number 297 (color plate 85), Rumpf 110, Kurth, Nakata and Noguchi.

Hosoye. Untinted ground with decoration of maple leaves. Signed: Sharaku.

The Art Institute of Chicago (Buckingham Collection).

97

Ichikawa Danjūrō VI as Mimana Yukinori, the son of Yukinari.

The outer robe is in white and faded violet with medallions in green and white. The under one is rose and white and has the medallions in white and faded violet. The sash is green and yellow. The mirror case is yellow and rose. As in the rest of the set the foreground is yellow. This is the fourth sheet in a pentaptych composed of numbers 94 to 98.

The inscribed impression in the dealer's advertisement (see number 94) is reproduced by Kurth and Nakata and as Rumpf number 111. It is signed Sharaku. The only recorded duplicate is the one we show and this has been trimmed so deeply that the signature cannot be seen.

The inscription referred to notes that the Danjūrō here represented is the sixth of his line. To avoid confusion it may be well to explain that Ebizō IV, who had won great fame as Danjūrō V, was the father of this actor. In the eleventh month of 1791 he exchanged names with his young son, then aged 15, who had previously been known as Ebizō III, and therefore during the period of Sharaku's brief productivity the father was called Ebizō IV and the son Danjūrō VI.

Hosoye. Untinted ground with decoration of maple leaves.

Museum of Fine Arts (Spaulding Collection).

98

Sakakiyama Sangorō II as Odae-Hime, the daughter of Michinaga.

The outer kimono is red and has a design of white fans with yellow, green and violet cords. The under kimono is in faded rose with patterns in violet and yellow. A red under garment is seen below. The trunk of the maple is printed in green and yellow, its leaves are in rose. The covering of the tonsure is violet. The lips are touched with rose.

This is the final sheet of a pentaptych of which the four preceding numbers are parts.

The inscribed impression (see number 94) gives the name of Fujikawa Murajirō, which probably is one used later by Sangorō the records of whose career are very meager. It is now in the Stoclet Collection of Brussels and is reproduced in the Vignier-Inada Catalogue, number 297, Rumpf number 112, and by Noguchi. Kurth and Nakata use a different one; and this is the first print in the five-sheet set of which there are two impressions in America.

Hosoye. Untinted ground with decoration of maple leaves. Signed: Sharaku.

Metropolitan Museum of Art (Mansfield Collection).

99

Ichikawa Danjūrō VI probably as Arakawa Tarō in some part of the production which included the main play named at the top of the page.

In the cartouche below the personal *mon* of the actor are his house and poetry names Naritaya and Sanshō.

The colors of the print are red-brown for the outer and green for the inner kimono, with the collars in rose. The face is marked in strong rose-red, and the fan-sticks are yellow.

The attribution given above is based on a description in the *Hyōbanki* of Danjūrō's appearance in the rôle and with the hair arrangement shown in the print. This would seem conclusive were it not for a doubt raised by the fact that the not always accurate *Kabuki Nendaiki* lists the part of Arakawa Tarō in this production as played by Ichikawa Omezō rather than Ichikawa Danjūrō. Quite possibly the actor here represented was succeeded by the other at some time during the run of the play, but it is even more likely that we have here one of the misprints from which the *Nendaiki* was by no means free.

We exhibit the only impression in America, and this bears a hand-written inscription reading: "Roku-dai-me," or "the sixth."

The one reproduced in the Vignier-Inada Catalogue, number 255, appears again as Rumpf number 53, and in Noguchi. Still a third is reproduced by Kurth and Nakata.

Aiban. Yellow ground. Signed: Sharaku.

The Art Institute of Chicago (Buckingham Collection).

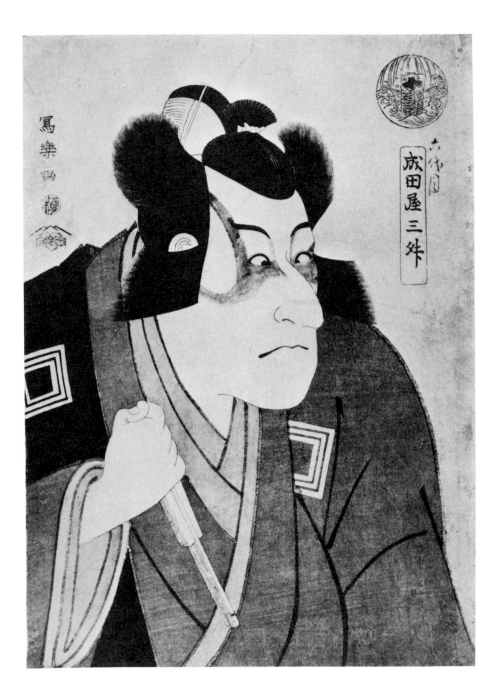

The diptych which follows records the *shosa* or pantomime-dance, TSUKAIJISHI, or KIRIKAMURO, which was performed as part of the production at the Miyako-za in the eleventh month of 1794.

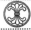

I OO

Nakayama Tomisaburō performing a lion-dance, known as a KIRIKA-MURO from the hair arrangement which shows a small bald spot on top of the head.

This is the left-hand sheet of a diptych and we will discuss the two prints together.

The hand-written inscriptions on the prints give the names of the actors, but must have been written at least ten years after publication because that about Yaozo says that later he was called Takasuke, a name which he did not take until 1804 or 1809. With the name Nakayama Tomisaburō is given his nickname "Floppy Tomi." The collection seals attached to the mount were on a backing of the left-hand sheet when that came to its present owner. The small one reads: Akino. The larger of the two is interesting because it is the collection seal of Ōta Nanpo (1749-1823) who is better known as Shokusanjin and who compiled the first book about the Ukiyo-ye School—*Zoku Ukiyo-ye Ruikō,* or "Biographical Studies of Ukiyo-ye Artists"—from the manuscript notes of Shikitei Samba which passed into his hands at some time prior to 1815. The compilation of this book is described in our prefatory essay.

The inscriptions on these two prints and on others here catalogued which came early to Germany and are reproduced by Kurth or in the advertisement at the end of the first edition of his *Sharaku,* are not in the handwriting of Ōta Nanpo (Shokusanjin) which is well known, but are supposed to have been written by Shikitei Samba from whose estate they are said to have come, and who made the notes from which Shokusanjin compiled his book. Before going to Germany the prints with these handwritten inscriptions belonged to Teranigi Kiniiji of Tokyo, and it is he who was responsible for the statement given to Rumpf that most, if not all of them, came from the estate of Shikitei Samba.

The two sheets of the diptych here exhibited were together in the Jaekel Collection in Germany when Kurth reproduced them in the first edition of his "Sharaku." They were reproduced together again in the 1922 edi-

tion of Kurth with one of them still credited to the Jaekel Collection although it had been sold to a Russian dealer, and the other to the collection of Madame Straus-Negbaur. *Ukiyo-ye Taisei* Vol. VIII, number 76, rephotographs from Kurth and shows them once more together.

Two other impressions of the left-hand sheet now are in America and one of these appears in the Vignier-Inada Catalogue, number 303, Rumpf number 94, Jacquin Catalogue, number 34, and in Noguchi.

Hosoye. Untinted ground with decoration of maple leaves. Signed: Sharaku.

Ledoux Collection.

I O I

Ichikawa Yaozō III performing a lion-dance.

The coloring in this print and number 100 is the same except for the fact that the under kimono and streamers in the left-hand sheet are orange and white, whereas here they are orange and yellow. In both the over garments are violet with decorations in green, yellow and rose; the outer kimono are rose-colored and decorated in green, yellow, violet and faded blue; the obi are violet and faded blue. The foregrounds are yellow, the tree trunk is yellow and green and the maple leaves are in faded rose.

This, the right-hand sheet of the diptych, has been discussed under the preceding number, and here we will only add that it was last reproduced as Rumpf number 95 and in the Straus-Negbaur Sale Catalogue, number 273, at which time it had been separated from the left sheet through the dispersal of the Jaekel Collection. No other impression has been recorded, but there is one other in America.

Hosoye. Untinted ground with decoration of maple leaves. Signed: Sharaku.

Ledoux Collection.

Urū Toshi Meika No Homare

OR

INTERCALARY YEAR PRAISE OF A FAMOUS POEM

INCLUDING THE SPECIAL KAOMISE SHOSAGOTO

OR ''FACE-SHOWING'' DANCE CALLED

MANZAI AND SAIZŌ

AFTER THE NAMES OF THE CHARACTERS

REPRESENTED IN IT.

MIYAKO-ZA, ELEVENTH MONTH OF 1794

NUMBERS 102 TO 115

OUTLINE OF THE PLOT

At the time when Sharaku was working, the various dramatic entities produced together usually had some thematic connection, clear or vague; and as the same characters often were represented in more than one part of a production it may be impossible to tell in which of these the actor appeared as he is shown in a print.

In the production at the Miyako-za in the eleventh month of 1794, the main theme was the rivalries in the court circles during a certain period of the ninth century and these were illustrated by the stories of the rival imperial princes Koretaka and Korehito on the one hand, and the rival poets Ono no Komachi and Ōtomo no Kuronushi on the other.

The rivalry of Koretaka and Korehito was over a question of succession to the throne, and discussion of its historical aspects would be of no interest whatever in connection with the prints, but the story of Komachi and Kuronushi should at least be given in outline here.

Ono no Komachi in her youth was the most beautiful and the most talented of all the ladies of the court. Her rank as one of the greatest poets

of Japan has never been questioned; but she is the symbol not only of beauty and of genius, but of sorrow as well, for in her later years all that had made her what she had been vanished, leaving only an old, worn woman, sick, in abject poverty and alone. Her career is imaged in seven stations which have furnished themes for the poets and painters of a thousand years, and the particular episode brought to mind by the title of this play is her quick-witted triumph over a rival poet of the court, Ōtomo no Kuronushi, who had forged evidence to show that her greatest and most acclaimed poem had not been composed by herself, and who sometimes is represented as embittered not only by professional jealousy, but also by the fact that his proffered love was scorned by the poetess.

The text of the present play does not seem to have survived, but the title indicates that it was especially composed because of the *urū* or intercalary month that was interpolated as a continuation of the eleventh month of 1794.

Our first print shows Komachi with a poem-paper in her hand.

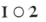

102

Nakamura Noshio II as Ono no Komachi, the heroine of beauty and of sorrow, holding a poem-paper, presumably the one to be inscribed with the verses which Ōtomo no Kuronushi tried to show that she had not composed.

This is the left-hand sheet of a triptych, with numbers 103 and 104 in the center and on the right.

There is no impression of the print in America and we have rephoto-graphed from the Vignier-Inada Catalogue, number 314, as Noguchi did. Rumpf for his number 79 rephotographed from the Catalogue of the Ritchie Sale (London 1911) an impression which was inscribed with the name of the actor. The coloring has not been described.

Hosoye. The background is recorded as untinted. Signed: Sharaku.

103

Sawamura Sōjūrō III as Ōtomo no Kuronushi, a nobleman of the court at which Komachi, who is represented in the preceding print, served, and like her famous as a poet.

In fine impressions of this subject such as the one exhibited, the dominant black of the outer robe is lightened with a superimposed pattern. The under garment bears a design of gray and white lozenges with rosettes of faded violet. The other tones in the composition are rose and yellow.

This is the central sheet of the triptych.

The Vignier-Inada Catalogue describes its impression, number 328, as on yellow ground, but reproduces it in color plate 98 with a background which apparently was untinted and so is like that of the one we exhibit, though slightly more yellowish in tone. In this reproduction the lozenge pattern in the sleeves of the under garment fails to show. The impressions in the Bigelow Collection at the Museum of Fine Arts and in the William

Rockhill Nelson Gallery of Art in Kansas City are in less good condition than the one we select, but both show the pattern and both have grounds that seem never to have had any trace of tinting.

Rumpf for his number 80 rephotographs from the Vignier-Inada Catalogue.

The subject is one of Sharaku's finest designs in hosoye form and the impression shown here was printed with very great care in all its elaborate details.

Hosoye. Untinted ground. Signed: Sharaku.

Museum of Fine Arts (Spaulding Collection).

I O 4

Segawa Kikunojō III as Hanazono Gozen, the wife of Ōtomo no Kuronushi who is represented in the central print of the triptych of which this is the right-hand sheet.

The only colors that remain distinguishable are the faded rose of the kimono and a little pale yellow elsewhere.

There was no impression of this subject in Paris when the Vignier-Inada Catalogue was compiled and Rumpf in his number 81 rephotographs the inscribed copy, signed Sharaku, from the Ritchie Catalogue which he says was on a faded ground that may once have been yellow.

The only impression in America is deeply trimmed on the right so that the signature is invisible and only the inside portion of the publisher's mark can be seen.

Hosoye. The background is in bad condition but shows no trace of having been tinted.

Schraubstadter Collection.

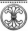
105

Sawamura Sōjūrō III as a messenger *(hikyaku)*, holding a child—in reality Ōtomo no Kuronushi in disguise.

There is no question as to the performance with which this print should be connected, but there is some doubt about the rôle represented. We have adopted Ihara's identification because the *Yakusha Ninsō Kagami* refers to Sōjūrō's appearance as a messenger in the ninth scene of the *ichibanme*. The name on the sign-post, Sekidera, is associated with the story of Ono no Komachi.

The bamboo is printed in black against moss green. The foreground is yellow. Sōjūrō is dressed in a short outer garment of red-brown with stripes of moss green on pale yellow. His skirt and the kimono of the child are in faded rose. The rest of the print is mainly in two tones of gray.

This subject is the only known Sharaku hosoye in which the background is printed in black to indicate that the action represented occurred at night. The nearest approach to it may be seen in number 78 which is also a night scene but is said to have had the sky printed in a deep gray that has oxidized.

The only impression hitherto reproduced was rephotographed by Noguchi and as Rumpf number 128 from the Vignier-Inada Catalogue, number 302, and is somewhat trimmed, especially at the bottom. There are two impressions in America.

Hosoye. Black ground indicating night. Signed: Sharaku.

Colburn Collection.

106

Segawa Kikunojō III as Hanazono Gozen, the wife of Ōtomo no Kuronushi who was shown in the preceding number disguised, and in his own semblance in number 103. The rôle played by Kikunojō here is the same as that in which he is represented in number 104, and in both cases chrysanthemums are used in the design of the costume. In the present print the actor is carrying plum blossoms.

The coloring of the under kimono is faded pale blue with a design of chrysanthemums in rose with green stems. The obi is black. The outer kimono is white with red plum blossoms. The under garment is red and so is the textile that covers the tonsure. The comb, as usual, is in yellow and the foreground is yellow.

This is another of the apparently unique prints that we have been able to add to the previously listed works of Sharaku and we place it tentatively as the central sheet of a triptych with number 107 on its right. The left-hand sheet does not seem to have survived, even in a single impression; but attention must be called to the fact that five hosoye connected with this play show branches coming in at the top, while the undulating line of the ground on which the actors stand appears to be continuous. More will be said on this point under the succeeding numbers.

Hosoye. Slightly grayish ground with branches above. Signed: Sharaku.

The Art Institute of Chicago (Buckingham Collection).

107

Nakamura Noshio II probably as Ono no Komachi, the same rôle as that in which he is represented in number 102, and again in a costume decorated with cherry blossoms. In the print now under discussion he is standing beside the trunk of a tree one branch of which comes into the top of the picture, and is carrying plum blossoms in his hands. We believe

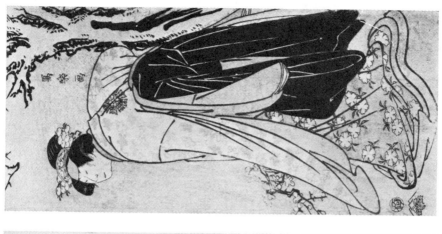

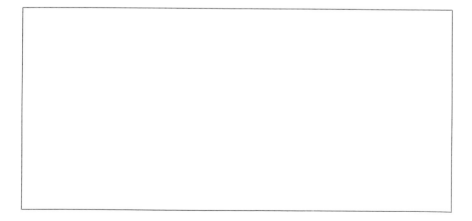

that this print should be placed on the right of the preceding one and that the two form the surviving portions of what once was a triptych. Attention once more is invited to the cherry blossoms in the design of Noshio's costume in 102 as well as here, and to the chrysanthemum design in the robe worn by Kikunojō in numbers 103 and 106.

The coloring of the costume is faded rose, faded violet, black and white. The foreground and the tree trunk are yellow.

The impression of the subject that we exhibit is the only one in America and is the one reproduced in the Vignier-Inada Catalogue, number 301, Rumpf 105, and by Noguchi.

Hosoye. Slightly grayish ground with branches above. Signed: Sharaku.

Museum of Fine Arts (Spaulding Collection).

1o8

Nakamura Nakazō II as Prince Koretaka disguised. The exact action of the play is not known, but this part of it seems to be developed from an episode in the *Ise Monogatari,* which has to do with the rivalry of the Imperial Princes Koretaka and Korehito. The *Yakusha Ninsō Kagami* gives extravagant praise to Nakazō's acting of the rôle, especially in the scene where he doffs the disguise shown in this print and the next, takes off his hat, pulls the strings of his sleeves, and appears clad as befits his station.

Here the under kimono seen above the waist is a faded rose decorated with Nakazō's personal *mon* in yellow. The kimono shown worn as a skirt probably once was blue, but is now a dull straw color. The bundle is a faded orange, the tree and background are yellow.

This print is another of those which we are able to add to the previously recorded works of Sharaku. No other impression is known.

The undulating line of the foreground, the branches above and the delicate printing on the skirt and in the cherry design on the bundle, all suggest some connection with the two preceding prints, numbers 1o6 and 1o7. It seems, however, impossible to arrange the three satisfactorily together as a triptych.

Hosoye. Slightly grayish ground with branches above. Signed: Sharaku.

Museum of Fine Arts (Bigelow Collection).

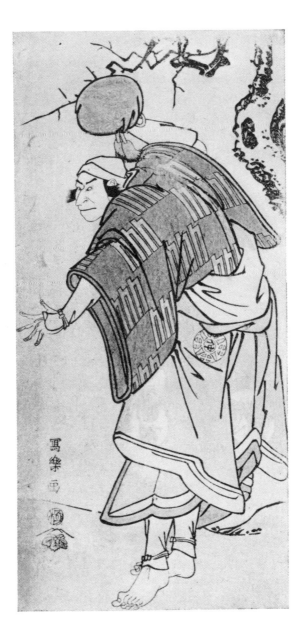

109

Nakamura Nakazō II as Prince Koretaka disguised. The rôle is the same as that in which Nakazō was shown in the preceding print, and that part of the costume which is fully visible there but seen here only about the neck is identical in the two, the design being composed of the actor's personal *mon*. In the cartouche above appear Nakazō's house and poetry names, Sakaiya and Shūkaku.

This very striking design is printed with the cap and under garment in brick red, and the stripes of the outer kimono in black, yellow and rose. The *mon* are in yellow and faded violet.

No other of Sharaku's ten surviving prints in the series of aiban size on yellow grounds can be assigned to this play, but there is some reason for an assumption that Nakazō would have been especially singled out for prominence in the pictorial record of the production because during this performance he succeeded to the name. Before then he had been known as Ōtani Oniji III, and Sharaku's portraits of him under that name and wearing the *mon* appropriate to it may be seen as numbers 19, 31 and 32 of this catalogue. Of the two impressions of the print in American collections we have chosen the larger. The other which is somewhat trimmed but perhaps more brilliant, has been reproduced in color in the Vignier-Inada Catalogue, number 257, and by Noguchi. Half-tone reproductions of it occur in Rumpf number 45, Nakata, *Ukiyo-ye Taisei* Vol. VIII, number 7, and Louis Aubert plate 18. The one exhibited here has not been reproduced before.

Aiban. Yellow ground. Signed: Sharaku.

Museum of Fine Arts (Spaulding Collection).

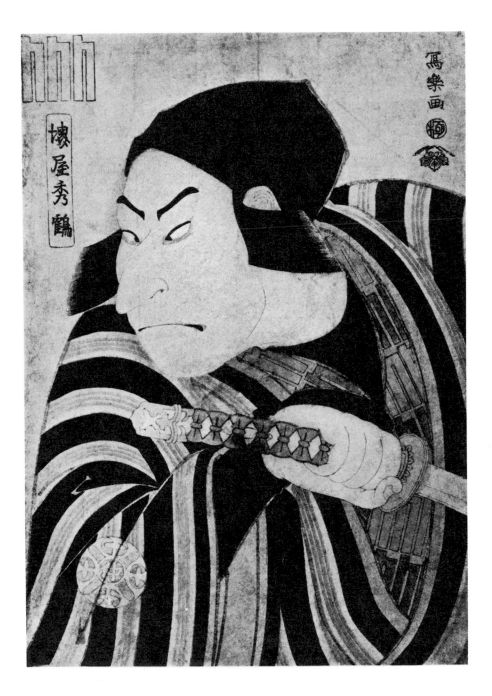

110

Sanogawa Ichimatsu III as Shizuhata, the younger sister of Hata Daizen Taketora whose portrait we have in number 112 as he appeared in a *jōruri* episode of this same production.

The coloring of the costume is in green, yellow, faded violet and faded rose. The foreground is yellow.

This print and the one that follows it seem to have some connection with numbers 106, 107 and 108, as all five have a definite and perhaps continuous foreground as well as blossoming branches at the top. We place these two separately, however, because of various differences between them and the other three. Perhaps the most prominent difference is that the plum blossoms at the top of the two now under discussion are printed in color and with a black outline, besides which they are on larger branches. In some of the five it is difficult to tell with certainty if the grounds originally were left untinted or had been lightly overprinted with pale gray.

The Vignier-Inada Catalogue, number 296, which Rumpf rephotographs for his number 103 and Noguchi uses, arranges this print and the next as the central and right-hand sheets of a triptych and suggests that the left-hand sheet which is lost probably represented a ghost. The suggestion is a plausible one but neither from the prints that have survived nor from what little is known of the play can it be positively confirmed or denied. The impression we exhibit is the only one in America.

Hosoye. Grayish ground with plum branches above. Signed: Sharaku.

Museum of Fine Arts (Spaulding Collection).

111

Arashi Ryūzō probably as Ōtomo no Yamanushi, who, according to the contemporary *Yakusha Ninsō Kagami* in this play pretends to be the prince Koretaka whom we have seen disguised in numbers 108 and 109.

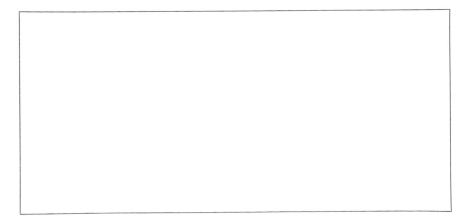

We place the print tentatively with number 110 as part of an incomplete triptych.

It must be noted that opinions differ as to the rôles in this production which are represented in the five prints with blossoming branches at the top, numbers 106, 107, 108, 110 and 111, and we have therefore indicated in the text for each print at least one of our reasons for the present attributions.

Ryūzō is here wearing a black kimono with decorations in white reserve and a blue lining. His waist cord is a faded purple. The foreground is yellow and the plum blossoms have been tinted with rose.

There are two impressions of this print in America. The one in the Grabhorn Collection, which was formerly in the Behrens Collection and is reproduced by Kurth, has a ground that certainly has been tinted with gray, as the ground of the one we exhibit we believe to have been. The subject has been reproduced in color from a trimmed impression in the Vignier-Inada Catalogue, number 296, where the ground is shown as tinted, and this plate has been rephotographed for Rumpf number 104, as well as by Nakata and Noguchi. For further discussion of the ground color in these five prints see number 110.

Hosoye. Gray ground with plum blossoms above. Signed: Sharaku.

Museum of Fine Arts (Bigelow Collection).

I I 2

Ōtani Hiroji III as Hata Daizen Taketora whose sister is shown in number 110.

This print forms a triptych with the two that follow it.

The hand-written inscription gives the name of the actor.

We have rephotographed the only known impression from the Vignier-Inada Catalogue, number 294 (color plate 81), as Noguchi did and as Rumpf has done in his number 99. Its present whereabouts is unknown.

The coloring in the Vignier-Inada reproduction shows an over garment mainly of brick red with black and yellow and an under kimono of faded purple. The curtains are of yellow bamboo with green and black trim and tassels of faded purple and rose.

Hosoye. Untinted ground with a raised curtain at the top. Signed: Sharaku.

I I 3

Segawa Tomisaburō II probably as Prince Koretaka disguised as a lady-in-waiting in the service of the Ōtomo.

The outer garment is violet with a design in white. The inner one is rose and white. The curtains are yellow with green and black trim. The tassels are rose and purple.

This central sheet of the triptych is not as rare as those on either side of it, for there are three impressions in America.

The subject is reproduced from one print, Vignier-Inada Catalogue, number 294, Rumpf number 100, and by Noguchi. Kurth and Nakata use another.

Hosoye. Untinted ground with a raised curtain at the top. Signed: Sharaku.

Museum of Fine Arts (Spaulding Collection).

114

Bandō Hikosaburō III as "Godaisaburō," a gentleman whose more formal name was Goinosuke Munesada.

He is dressed in a blue-green kimono with *kamishimo* of yellow and faded violet lined with fading rose. The tonsure is in faded light blue. The curtains are of yellow bamboo with green and black trim and tassels of faded violet and rose.

This forms the right-hand sheet of a triptych with the two preceding numbers.

We exhibit the only impression in America and the existence of no other has been recorded. The print has been reproduced in plate 181 of the large Moslé Catalogue, as Rumpf number 101, and by Kurth and Nakata.

Hosoye. Untinted ground with a raised curtain at the top. Signed: Sharaku.

The Art Institute of Chicago (Buckingham Collection).

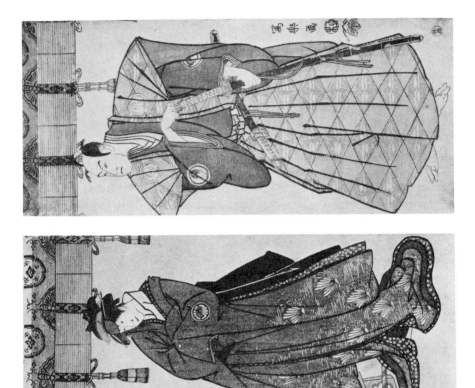

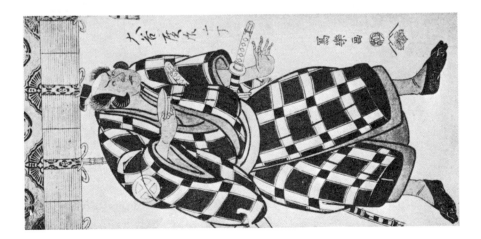

 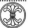

115

Nakamura Nakazō II in the rôle of Aramaki Mimishirō pretending to be Saizō in a *kaomise shosagoto* or "face-showing" dance interlude, entitled MANZAI-SAIZŌ, from the names of the traditional characters represented in it.

The *Yakusha Ninsō Kagami* notes that the other part, that of Manzai, was danced by Segawa Kikunojō and that a special reason for the "face-showing" was Nakazō's assumption of his new name, to which we have referred in our description of number 109. In any case this *kaomise shosa* originally was a New Year's dance and a "face-showing" was customary in productions of the eleventh month which was considered the opening of the theatrical season. There are interesting discussions of *kaomise* in general and especially of the MANZAI-SAIZŌ dance in the glossary of Miss Hirano's monumental book on Kiyonaga.

Presumably this print was part of a diptych, the lost sheet of which gave a portrait of Kikunojō. See number 129.

Here, against a ground of yellow, the actor is seen dressed in a blue *kamishimo* and a kimono of violet the designs on which are printed in yellow, rose, blue and green. The under garments are in rose, the *tabi* are blue, the *zōri* yellow. The strings on the hat are green and there are touches of rose at the eyes.

This is the only example of the subject in America. A somewhat less trimmed copy is reproduced by Kurth and Nakata and as Rumpf number 82 by rephotographing from the 1904 large Barboutau Catalogue print number 730, and we suspect that their listings of that impression as on a gray ground were guesswork because the Barboutau Catalogue does not mention the ground colors and the only other recorded impression, which is the one we exhibit, is printed on a ground of lovely yellow thus again making a portrait of Nakazō stand out among the prints concerned with the production in which he took that name.

Hosoye. Yellow ground. Signed: Sharaku.

The Art Institute of Chicago (Buckingham Collection).

Nido No Kake Katsuiro Soga

OR

THE EVER VICTORIOUS SOGA

KIRI-ZA, NEW YEAR 1795

NUMBERS 116 TO 118

OUTLINE OF THE PLOT

The Soga brothers, Jūrō Sukenari and Gorō Tokimune, were respectively five and three years old at the time when their father was assassinated by Kudō Suketsune. This was in the year 1177. Their father's enemy, fearing that they would take revenge in accordance with the Confucian maxim, "Thou shalt not live on the same earth with thy father's slayer," tried to have them killed in their childhood, and in this enlisted the support of the Shogun Yoritomo who had himself been responsible for the death of their grandfather.

The intervention of various influential personages saved the lives of the two boys, but Suketsune was proved right in fearing their enmity, for in 1193 they attacked and killed him. During the attack which was made at night at the Shogun's hunting camp, Jūrō was himself killed. Gorō was captured, and was executed at the insistence of Suketsune's son, in spite of the fact that even the Shogun wished to pardon him on account of his youth and filial piety.

The story has been famous in Japan ever since, and for centuries the brothers have been heroes of the stage.

Both this and the following play present variations of the theme, but these need not be discussed here, as the only extant Sharaku prints for the production now under consideration represent merely the climactic scene where the brothers finally confront their enemy.

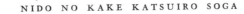
116

Ichikawa Yaozō III as Soga no Jūrō Sukenari, one of the brothers who died nobly in the flower of young manhood to avenge their father, and whose graves may still be seen side by side near beautiful Lake Hakone. The loyalty and bravery with which these two young men carried out what the customs of the twelfth century made them believe to be their duty, has endeared them to many and has made the various plays in which their story is enshrined among the most perennially popular subjects of the Kabuki stage. The costume of Soga no Jūrō traditionally indicates the rôle through its design of those delightful birds which are called *chidori* by the Japanese, and by us "sanderlings."

We place the Soga no Jūrō somewhat doubtfully as the left-hand sheet of the triptych, following in this respect the arrangement of Rumpf rather than that adopted by the Vignier-Inada Catalogue.

The print is in poor condition, but as we are attempting to describe even those colors that in their present state have little or no resemblance to what they once were, we will say that although now we can see little but varying tones of yellow, the kimono seems once to have been mainly in rose and violet.

The impression we exhibit is the only one in America and the existence of any other is doubtful. It has been reproduced in the Vignier-Inada Catalogue, number 292, and as Rumpf number 113. It was last described in the catalogue of the Mutiaux Sale.

Hosoye. Background of lowered curtains. Signed: Sharaku.

Ledoux Collection.

117

Ichikawa Danjūrō VI as Soga no Gorō Tokimune. In this print we see the other of the two boys who accomplished the vendetta described under the preceding number. Soga no Gorō usually is represented in prints of this period with a design of butterflies in his costume.

This print and the two that precede and follow it form a triptych which we have arranged in the order adopted by Rumpf rather than with the sheets here placed at the left and center transposed, as the Vignier-Inada Catalogue has them.

The curtain is in yellow bamboo with bindings in violet and black. The outer garment of the actor is red; the under one is pink with the butterflies in white. The textile at his waist has stripes of pale blue.

Until lately there were two impressions in America. The one that we reproduce is slightly trimmed but is in quite good condition. The other was reproduced in the Vignier-Inada Catalogue, number 292, as Rumpf number 114, and in the sale catalogue of the Mutiaux Collection from which it passed to the collection of the late H. P. Garland from whose estate a number of prints recently have gone back to Japan.

Hosoye. Background of lowered curtains. Signed: Sharaku.

Museum of Fine Arts (Spaulding Collection).

118

Ichikawa Ebizō IV as Kudō Suketsune, the victim of the revenge accomplished by the brothers shown in the central and left-hand sheets of the triptych.

The curtains are in green and yellow with black and violet trimmings. The robe and *hakama* of the actor are blue with a pattern of green-leaved thistles in rose. The under kimono likewise is in rose, and the strings of the black hat are green.

This print is in superb condition and the only duplicate of it in America is less brilliant in color. A trimmed impression is reproduced in the Vignier-Inada Catalogue, number 292, as Rumpf number 115, and by Noguchi. Nakata uses another.

Hosoye. Background of lowered curtains. Signed: Sharaku.

The Art Institute of Chicago (Buckingham Collection).

Edo Sunago Kichirei Soga

OR

THE SOGA, EVER HONORED ON THE SANDS OF EDO

AND THE *nibanme*

GODAIRIKI KOI NO FŪJIME

OR

LOVE SEALED IN THE NAME OF THE GODS

MIYAKO-ZA, FIRST MONTH OF 1795

NUMBERS 119 TO 127

OUTLINE OF THE PLOT

In 1795 it had been for many years a custom to produce in the first month a play about the Soga brothers, but in order to avoid the monotony of repeating the same thing over and over, changes constantly were being made in the course of the action, and various dances and *jōruri* episodes were introduced. Many of these had little or nothing to do with the central story and really were in the nature of interpolations, although it was the practice to include them under the title of the chief play.

In connection with the present production it is interesting to note that for the first time in a number of years the *nibanme* or second part was formally recognized as being a distinct entity by giving it a separate title. In our arrangement the prints having to do with this *nibanme* are listed as numbers 122 to 127, and the outline of the plot is given in its place.

The Soga story with which the following three prints (numbers 119 to 121) are concerned already has been outlined in connection with the previously listed production NIDO NO KAKE KATSUIRO SOGA, and in spite of differences in the subsidiary episodes of that play and EDO SUNAGO KICHIREI SOGA, it is unnecessary to go into further detail because for both productions Sharaku seems to have illustrated only the invariable central scene of the story in which the villain is confronted by the two heroes.

119

Sawamura Sōjūrō III as Soga no Jūrō Sukenari.

Again we have a triptych showing the Soga brothers and their enemy Kudō Suketsune as we had in numbers 116, 117 and 118.

The *chidori* in the costume of the actor traditionally indicate that he is playing Soga no Jūrō. This is the left-hand sheet of the triptych.

The *kamishimo* and *hakama* of the costume are in faded blue with stripes of faded violet and the *chidori* design in white. The under garment is red. The tonsure and the collar are in pale gray-blue.

The print we exhibit is the only impression in America. Another that was somewhat trimmed is reproduced in the Vignier-Inada Catalogue, number 293, as Rumpf number 116, and by Noguchi.

Hosoye. Across the background runs a horizontal band of faded blue bearing in white the *mon* of the Itō family which designates the Soga. Signed: Sharaku.

Metropolitan Museum of Art (Mansfield Collection).

120

Bandō Mitsugorō II as Soga no Gorō Tokimune.

The butterfly design identifies the rôle as it did in the Soga no Gorō sheet of the preceding triptych, which like the one now being considered showed the two brothers facing their hereditary enemy.

This is the central sheet. The coloring has not been described.

We have rephotographed as Rumpf did for his number 117, and as

Noguchi did, from the Vignier-Inada Catalogue, number 293, a slightly trimmed impression formerly in the Vever Collection and now in that of Mr. Matsukata.

Hosoye. Background as in the preceding number. Signed: Sharaku.

1 2 1

Bandō Hikosaburō III as Kudō Suketsune, the villain of the tragic story. This is the right-hand sheet of the triptych.

The peculiar hair arrangement used on the Kabuki stage to indicate malefactors of high rank may be seen again here.

Once more we have been obliged to rephotograph a print now in the Matsukata Collection from the reproduction in the Vignier-Inada Catalogue, number 293. Rumpf uses for his number 118 the same trimmed impression, and Noguchi publishes it again. The only other known to the writers of this catalogue is in the Rijksmuseum voor Volkenkunde at Leiden. The coloring has not been described.

Hosoye. Background as in number 119. Signed: Sharaku.

Godairiki Koi No Fūjime

The six prints that follow as numbers 122 to 127 certainly have to do with scenes in GODAIRIKI KOI NO FŪJIME which was played as the *nibanme* after the Soga piece, one scene of which is recorded in the preceding triptych; and numbers 128 and 129 which we class as unidentified, have been connected by some authorities with the same production.

Among all the plays with which Sharaku's prints deal this is the only one of which a complete text is known to exist, and in its altered version of the well known story of Gengobei and Koman the action was briefly as follows: When a precious flute long treasured in a provincial household was found to be missing, the young heir of the family, accompanied by Gengobei, Sangobei and other retainers, was sent to Edo to search for it. The night life of the old Tokugawa capital had plenty of allurements for provincials, and Sangobei promptly fell in love with a geisha called Koman who, in order to get rid of him, pretended love for his companion, Gengobei. Sangobei, furious at this, slandered his fellow retainer to their young master and got him discharged from service. The disgrace of Gengobei on her account made Koman really fall in love with him, but the attentions of Sangobei became so urgent that she was driven to pretend dislike for the man for whom she did care, and Gengobei, who had returned her love, was driven by jealous rage to kill her. When Koman was dead Gengobei learned that her devotion to him had been real and unwavering, and as he found the missing flute in the possession of Sangobei it made a natural theatrical *dénouement* for the hero of the piece to kill the villain, restore the musical instrument to its owner and so reinstate himself in the good graces of his lord.

In the older version of the story with which the public had been familiar, Gengobei and Sangobei were friends, Koman was not a geisha but the wife of Sangobei, and Gengobei, instead of being in love with her, was

devoted to a girl called Oman; all of which is very much as though a new play should be put on with the names of the chief characters Romeo and Juliet, but with the plot totally different from that of the Shakespearean drama. A more detailed discussion of the original form of the Gengobei-Koman story may be found in our introductory essay.

The four following prints, numbers 122 to 125, are parts of a pentaptych, the fifth sheet of which is unknown but in all probability represented Segawa Kikunojō as the geisha Koman. We have rearranged the order adopted by Rumpf for the surviving sheets and consider that the missing one came at the extreme left.

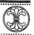

122

Iwai Kumesaburō as the geisha Kumekichi.

He is dressed in an outer kimono which probably once was purple and now is pale chocolate brown. The obi is mainly pale rose with circles in green and black. The under kimono is in faded rose. The foreground probably was yellow; the once blue bands in the background have faded to dull straw color with a white wave design which has become almost invisible.

We believe that in the original set of five sheets the one now unknown came at the left of this one, and we have reason to assume that the print we place here as next in order survives only in the much trimmed impression exhibited, which was rephotographed by Rumpf for his number 119 from a cut in the catalogue of the Crewdson Sale (London 1919).

Hosoye. The background is the wall of a room decorated with three horizontal bands the upper and lower of which once were blue with water motives in white, while the central band shows flowering cherry branches against an untinted ground. Signed: Sharaku.

Museum of Fine Arts (Bigelow Collection).

123

Sawamura Sōjūrō III as Satsuma no Gengobei, the hero of the piece.

The outer garment is in gray and white. The under one is solid green.

In the composition of the original pentaptych Gengobei presumably occupied the central position with two women on either side of him. The impression we exhibit is the only one in America and being slightly trimmed on the left, as the preceding number was on the right, the con-

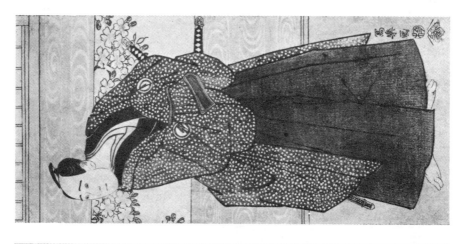

tinuity between the two of the detached cherry branch which is lower than the others fails to show clearly, though more of it can be seen here than is visible in the other print. A more nearly intact impression, reproduced in color in the Vignier-Inada Catalogue, number 295, has been rephotographed for Rumpf number 120, and by Noguchi.

Hosoye. Background as in number 122. Signed: Sharaku.

Museum of Fine Arts (Spaulding Collection).

124

Segawa Yūjirō II as the servant girl O-Towa.

We believe that this print should be placed where we have it and not at the extreme right end of the set, partly because the cherry branches of number 125 must come from this tree and would do so more naturally in this arrangement, and partly because the actor, though looking toward the left, is moving toward the right.

We have rephotographed the reproduction in Kurth as Rumpf did for his number 122. The coloring has not been described. Nakata reproduces a different impression, much trimmed on the left.

Hosoye. Background as in number 122. Signed: Sharaku.

125

Segawa Tomisaburō II as another of the geisha in the entourage of Gengobei.

He is dressed in an outer kimono of faded purple and wears an obi that is mainly in green. The horizontal blue bands with white water motives on the background have lost their color, and while the print is in much better condition than number 122 is and than number 124 appears to be, the original tonality of the set can only be judged from number 123, which shows Gengobei himself.

We consider this to be the right-hand sheet of what once was a pentaptych of which only the four sheets that are grouped together here have survived.

The original Japanese collector who wrote inscriptions on this and other prints by Sharaku which found their way to Germany and are reproduced by Kurth, sometimes added to the name of the actor the nickname by which he was popularly known. In this case the inscription reads: Segawa Tomisaburō, generally called Hateful Tomi. *(Yo ni Iya Tomi.)* The picture is one of Sharaku's most malicious portraits, but the second Tomisaburō had been an amateur for a large part of his life and even in his later years may not have been as finished an actor as those with whom he played.

No other impression of the print is known to have survived. This one which was at one time in the Jaekel Collection, has been reproduced by Rumpf as his number 121, as well as by Kurth, Nakata and others.

Hosoye. Background as in number 122. Signed: Sharaku.

Ledoux Collection.

126

Sawamura Sōjūrō III as Satsuma no Gengobei, a rôle in which we have seen him depicted at a happier moment in number 123. Here he is drawing his sword presumably in the scene where he kills Koman.

In the cartouche below the personal *mon* of the actor are his house and poetry names Kinokuniya and Tosshi.

The outer kimono is in faded violet with stripes of gray and yellow, and the last mentioned color shows again in the lining of the sleeve. The under robe is in rose with the collar in black. The tonsure is in faded light blue as are the wrappings of the sword hilt with its yellow (golden) fittings.

The impression we exhibit is the only one in America. Another is reproduced in the Vignier-Inada Catalogue, number 260, as Rumpf number 54, and by Noguchi.

Aiban. Yellow ground. Signed: Sharaku.

The Art Institute of Chicago (Buckingham Collection).

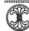

127

Bandō Mitsugorō II as the retainer Hachiyemon.

In the cartouche under Mitsugorō's personal *mon* are his house and poetry names Yamatoya and Zegyō.

The actor now has changed from the costume and hair arrangement appropriate to the rôle of Soga no Gorō in which he is shown in number 120, and is playing the rôle of a retainer of Satsuma no Gengobei whom we have seen in numbers 123 and 126.

We have rephotographed from the Vignier-Inada Catalogue, number 259, as Rumpf did for his number 48, the only known impression which was at one time in the Rouart Collection in Paris and now is in that of Mr. Matsukata in Kobe. The coloring has not been described.

Aiban. Yellow ground. Signed: Sharaku.

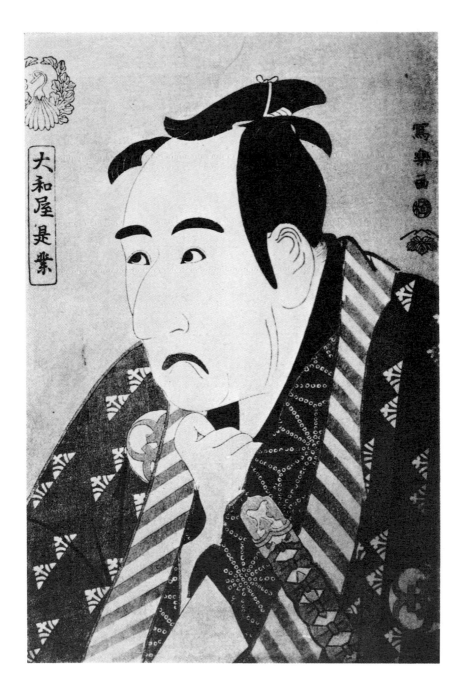

Unidentified Actor Prints

128

Segawa Kikunojō III possibly as Koman in GODAIRIKI KOI NO FŪJIME.

In the cartouche below the personal *mon* of the actor are his house and poetry names Hamamuraya and Rokō.

The serious doubt of the identification given above is due to the fact that in the version of the Koman-Gengobei story which was put on for the production whose scenes we have been listing, Koman was transformed from Sangobei's wife into a geisha and is said to have appeared throughout the play in geisha costume; whereas the costume represented in the print is that of a married woman of the middle class and therefore would be correct for Koman in the earlier version. The other possible identifications, however, have equally forceful objections that can be made to them. In different sections of the same production Kikunojō appeared as O-Hisa, a maid servant, and in an unidentified rôle which may possibly be recorded in the print that follows. For neither of these parts is the costume correct. If we go back to the plays put on at the Miyako-za in the eleventh month of 1794 under the general title of URŪ TOSHI MEIKA NO HOMARE we find the actor playing three parts—Hanazono Gozen, a lady of the nobility, who is not recorded to have appeared in any part of the production in disguise, the tea-house waitress O-Hama, and Yamato Manzai in a *shosagoto*. Clearly none of these gives the clue. The only remaining possibility is the rôle of O-Sono in a production of the fourth month of 1795, and it is highly unlikely that one aiban would have appeared alone three months after the last of the nine others and at a date later than that at which all the evidence we have accumulated shows that Sharaku ceased to design prints.

In the picture the actor wears an outer kimono of moss green with a black collar and a black obi in which is a floral pattern in black. The under kimono is violet and has below it an under garment of rose with a white collar. The comb is in soft yellow and the covering of the tonsure is violet.

There are two impressions in America. The one of these that we exhibit

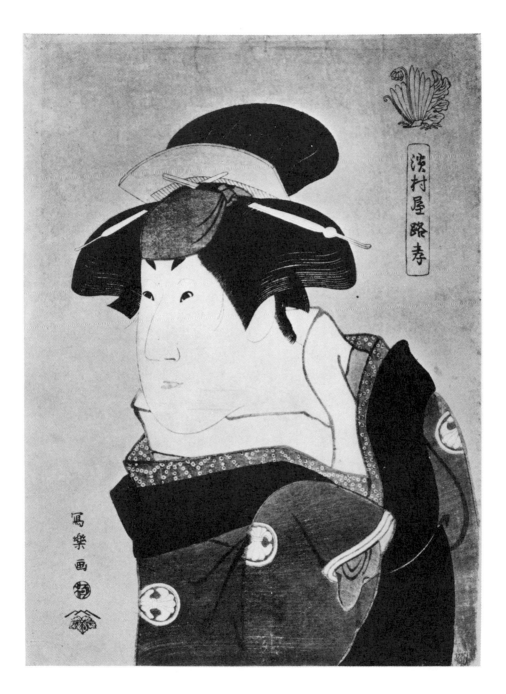

has been reproduced by Kurth and Nakata and in the catalogue of the sale of prints from the Kunsthalle of Bremen. A third may be studied in reproduction in the Vignier-Inada Catalogue, number 258, and as Rumpf number 52.

Aiban. Yellow ground. Signed: Sharaku.

The Art Institute of Chicago (Buckingham Collection).

129

Segawa Kikunojō III in an unidentified rôle.

The orthodox way to catalogue this subject is to say that it represents the third Segawa Kikunojō in the rôle of the *shirabyōshi* Hisakata pretending to be the New Year Dancer Yamato Manzai in URŪ TOSHI MEIKA NO HOMARE. The reasoning back of this attribution is that a contemporary play-bill shows the actor in that part with a somewhat similar hat and with an open fan, and that therefore the print must go with number 115 as the missing portrait of Kikunojō dancing with Nakamura Nakazō II in the Manzai-Saizō interlude. The two prints, however, face in the same direction and do not form a diptych; besides which number 115, at least in the only impression actually known to us, is printed on a ground of pale but definite yellow, whereas the sheet now under consideration is on a completely untinted ground. The hat is correct for the rôle and so is the mantle which, by the way, is not shown in the *banzuke,* but the two prints certainly do not look as though they were designed to go together.

The other possible identification would connect the subject with MITSU-SEGAWA AZUMA NINGYŌ, a *nagauta* given at the end of GODAIRIKI KOI NO FŪJIME, various scenes from which we have just been listing. It cannot, however, represent the actor as he appeared there in an *Otokomai* or male dance, because the costume he used for that is shown to be quite different in an extant play-bill covering the performance. The title of the piece, however, might be translated either as "The Third Segawa's Eastern Dolls" or as "Segawa's Three Eastern Dolls," and if the last mentioned of these two possibilities is correct the actor may have appeared in three costumes—an assumption which we have not been able either to prove or to disprove.

As in number 128, which we connect tentatively with GODAIRIKI KOI NO FŪJIME, Kikunojō is robed in faded violet over faded rose, but in the print now under discussion he has taken off his outer kimono and has put on a black ceremonial hat, while over his left shoulder is thrown loosely a great mantle now greenish gray in tone, which is decorated with

his personal *mon* in white. This use of the *mon* in white would indicate the Manzai rôle, but it appears again in color at the bottom of the kimono. The obi is black.

The subject is one of the most justly famous of Sharaku's designs in hosoye form, a superb thing in composition, dramatic power and characterization.

There is no other impression in America but two others have been reproduced. For reproductions in color we refer to Vignier-Inada Catalogue, number 323, plate 97, and Noguchi; the more important reproductions in half-tone are those in Rumpf number 83, Kurth, Nakata and the large Barboutau Catalogue.

Hosoye. Untinted ground. Signed: Sharaku.

Ledoux Collection.

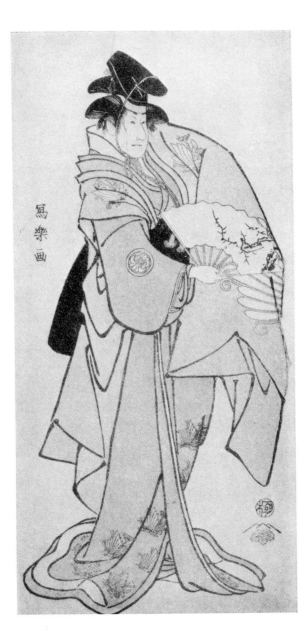

Miscellaneous Prints

NUMBERS 130 TO 136

130 · 131

These two prints can best be considered together because they were issued, presumably at the close of 1794, in memory of three actors who had died and in special commemoration of Ichikawa Monnosuke II whose death occurred during the eleventh month of that year.

In the print that we place at the left Monnosuke is shown dressed as he had been in a *shibaraku* rôle, probably that of Saito Musashi-Bō Benkei which he had played with Kanzayemon in 1792, and in the right hand one he is being received in Hades by his former partner, Nakajima Kanzayemon III who here is shown as Emma Dai-Ō, the King of the Dead, this being the part that he had played opposite Monnosuke in the main part of the same performance. Kanzayemon had died in the first month of 1794,—nine months before Monnosuke.

The actor dressed as a woman who is kneeling beside King Emma and pointing toward the new arrival in his realm, is Nakamura Tomijūrō I who had been particularly renowned for his playing of female parts some years before, and who had died in 1782. As Tomijūrō had been at the height of his fame when Monnosuke was young the two prints apparently associate the great actor who had just died with one of the earliest and one of the latest of his distinguished companions.

The coloring of the costume worn by Monnosuke has not been described but we know that in *shibaraku* parts the heavy over mantle habitually worn was in brick-red and bore the Ichikawa *mon* in white. In the right-hand sheet Kanzayemon is in pale yellow and lavender with touches of rose. Tomijūrō wears a rose under kimono and an outer kimono of black which bears his *mon* of arrows in alternate stars of white and lavender.

The print showing Monnosuke is known only in a single, trimmed, impression, now in the Matsukata Collection and formerly in that of M. Vever. We have rephotographed this from the Vignier-Inada Catalogue, number 288, as Rumpf did for his number 1, and as Noguchi has done. The Vignier-Inada Catalogue, almost certainly through a typographical error, lists both of the sheets now under discussion as having

mica grounds. Kurth questions this statement, Rumpf discards it, and as mica grounds had been prohibited before Monnosuke died there can be little doubt of its falsity. Incidentally, the right-hand sheet which we can show in an actual impression rather than from a photograph, is not on a mica ground but on one that is tinted with gray.

The print showing Kanzayemon and Tomijūrō receiving Monnosuke is known to exist in two impressions. The one of these that we exhibit is cut only slightly at the top, bottom and on the right, but has been trimmed considerably on the left. It now measures 12 x 8 inches instead of the usual 13 x 9 of the aiban form. It was at one time in the Behrens Collection. The present whereabouts of the other is unknown, but it is of the full size and is reproduced in the Vignier-Inada Catalogue, number 289, as Rumpf number 2, and as the title page of Noguchi.

Both prints: Aiban. Grounds as discussed above. Signed: Sharaku.

Right-hand sheet: Grabhorn Collection.

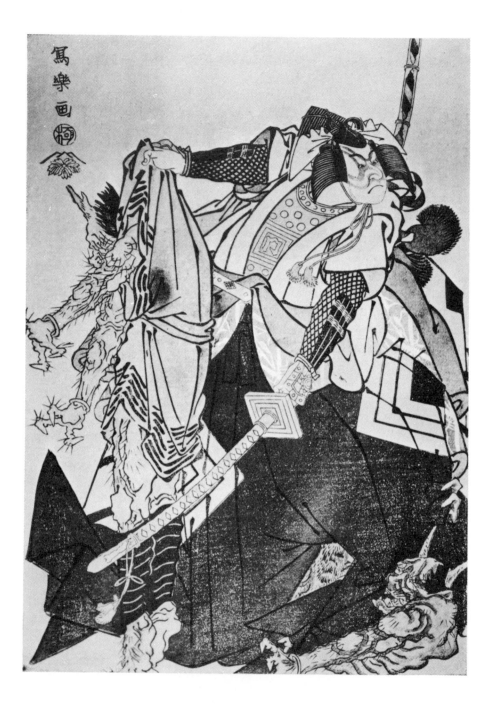

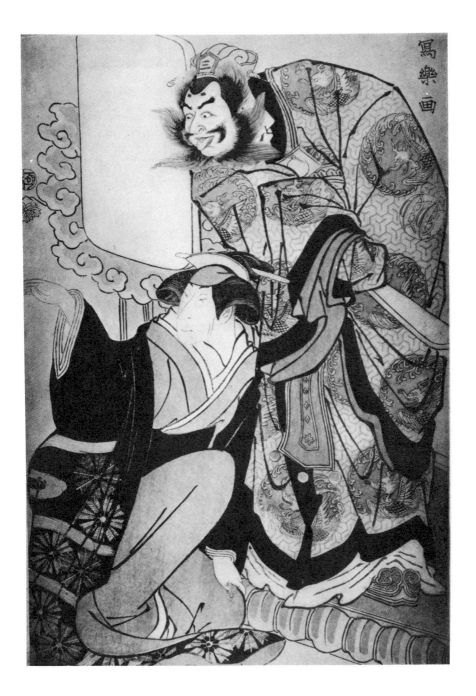

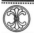

132 · 133 · 134

Wrestlers and umpires contemplating the child wonder Daidōzan Bungorō, who was entered as a student of wrestling in 1794.

The left-hand and right-hand sheets of this triptych show in each of the two, five well known wrestlers of the period whose names are given. Rumpf transcribes all ten of these names and it seems unnecessary to list them again here, though we would mention the fact that as one of the wrestlers depicted, Tanikaze Kajinosuke II, died in the first month of 1795 his presence in the print helps to place its date as before that time.

Japanese authorities on the history of wrestling have noted that all ten of the champions shown appeared in the programs of 1794, and have dated the print even more exactly as of the eleventh month of that year. The central sheet shows the child prodigy in the ring with two umpires gazing at him, and it may be assumed that the picture commemorates his entrance into the fraternity of the gentle art. Number 135 shows the boy again, but there alone.

We rephotograph from the Vignier-Inada Catalogue, number 251, an impression whose present location is unknown, and in this we follow the precedent established in Rumpf Numbers 39 to 41, and by Noguchi. The coloring has not been described.

Ōban. Gray ground. Signed: Sharaku.

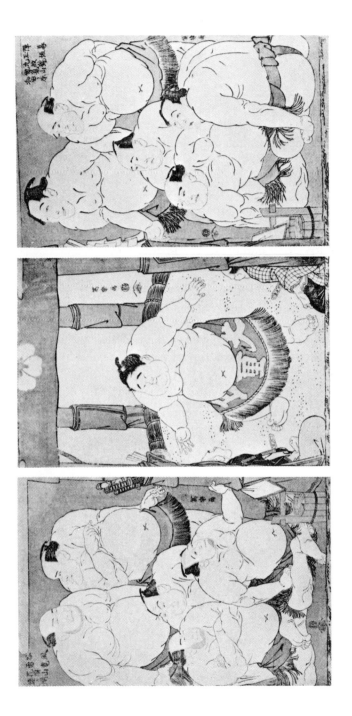

135

Portrait of the famous fat boy Daidōzan Bungorō showing his strength.

In the preceding number we saw the same prodigy of corpulence and power in the wrestling ring. Here we have him alone and dressed in what has been described as a bathrobe with black and yellow stripes. The text above gives his age, weight, girth etc.; but exciting as he was to the public and to the print makers of the time, all we feel called on to record here is that he appears in the print at the age of seven and that considerably before then his father had presented a petition for financial help in feeding him. The measurements and the statement of age given in the print fix its date as at the beginning of 1795.

We have rephotographed from the Vignier-Inada Catalogue, number 250, an impression now in the Matsukata Collection, which seems to be the same one reproduced as Rumpf number 42 and by Noguchi. Kurth uses another.

Ōban. Described as on yellow ground. Signed: Sharaku.

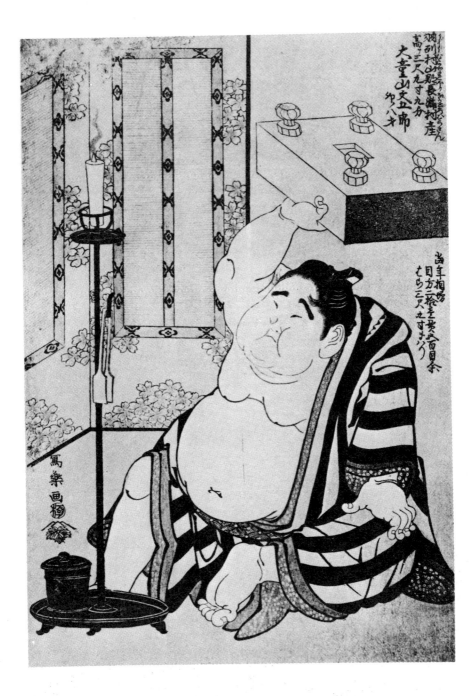

136

An illustration of the famous story, MOMIJI-GARI, the Maple Picnic. The tale relates that Taira no Koreshige went out to view the autumn maples and fell in with a party of young girls whose picnic he shared happily until one of them suddenly turned into a gigantic demon and tried to kill him.

This print and another which Rumpf reproduces as his number 43, but which we have ventured to consider spurious, stand somewhat apart from the rest of Sharaku's work, and neither of the two is known to exist in more than a single impression. The one here under discussion was reproduced as Rumpf number 44, and last appeared as number 113 in a Japanese auction held in April, 1937, from the catalogue of which we have rephotographed it. The coloring has not been described, in so far as we have been able to ascertain, except for that of the background. The date cannot be determined accurately, but from the signature and other bits of circumstantial evidence we would assign it to the close of 1794 or the beginning of 1795.

Aiban. Yellow ground. Signed: Sharaku.

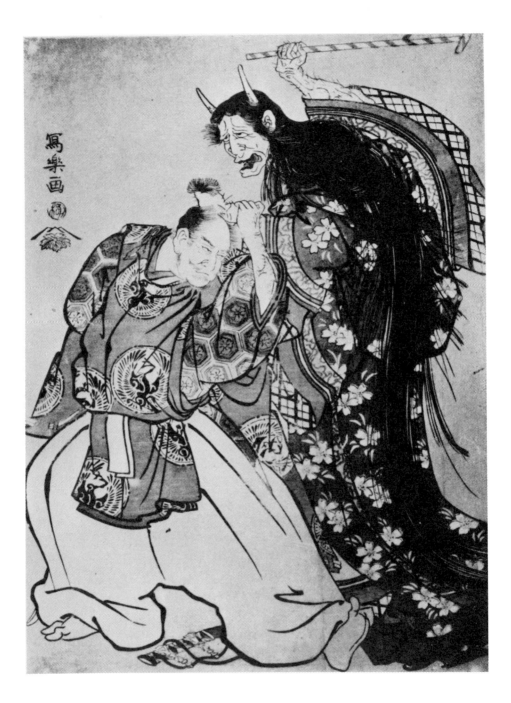

Drawings of Actors

The fire that followed the Tokyo earthquake of 1923 destroyed one of the two sets of known drawings by Sharaku, those of wrestlers which Rumpf reproduces from previously obtained photographs. The other set, eight drawings of actors, which once were together in the collection of Pierre Barboutau of Paris, we believe still to exist, and these, therefore, must be counted as among the surviving works of the artist. The present whereabouts of five out of the eight has not been ascertained, and these can be shown only through rephotographing reproductions in the Barboutau Catalogue; the other three, however, are in American collections and consequently are among the originals exhibited.

The set has been studied with great care by Japanese as well as by foreign experts, and the inevitable conclusion seems to be that the drawings were made by Sharaku to be printed in a book that would record not actual stage scenes but various actors from the three leading theatres grouped together according to the fancy of the artist. No actor is portrayed more than once in the set. Changes in design are indicated by pasting the desired corrections over the parts to be altered and in some cases the *mon* of the actors seem to have been changed or written over with a probably later indication of the name or rôle which cannot always be shown to be correct.

Seven out of the eight drawings are appropriate for double-page illustrations and each of these shows the line of separation in the center. The eighth is half the width of the others and presumably would have been printed on the final single page of the book. This smaller sheet has the Sharaku signature pasted on and, according to the Barboutau Catalogue, it bears the seal of Toyokuni. In the reproduction we have rephotographed this seal is invisible, but its presence would indicate merely that at some time the drawing had been in the collection of one of Sharaku's great contemporaries. Toyokuni and Sharaku occasionally made prints of the same subject, as in number 78 of this catalogue where reference is made to Toyokuni's depiction of the same actor in the same rôle, and if our identification of number 146 is correct, still another connection between the two artists is indicated.

The signature pasted on the final sheet reads Sharaku *gwa*, not Tōshūsai Sharaku *gwa*, and if an analogy may be drawn from the prints, this fact would date the set not earlier than the eleventh month of 1794. In that

month Ōtani Oniji III became Nakamura Nakazō II and ceased to use the uncorrected *mon* with which he is shown in one of the original drawings exhibited. This seems to establish the fact that the sketch in question could not have been made after that time, and there is one clear indication of the eleventh month in the same sheet, as the kimono worn there by Segawa Kikunojō is the one in which we have seen him dressed in number 106, a print which represents him in a production of that date. Inferences might be drawn from more than one other sheet which would lead to the same conclusion, but we confine ourselves to pointing out that in the sketch showing Nakayama Tomisaburō the costume is the same as the one he is wearing in print number 94, which also has to do with an eleventh month play.

It is true that in most cases the method of ratiocination we have been following fails to produce any result, and in others it tends to show either that Sharaku had some of his own prints before him when he made the drawings or that he had done at least one of his sketches while a production of the seventh month still was running. (Compare the striped kimono of Iwai Kiyotarō in number 143 and in print number 35 which we have placed in NIHONMATSU MICHINOKU SODACHI.) But we find that none of the drawings suggest prints which appeared after those of the eleventh month, and therefore we would assign the set to the summer and autumn of 1794. Some have tried to date it several years earlier.

Books such as those for one of which these drawings appear to have been made, generally had twelve double illustrations, and we do not know if Sharaku failed to design the requisite number or if some of his drawings showing certain famous actors not included among the twenty-one he does portray, have been lost. Some of those that we have appear to belong together as compositions in two parts, others do not, and our reproductions of the set are arranged accordingly.

137

Osagawa Tsuneyo II, Sawamura Sōjūrō III and Ichikawa Yaozō II, grouped before a rolled-up curtain closely resembling that which appears in prints numbered 112 to 114, which record a play given in the eleventh month of 1794.

The identifications of the rôles written over the *mon* of two of the actors probably are a later addition and erroneous in their attributions.

The only indications for color in this ink drawing are red on the lips of Yaozō and the eyelids of Sōjūrō, and blue on the shaven chin of the last mentioned actor.

This drawing has been reproduced in the Barboutau Catalogue, number 218C, as Rumpf Drawing number 1, and by Kurth, Nakata and Noguchi. It is described under number 32 of the Jacquin Catalogue.

Unsigned. Size 8½ x 12 inches.

Museum of Fine Arts (Spaulding Collection).

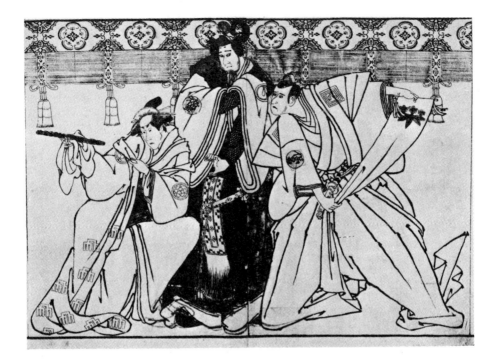

138 · 139

Left-hand sheet: Ichikawa Tomiyemon, Sakata Hangorō III and Sano-gawa Ichimatsu III. Right-hand sheet: Ichikawa Danjūrō VI and Onoye Matsusuke I. The background in both sheets is the same, a lattice fence on either side of the uprights of a *torii,* the cross pieces of which are invisible.

We make no comment on this diptych except to point out that in his designs for prints Sharaku did not use decorative backgrounds before the eleventh month of 1794 but did use them at that time and for the first month productions of 1795.

These two drawings have been rephotographed here from the Barbou-tau Catalogue, numbers 218H and G, as Rumpf rephotographed them for his Drawings numbers II and III, and as Kurth, Nakata and others have done.

Unsigned. 8½ x 12 inches each.

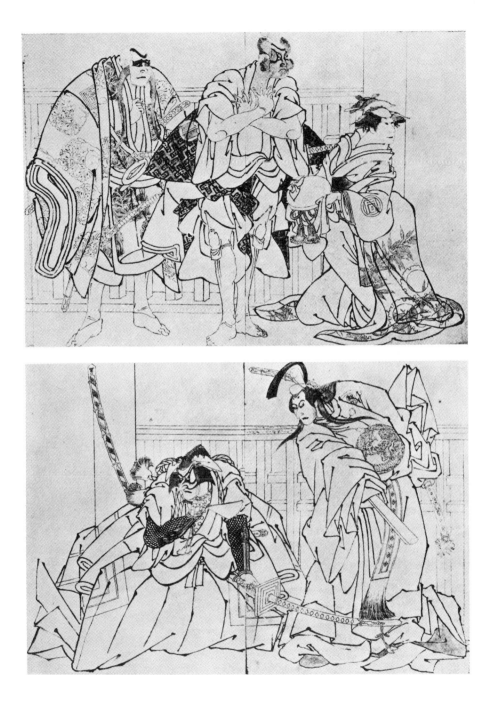

140 · 141

Left-hand sheet: Segawa Kikunojō III, Ōtani Oniji III, and Bandō Mitsugorō II. Right-hand sheet: Ichikawa Komazō II, Ichikawa Omezō and Nakayama Tomisaburō. The composition of the two sheets is tied together by the maple trees at either end and the leafy branches that droop into both pictures. These form the only background for the figures of the three wandering entertainers on the left, but the upper class people on the right and their servant are seen against the curtain hung for a picnic.

In our preliminary discussion of the dating of the set, attention has been called to the fact that the kimono worn in this diptych by Kikunojō and by Tomisaburō are the same as those in which they are shown in prints 106 and 94, one of which had to do with a performance at the Miyako-za in the eleventh month of 1794, and the other of which portrayed a scene from the production at the Kiri-za which was put on at the same time. To this statement we would add that the maple tree of the drawing appears again in the print of Tomisaburō.

The indications of coloring in the left-hand sheet are red for the lips of all three actors, with a little blue on the chin of Oniji and elsewhere.

The original we exhibit of the left-hand sheet showing the three mountebanks, was rephotographed from the Barboutau Catalogue, number 218D, for Rumpf Drawing number IV, as well as by Kurth, Nakata, etc. It was described under number 31 of the Jacquin Catalogue and it passed from that sale to the Spaulding Collection. The right-hand sheet has been rephotographed by us from the Barboutau Catalogue, number 218F, as Rumpf rephotographed it for his Drawing number V, and as the usual others have done.

Unsigned: Size: 8½ x 12 inches each.

Left sheet: Museum of Fine Arts (Spaulding Collection).

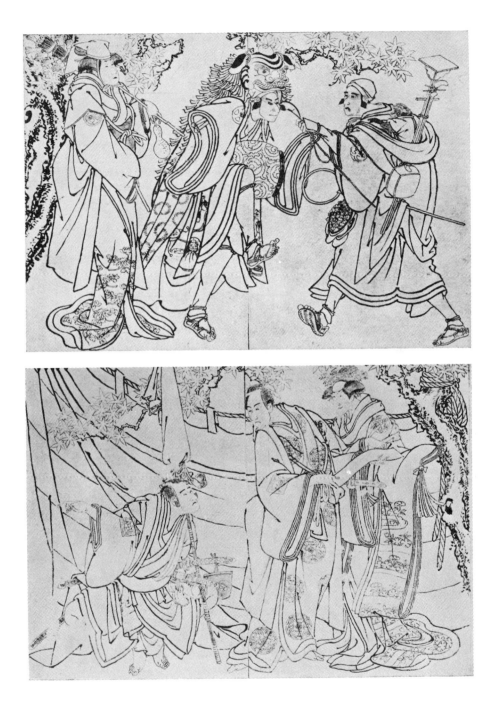

142

Morita Kanya VIII and Arashi Ryūzō. The background shows the entrance to a house with a large lantern, a fence and tree at the left. On the lantern is the Sasarindō crest that appeared in number 137 and is associated with the Genji. The attitude of Kanya who is holding a portable lantern between his teeth, is said by Rumpf to have been copied from a print by Shunshō.

The drawing is in black and gray inks. The tonsures are blue. There is red around the eyes of the figure at the left.

This sheet has been reproduced in the Barboutau Catalogue, number 218B, as Rumpf Drawing number VI, and by Kurth, Nakata, etc.

Unsigned. Size 8½ x 12 inches.

The Art Institute of Chicago (Buckingham Collection).

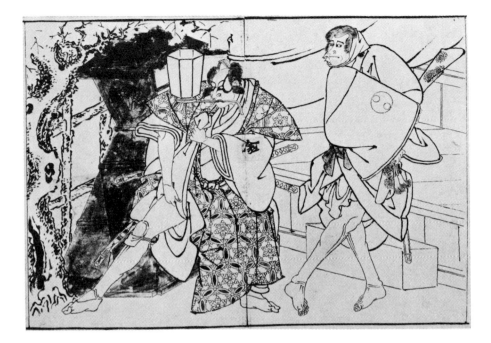

143

Bandō Hikosaburō III, Nakamura Sukegorō II and Iwai Kiyotarō. They are at the entrance to a house and in the background is a hedge, snow-covered.

The drawing has been reproduced in the Barboutau Catalogue, number 218E, from which we have rephotographed it as Rumpf did for his Drawing number VII, and as Kurth, and Nakata have done.

Unsigned. Size 8½ x 12 inches.

I44

Matsumoto Yonesaburō kneeling and an actor of the Segawa line, probably Segawa Yūjirō II, standing. The character *Yū* indicating Yūjirō appears to have been written on the Segawa *mon*. The print is without background and is half the width of the others. The signature has been pasted on, and, as was noted in our preliminary remarks about the set, the drawing is said to bear the seal of Toyokuni which would indicate that at one time it had been owned by him. The seal is not visible in the reproductions.

It has been suggested that this half-width drawing was not for the final single page of the book for which the others apparently were made, but was a separate entity, perhaps designed to go into the set of two full-length figures on mica grounds, but never printed with them. The standing actor might be Segawa Tomisaburō or Segawa Kikunojō rather than Segawa Yūjirō, but even if that is the case the drawing could not represent any actual stage scene unless Yonesaburō who ordinarily was at the Kiri-za, could be shown to have become temporarily a member of the Miyako-za company and could be found to have played such a scene as that depicted with any of the Segawa actors mentioned.

This drawing was reproduced in the Barboutau Catalogue, number 218A, from which we have rephotographed it as Rumpf did for his Drawing number VIII, and as Kurth, Nakata and others have done.

Signed: Sharaku. Size: 8½ x 6 inches.

Fans

NUMBERS 145 AND 146

I45

Okame—a popular conception of the Shinto deity Ame no Uzume no Mikoto—throwing beans in the annual demon-chasing ceremony.

This curious fan which quite possibly is an authentic work by Sharaku, has a background of light gray mica, or mica over light gray. It seems to have been printed in so far as the outlines of the figure and the signature are concerned, but the costume and comb are hand colored in black and gray and yellow.

The poem has been translated as follows: "As the mountains are so high there is no fear that a storm will injure the flowers in the ravine." This is, however, a play on words, which makes the *double entendre* of the lines signify that Okame's small nose is protected by her over-hanging cheeks.

Signed: Sharaku. Size: 15¾ inches between the upper corners.

The Art Institute of Chicago (Buckingham Collection).

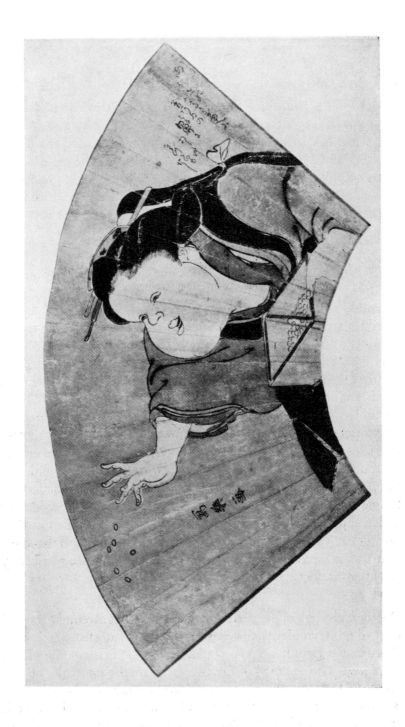

146

It would be pleasant to say with assurance that this remarkable fan is a portrait of Toyokuni by Sharaku; but a catalogue must sometimes seek safety in equivocations and qualifying clauses, and the drawings of actors made to be cut on wood-blocks give insufficient evidence as to the quality of Sharaku's original brush work to enable anyone to say with certainty that the painting now under consideration which seems to us far finer in that particular, is by him. We believe that it is, but we cannot establish the fact.

Our photograph is from a reproduction of the fan which appeared with an article about it in the November 1932 issue of *Ukiyo-ye Geijutsu*. The author, Muneshige Narasaki, does not give the name of the owner but does say that the original is in Matsukase, Ise. He describes the portrait as that of an elderly looking man of the Tea-Master or Haiku-Poet type. He fails, as we do, to see the significance of the white doll figure of a child, or to identify the object beneath its outstretched right hand. The print on which it is standing is signed Toyokuni and bears the name of a publisher which Mr. Narashige reads Maru-kyū. He considers the subject of the print to be O-Han and Chōyemon and very tentatively tries to connect this with the production of a play about them in 1803. If we could see an actual impression of the print itself and could identify the actors, this dating might be possible to confirm or disprove; but having before us only the photograph of a not very clear reproduction of an ink copy, we can do no more than call attention to the fact that the story of Chōyemon was a favorite on the Kabuki stage and that Sharaku himself made prints for a production of it in 1794. (See numbers 36 to 39 of this catalogue.)

Our identification of the portrait as representing Toyokuni (1769-1825) is based on its similarity to a bust-portrait of that artist which is reproduced as the right-hand cut on plate 17 of the first volume of Succo's *Toyokuni*. The contours of the two faces are the same, the bushy eyebrows are the same, but the most striking resemblance between the two is in the deep lines about the nose and mouth. The portrait on the fan is of an older man whose face has become more deeply furrowed, but the

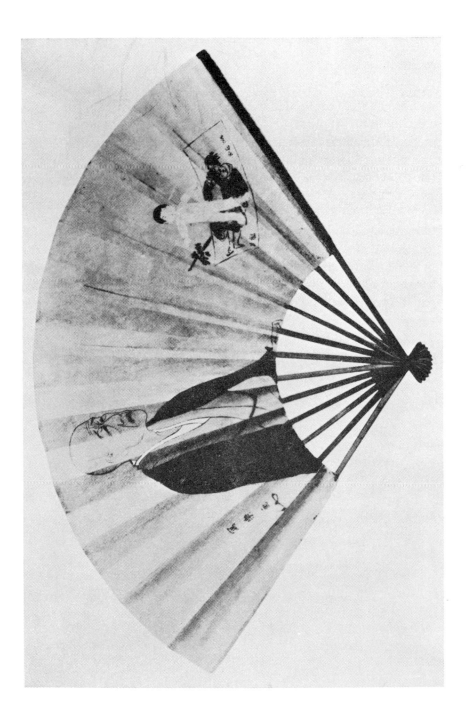

characterization is worthy of Sharaku and the quality of suggestive line in every detail of the mask makes one remember print after print in which character and theatrical verisimilitude were accented by just such exaggerations. The face, we admit, seems too old for a man of 34, but soon after 1800 Toyokuni himself may have suffered as rapid and as sad a decline as his art did; and it must not be forgotten that the earliest references to Sharaku mention his habit of exaggeration to which we have once again called attention just above. Of course the identification is tentative; but does not the complimentary presence in the picture of a print signed "Toyokuni" give a definite clue as to the portrait?

Our catalogue ends as any catalogue which deals with so difficult a subject should end, with a question mark; and we have only to add that those who have compiled it will wait with genuine interest to learn what corrections and additions will be made by those who follow down the path for which we have helped to clear the way.

The fan is signed Sharaku and bears beneath the signature his *kakihan* or written seal.

GLOSSARY

Aiban: Middle size. For prints about 13 x 9 inches.

Banzuke: Play-bill. Most of those used for the present plays were crudely illustrated.

Chidori: Small shore-birds similar to sanderlings.

Daimyo: A feudal lord whose annual income from his fiefs amounted to at least 50,000 bushels of rice.

Edo: The older name for the present Tokyo.

Geisha: A trained female entertainer.

Gozen: A title of respect. Approximately, His or Her Excellency. As used for the plays treated here, applied only to women.

Gwa: Drew. Used with the signature of an artist. The equivalent of "Pinxit."

Hakama: Wide pleated trousers or divided skirts used by men for formal wear.

Haori: A short coat-like garment.

Hibachi: Literally "fire-box." A brazier or charcoal-burner.

Hosoye: Narrow picture. For prints about 13 x 6 inches.

Ichibanme: Literally "first." Technically the first part of a performance.

Jōruri: A narrative song originally used for the puppet stage and taken over by the kabuki for particular episodes.

Kabuki: The popular theater.

Kamishimo: Literally "upper and lower." A formal garment, the upper part of which has stiff wing-like shoulders.

Kimono: A garment. Literally "thing worn." In particular the long dress worn by both men and women.

Manji: A swastika.

Mon: A crest. A personal or family mark of identification.

Nagauta: A style of music sometimes used in the theater as an accompaniment.

Nibanme: Literally "second" or "secondly." Technically the "second part" of a performance. See discussion under No. 1-a.

Nō: A formal, highly stylized dance-drama of religious or ethical import.

Ōban: Large size. For prints about 15 x 10 inches.

Obi: A sash or girdle. Obi used by women usually were much wider than those used by men.

Saké: Rice wine.

Samurai: A member of the military caste.

SHIBARAKU: Literally, "Wait a while." An interlude. See under No. 93.

SHIRABYŌSHI: A dancing girl.

SHOSA or SHOSAGOTO: A dance or dance-episode.

TABI: Socks with a separate division for the big toe.

TORII: An ornamental entrance usually used in front of Shinto shrines.

UKIYO-YE: Literally "pictures of the passing world." The name of a school of genre painting.

YAKKO: A male servant in a military household.

ZŌRI: Sandals.

A LIST OF BOOKS AND CATALOGUES REFERRED
TO IN THE TEXT

AUBERT: Louis Aubert, *Les Maîtres de l'Estampe Japonaise*. Paris. 1914.

BARBOUTAU: *Biographies des Artistes Japonais dont les Oeuvres Figurent dans la Collection Pierre Barboutau*. Tome II, *Estampes et Objets d'Art*. Paris. 1904.

BENESCH: Otto Benesch, *Sharaku, Hokusai, Hiroshige. Die Spätmeister des japanischen Holzschnitts*. Wien [1937].

BREMEN: *Japanese Color Prints from the Art Museum, Bremen*. Part II. The Walpole Galleries, New York. November 1922.

CHARVARSE: *Estampes Japonaises Appartenant à Monsieur C——— et à divers Amateurs*. Hôtel Drouot, Paris. Février 1922.

CREWDSON: *Catalogue of the first portion of the valuable and extensive collection of Japanese and Chinese Works of Art made by the late Wilson Crewdson, Esq.* Sotheby, Wilkinson & Hodge, London. 1919.

EDO SHIBAI NENDAIKI: "Chronicles of the Edo Stage." The date and authorship of this book are unknown, but its text is included in No. 21 of a compilation known as *Mikan Zuihitsu Hyakushū* which appeared in 1927.

FICKE: Arthur Davison Ficke, *Chats on Japanese Prints*. New York. 1915.

FICKE: *The Japanese Print Collection of Arthur Davison Ficke*. The Anderson Galleries, New York. 1925.

FINE ARTS SOCIETY: *see* Morrison.

HAISHI OKUSETSU NENDAIKI: "Chronicle of Fictions and Traditions." (Text in Japanese). Edo. 1802.

HAYASHI: *Dessins, Estampes, Livres Illustrés du Japon* réunis par T. Hayashi. Hôtel Drouot, Paris. 1902.

HIRANO: Chie Hirano, *Kiyonaga. A Study of His Life and Works*. With a portfolio of plates. Boston. 1939.

HYŌBANKI: *see* Yakusha Hyōbanki.

JACQUIN: *Rare and Valuable Japanese Color Prints. The Noted Collection Formed by a Distinguished French Connoisseur of Paris.* The Walpole Galleries, New York. 1921.

JAVAL: *Collection Emile Javal Estampes Japonaises.* Hôtel Drouot, Paris. 1926.

KABUKI NENDAIKI: *see* Nendaiki.

KABUKI SAIKEN: Iizuka Tomoichiro. (Text in Japanese). Tokyo. 1926.

KABUKI ZUSETSU: Morizumi Kenji and Akiha Yoshimi. (Text in Japanese). 2 vols. Tokyo. 1931.

KURTH: Julius Kurth, *Sharaku.* München. 1922.
Second edition, much the same plates as 1910 edition but rearranged and partially rewritten.

LOUVRE: Gaston Migeon, *L'Estampe Japonaise.* Tome I. Musée du Louvre, Paris. 1923.

MATSUKATA: "Catalogue of Ukiyoye Prints in the Collection of Mr. K. Matsukata." (Text in Japanese). Edition limited to 300 copies. Osaka. 1925.

MATSUKI: *Ukiyoye Hanga Seisui.* "Selected Gems of Ukiyoye Prints." Collected by Z. Matsuki. 3 vols. Kyoto. 1925.

MIGEON: Gaston Migeon, *Chefs-d'Oeuvre d'Art Japonais.* Paris [1905]. *see also* Louvre.

MIHARA: "Catalogue of a Special Exhibition of Prints Selected from the Collection of Mr. A. S. Mihara." (Text in Japanese). Imperial Institute of Art, Tokyo. 1930.

MORRISON: *Exhibition of Japanese Prints.* Illustrated catalogue with notes and an introduction by Arthur Morrison. The Fine Arts Society, London. 1909.

MOSLÉ: *Japanese Works of Art Selected from the Moslé Collection.* (Two large portfolios.) The edition with text in English limited to 200 copies. Leipzig. 1914.

MUTIAUX: *Objets d' Art d'Extrème Orient et Estampes Japonaises Appartenant à Divers Amateurs.* Hôtel Drouot, Paris. Mars 1922.

NAKATA: Katsunosuke Nakata, *Sharaku.* (Text in Japanese). Tokyo. 1925.

NENDAIKI: Tachikawa Emma, *Kabuki Nendaiki.* "The Kabuki Chronicle." Edited by Yoshida Eiji. (Text in Japanese). Tokyo. 1926.

NOGUCHI: Yonejiro Noguchi, *Sharaku.* (Text in Japanese). Tokyo. 1925.

RITCHIE: *Catalogue of Japanese Color Prints of the Best Period Forming Part of the Collection of H. A. Ritchie, Esq.* Christie, Manson & Woods, London. 1910.

RUMPF: Fritz Rumpf, *Sharaku.* Berlin. 1932.

STRAUS-NEGBAUR: *Sammlung Tony Straus-Negbaur. Beschrieben von Fritz Rumpf.* Auktionsleitung. Berlin. 1928.

SUCCO: Freidrich Succo, *Utagawa Toyokuni und Seine Zeit.* 2 vols. München. 1913.

UKIYO-YE NO KENKYU: An illustrated quarterly journal devoted to the Ukiyo-ye arts and artists. (Text mainly in Japanese). Tokyo. October 1921-January 1928.

UKIYO-YE TAISEI: "The Complete Ukiyo-ye." (Text in Japanese). 12 vols. Tokyo. 1930-1931.

UKIYO-YE TAIKA SHŪSEI. "Collected Masterpieces of Ukiyo-ye." (Text in Japanese). 20 vols. Tokyo. 1931-32.

VIGNIER-INADA: *Kiyonaga, Buncho, Sharaku Estampes Japonaises Tirés des Collections de Mm. * * * et Exposées au Musée des Arts Décoratifs en Janvier 1911.* Catalogue dressé par M. Vignier avec la collaboration de M. Inada. Ouvrage tiré à 125 exemplaires. Paris. 1911.

VON SEIDLITZ: W. de Seidlitz, *Les Estampes Japonaises.* Traduction de P. André Lemoisne. Paris. 1911.
The French translation of this book is better illustrated than either the original German edition or the one in English.

YAKUSHA HYŌBANKI: "Comments on Actors." Published throughout the eighteenth century by Hachimonjiya. (Text in Japanese).
These chronicles or theatrical year-books give critical opinions as to how the actors included in their listings had played the parts assigned to them.

YAKUSHA NINSŌ KAGAMI: "The Mirror of Actors' Faces." (Text in Japanese). Edo. 1795.
The only copy known to be in existence is the one in Tokyo which was used by Dr. Ihara and Mr. Kimura in their researches for this catalogue.

ZOKU UKIYO-YE RUIKŌ: "Biographical Studies of Ukiyo-ye Artists." (Text in Japanese). Edo. 1833.